A DRAWING HANDBOOK

Themes, Tools, and Techniques

Nathan Goldstein

Art Institute of Boston

Prentice-Hall, Inc., Englewood Cliffs, New Jersey 07632

Library of Congress Cataloging in Publication Data

Goldstein, Nathan.
 A drawing handbook.

 Bibliography: p.
 Includes index.
 1. Drawing—Technique. 2. Artists' materials.
 3. Drawing—Themes, motives. I. Title.
 NC730.G617 1986 741.2 85-6278
 ISBN 0-13-219312-4

Editorial/production supervision and
 interior design: Sylvia Moore
Cover design: Diane Saxe
Manufacturing buyer: Harry P. Baisley
Page layout: Gail Cocker

In memory of Jack Kramer,
who loved drawing so much
and did it so well.

On the cover:
Edgar Degas. *Back View of a Standing Ballerina*
The Louvre, Paris
Courtesy Musées Nationaux, France

Printed in the United States of America

10 9 8 7 6 5 4 3 2

ISBN 0-13-219312-4 01

Prentice-Hall International (UK) Limited, *London*
Prentice-Hall of Australia Pty. Limited, *Sydney*
Editora Prentice-Hall do Brasil, Ltda., *Rio de Janeiro*
Prentice-Hall Canada Inc., *Toronto*
Prentice-Hall Hispanoamericana, S.A., *Mexico*
Prentice-Hall of India Private Limited, *New Delhi*
Prentice-Hall of Japan, Inc., *Tokyo*
Prentice-Hall of Southeast Asia Pte. Ltd., *Singapore*
Whitehall Books Limited, *Wellington, New Zealand*

CONTENTS

PREFACE

For the past ten years I have conducted drawing workshops and seminars in numerous art schools and departments of art, from Rhode Island to Hawaii. Over that time it became ever more clear to me that the rock-bottom issue for beginning students is the mastery of the basics of drawing, that fundamental and illusive forming skill. I have even encountered advanced students uneasy about their grasp of drawing and eager to discuss and reexamine perceptual or technical matters of the most elementary kind.

Likewise, virtually every artist-teacher I have met in my travels has pointed to the mastery of the fundamentals of drawing as a student's first hurdle in his or her development as an artist, and many have shared with me their sometimes ingenious methods for getting their students to see and thus to draw better. After awhile, it occurred to me that a lean book which did not attempt to be a comprehensive examination of the great realm of drawing, but which concentrated instead on important first considerations of drawing, could be a useful aid to students and teachers alike. This book is my attempt to organize and to clarify those basic perceptual and technical facts necessary to making our drawings more nearly reflect our visually expressive intentions. I have, therefore, concentrated on those challenges and questions I found to be uppermost in students' minds, and have tried to show outstanding resolutions of these matters in the many master and student drawings reproduced here.

In the visual sphere, I have tried both to show the interdependence of objective, measurable matters and subjective, empathic ones and to make the connection between the narrative and dynamic function of the marks themselves. For at the outset of learning to draw it is important for the student to recognize that drawing, even in a highly objective mode, has to do with more than faithfully recording observed facts; it also has to do with making visual connections and contrasts, with creating circuits of association that send harmonies and tensions resonating through a work, giving it some greater enveloping expression and order.

In the technical sphere, I have provided some facts about the nature of those drawing materials most often employed, and some guidance on how they may be used. I have also included information on the care and storage of drawings, and on matting and framing.

Additionally, I have discussed various subject categories and drawing themes in order to expand and clarify what may be drawn and in what mode a subject may be addressed. I have also touched on the useful concept of the right and left brain hemispheres and their differing roles in drawing, with a view to showing that these differences in seeing, which I refer to as *creative vision* and *functional vision*, have been known to artists and art teachers for some time. As it relates to drawing, the two-brain concept, however its accuracy is finally assessed by science, is a helpful model for the student

trying to unravel the complexities of seeing, and it deserves mention in a discussion of basic perceptual matters.

In concentrating on the fundamentals of drawing, I have tried to steer clear of how-to-do-it solutions. Instead, by discussing basic visual phenomena, types of drawing, themes, and practical technical facts, I have attempted to provide for the serious student the kind of information necessary when embarking on an exploration of the magnificent realm of drawing.

I wish to express my deep appreciation to the many students, artists, and friends who have helped in various ways to bring this book into being. I wish also to thank the many museums, galleries, and individuals for granting me permission to reproduce drawings in their collections.

I wish especially to thank Carl Mastendrea and Paul Beauchemin, who photographed a number of the works, art materials, and models reproduced here. Special thanks to Bud Therien of Prentice-Hall for his initiative and considerate assistance, and to Sylvia Moore, production editor, and Gail Cocker, designer of page layout, for their finely honed skills and deep involvement in helping to give this book its present form.

I am particularly grateful to Harriet Fishman, herself an artist, for her help with the correspondence chores and for her support and good counsel. A special thanks to little Jessica, who always returned my stapler, masking tape, and erasers. Finally, a special thanks to my daughter, Sarah, whose affection and sense of wonder have always nourished me.

1

MATERIALS

Tools, Media, and Supports

The instruments and materials we draw with are not passive; they are active agents that influence every drawing's development. For this important reason, early in our study of drawing we need to understand something of their differing properties. Each tool, medium, and surface has its own character and limitations, and these traits combine in various ways that affect not only the way our drawings appear, but even the way we see our subject.

For example, whatever our subject the resulting drawing in, say, pen and ink, will differ in two ways from one in, say, compressed charcoal. First, when using pen and ink we are more likely to rely on linear devices such as **contour*** and **calligraphy** than when we use compressed charcoal, which so easily produces broad strokes of **tone** and soft edges. And second, our natural response to the light, linear character of pen and ink and the more somber, tonal nature of compressed charcoal leads us to search out in our subject those qualities our pen or chalk can more easily and effectively state. This can be seen in Figures 1.1 and 1.2 where, in addition

*Boldface terms are defined in the glossary.

Figure 1.1 (*student drawing*)
David Amoroso, North Virginia Community College
Pencil. 24 × 18 in.

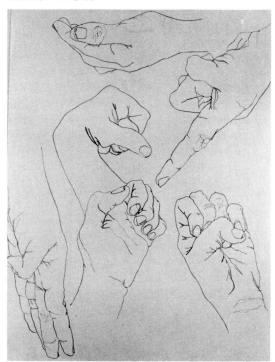

1

Figure 1.2 (*student drawing*)
Lisa Volpe, Rutgers University
Grey pastels. 12 ½ × 20 in.

to the obvious textural differences between ink
and chalk lines, we see an emphasis on con-
tours, overlappings, and calligraphic play in the
pen-and-ink drawings, and on a more tonal
treatment in the chalk drawing.

As these two drawings suggest, the more
familiar we become with the materials of draw-
ing, the more skillfully we can draw what we
see or intend, and broaden as well the range of
what there is to be seen or striven for. The
following is a survey of the most frequently
used drawing media, instruments, surfaces, and
materials, with suggestions on how they may
be used to serve better our creative needs.

ABRASIVE MEDIA

Here, the term *abrasive* defines all those "dry"
media such as the various drawing chalks, pen-
cils, and crayons which are applied by rubbing
across a roughened surface, filing away minute
particles from them to lodge among the hills
and valleys of the surface.

Vine Charcoal

Vine or stick charcoal (Figure 1.3), prob-
ably the oldest drawing medium known, re-
mains one of the most versatile and popular
mediums in use by students and professionals
alike. Usually made from 6-inch lengths of wil-
low, beech, vine, or basswood twigs, and vary-
ing in thickness from 1/4 inch to 1/2 inch, vine
charcoal is simply carbonized wood. It is usually
available in three or four degrees of hardness,
from "very soft" to "hard." Although the nar-
row tonal range of the hard vine charcoal re-
stricts its use to producing subtle nuances of
value in extended tonal drawings, the greater
range of value of the softer sticks, and their
versatility in creating delicate or strong visual
effects (Figure 1.4), make this a desirable me-
dium for the beginner, especially as vine char-
coal contains no adhesive agent, or **binder**, and
can be easily dusted away. But for this reason
completed charcoal drawings must be sprayed
with a protective layer of *fixative*, a weak solu-
tion of shellac or lacquer that holds the charcoal

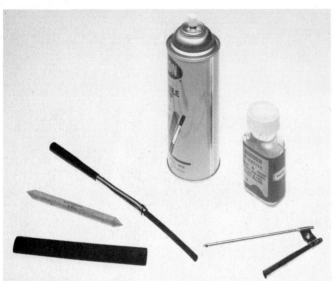

Figure 1.3
Clockwise from lower left: thick charcoal stick; a rolled paper tortillon; a charcoal extender with vine charcoal; aerosol spray can of fixative; bottle of fixative and blower. The thinner stem of the blower is inserted into the bottle; user blows into outer end of thicker stem, producing a fine spray. Use of fixative in either form must be in a well-ventilated room or out-of-doors, since the fumes contain harmful ingredients.

Figure 1.4 (*student drawing*)
Gloria Valera, Drake University
Charcoal. 24 × 18 in.

particles to the drawing surface. Fixative also isolates the particles from any subsequent layers of charcoal or any other medium applied over them. Available in aerosol spray cans, fixative can also (and more safely and economically) be applied by a hand-held mouth-blower (Figure 1.3).

To avoid these charcoal particles being blown about by the force of the fixative spray, place the drawing horizontally and, holding the can or blower about fifteen inches from the work, pass it back and forth over the work, allowing the spray to settle gently upon the surface. Always fix your drawings in a well-ventilated area or, when possible, out of doors, since repeated inhaling of the fumes is unhealthful.

Applying a light fixative coating to a drawing after its initial tones have been established helps to avoid unwanted smudging and also creates a more receptive surface upon which to add darker tones. Be sure the fixative you purchase is designated as "workable" fixative, which allows you to draw over it, and not "final" fixative, which is used to protect a completed drawing. An economical (and safer) variant of manufactured fixatives is casein, a strong binding agent found in milk. The high casein content in skim milk makes it an effective fixative, when diluted with an equal amount of water and applied with the blower. Such a fixative has the additional advantage of being workable.

Fixed charcoal drawings (and works in most abrasive media) should not be assumed safe from smudging, if they are roughly handled. To store such works safely, you should either mat and frame them under glass or isolate each work by placing protective sheets of any non-absorbent or smooth-surfaced paper between them. Avoid sudden, lateral shifts in moving such stacked works, as some smudging is likely to occur.

Using Vine Charcoal. Although vine charcoal's rugged character and ease of application are more suited to drawings of a bold and spontaneous nature than to works of delicacy and precision, it has a long history of use in the art academies of the West for just such extended, "academic" tonal studies (Figure 1.4). Tones are applied either by close **hatchings** in various directions or by turning a short length of charcoal on its side to produce broad strokes (Figure 1.5). Charcoal can be blended with a paper stomp called a tortillon (Figure 1.3), or by a small piece

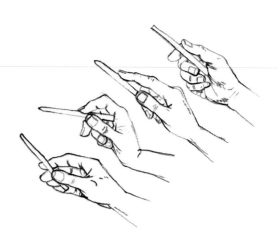

Figure 1.5

of cloth, **chamois**, or even facial tissue. The kneaded eraser is also useful for such operations and, if shaped to a point, can be used for picking out small, light tones or lines.

Charcoal holders (Figure 1.3) enable the user to work at a greater distance from a work, and to utilize small fragments of charcoal. Available in most art stores, vine charcoal powder is applied by such blending tools as the tortillon, the chamois, or cloth. It is easily made in the studio by pulverizing vine charcoal. The charcoal stick can be sharpened to a point with a fine-grained sandpaper. If the stick is turned frequently when drawing, the point can be maintained indefinitely.

Vine charcoal takes well to any drawing surface with a moderate **grain** or **tooth**, but adheres poorly to smooth surfaces. It is compatible with all members of the charcoal and chalk families and is often used in combination with other abrasive or fluid media. Because it is easily brushed away or fixed, vine charcoal has been used for centuries to make the preliminary drawings that underlie many paintings.

Compressed Charcoal

Made of pulverized carbon (charcoal) and a binding agent, compressed charcoal produces a wider range of values than vine charcoal, has superior holding power, and is less easily erased or blended. It is available in either round or square-sided sticks and in pencil form, in a range of degrees from the rich black of #.00 (the softest charcoal) to the less dense black of #5 (the hardest) (Figure 1.6).

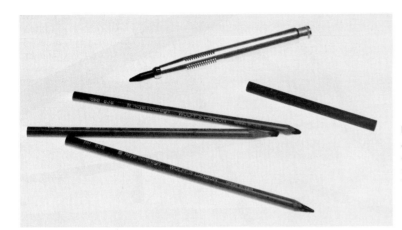

Figure 1.6
At bottom, three compressed charcoal pencils; at top, a mechanical lead holder for compressed charcoal sticks; at right, a round compressed charcoal stick. This versatile and popular medium, available at any art supply store, is ideal both for drawings of a rugged kind and also, in its harder degrees, for drawings of great delicacy.

Using Compressed Charcoal. Ideal for quick, exploratory sketches and drawings of a bold or gestural nature, it is more often used for its great tonal range and rugged line quality than for extended works of a more precise kind. However, long studies in compressed charcoal, especially in pencil form, are not uncommon (Figure 1.7).

Although moderately grained papers provide the best surface, compressed charcoal takes well to smoother ones as well. Like vine charcoal, completed drawings must be thoroughly fixed to avoid smudging. Compressed charcoal intermixes well with vine charcoal and other types of chalk and is sometimes used in conjunction with white chalk on a toned surface, and even over drawings begun in one of the fluid media. Being somewhat water-soluble, it can be brushed over with water or any fluid media to produce various textural effects.

Graphite Pencils and Sticks

Erroneously called a lead pencil because of the use in antiquity of various metallic styluses, of which lead and lead alloy metals were the most popular, the graphite pencil remains one of the most familiar and favored drawing tools for the beginner. Graphite pencils come in a range of some twenty degrees of hardness (Figure 1.8). The hardest pencils range from the moderately hard 1H to the extremely hard 9H. The latter is capable of only thin gray lines. The soft pencils range from the moderately soft 1B to the velvety soft 8B. Graphite pencils designated H, F, and HB are of subtle differing degrees of hardness that fall between the H and

Figure 1.7
SIGMUND ABELES (1934–)
Self-Portrait
Compressed charcoal and charcoal pencil. 24 × 18 in.
Courtesy of the artist

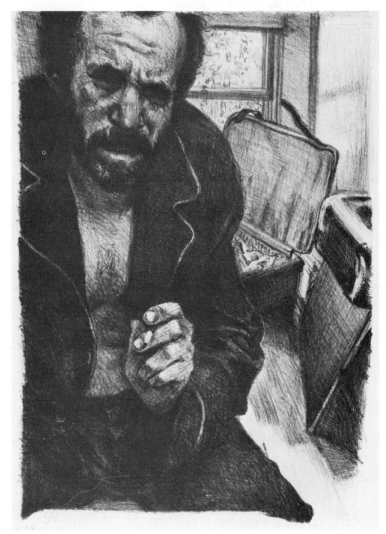

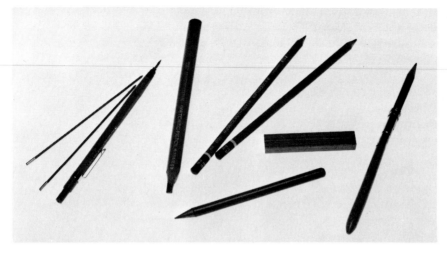

Figure 1.8
From left to right: a mechanical holder for graphite leads (shown alongside); a broad sketching pencil, sometimes called a carpenter's pencil; two pencils made of a mixture of graphite and carbon in a slightly waxy base; a broad graphite stick, useful for drawing in large tones; and a pencil extender. At bottom: a woodless graphite pencil. Coated with a thin protective material, this pencil is made entirely of graphite, which is sharpened to a point in the usual manner. "Lead" pencils and sticks, in some form, are part of every artist's equipment.

B categories. Additionally, various other soft drawing pencils are available, such as Ebony, Black Magic, and Midnight Sketching, to mention a few brand names. These carry no degree designation, but are equivalent to a 7B or 8B pencil. Some of these contain a mixture of carbon and graphite, enabling them to produce richer dark tones, just as the addition of clay to graphite controls the degree of hardness in the H category. The more clay added to the graphite, the finer and grayer the line it produces will be.

Graphite sticks and blocks are manufactured in far fewer degrees, and mainly in the softer designations. Of these, 2B, 4B, and 6B are the most readily found in art stores. Graphite powder, often available, is easily made in the studio by pulverizing leads or sticks of the desired degree. Thin graphite leads in a variety of hard and soft degrees are available for use in mechanical writing pencils, as are thicker leads, for use in specially designed artist's lead holders (Figure 1.8).

Using Graphite. Despite graphite's versatility and ease of erasure, its freshness—that is, its pleasant texture and look of spontaneity—is fragile and easily lost. Extensive blending, erasing, smudging, and reworking of tones and edges causes graphite drawings to take on a shiny, worn look. In extended tonal drawings, such an overworked effect also results from the use of only one pencil, often one of the harder kind. Because the tonal range of any single pencil is limited (especially those in the H category), at least two or three pencils should be used in drawings intended to be fully tonal. A good all-purpose three-pencil selection might include a 2H, a 2B, and a 5B or 6B. However, a paper's surface must also be considered in determining the kinds of pencils to use. The softer or more grained the paper, the darker will be the line produced on it by any pencil. While some artists favor the delicacy and precision of the harder pencils, the more limited tonal range of these pencils and the faint, hard lines they produce often promote an overcautious and timid drawing style among beginners. The softer pencils give a wider tonal range, but also can be used in quite precise ways (Figure 1.9).

Graphite lines or tones are easily blended with the tortillon, chamois, or cloth, but great care must be taken to avoid overdoing it. Such operations are seldom employed by seasoned artists, most of whom prefer the texture and freshness of massed lines and broad strokes.

Interesting effects are made possible through dissolving graphite by brushing over it

with rubbing alcohol or turpentine, or by mixing graphite powder and either of these fluids to produce the desired tones. Washes of tone produced in this way are still somewhat erasable.

Although for small-sized drawings and for work where great precision is required graphite pencils are usually held as for writing, holding them in any of the several ways shown in Figure 1.5 (especially in a drawing's early stages, when more sweeping gestural and diagrammatic considerations predominate) permits the user to employ wrist, arm, and shoulder movements that enhance the variety and character of the lines. Graphite is frequently used in mixed-media combinations, including those that employ fluid media such as ink, watercolor, or oil (Figure 1.10).

Figure 1.9
UMBERTO BOCCIONI (1882–1916)
Woman's Head
Pencil
Courtesy of the Art Institute of Chicago, gift of Mrs. Tiffany Blake

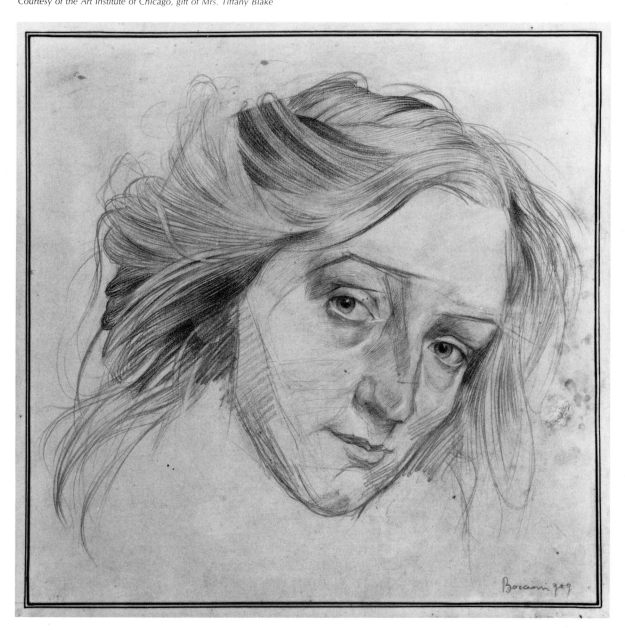

Figure 1.10 (*student drawing*)
Rani Perella, School of Art, Arizona State University
Graphite and ink. 22 × 15 in.

Chalks, Pastels, and Conté Crayons

The term *chalk* has come to be freely applied to a wide variety of dry drawing media that includes compressed charcoal, pastel, and conté crayon (see later in this chapter). Among artists, the term generally refers to any of the black, brown, or reddish drawing media made of dry pigment and nonfatty binders, whereas the term *pastel* is used to define chalks containing high-grade and usually permanent pigments that are manufactured in an extensive range of pure hues and in several tints and shades of each hue.

Pastels are made in cylindrical or square-sided sticks or in pencil form and can be purchased individually as well as in sets (Figure 1.11). Their soft, rich texture and spectrumlike color intensity give them a painterly look and brilliance when applied in layers of bold, densely placed strokes. Square-sided, somewhat harder pastel sticks such as Nupastels are less given to the crumbling effects that enrich the character of soft pastels, and they are more efficient in small-scale works where a high degree of exactitude and detail is desired. Pastel pencils are also harder than their stick counterparts and are likewise used mainly in smaller works of a precise nature.

Because pastels cannot be mixed on the palette in the manner of paint, but must be **optically** "mixed" by hatchings and layers of colors that collectively produce the desired hue and tone, a minimum set should include some forty or more sticks from the over 600 hues, tints, and shades available. Unlike some fluid media, pastel does not undergo any color change after it is applied. If pastel works are well protected by framing (placing narrow strips of wood or mat board between the drawing's mat and the glass will prevent pastel particles from adhering to the glass), they can remain unchanged indefinitely.

Another chalk medium, conté crayon, while similar to pastel, possesses a more creamy, slightly greasy texture. A longstanding favorite among artists, conté crayon is especially well suited to student drawing. Its effects range from the most delicate to the boldest of strokes and tones, making it an excellent tool for quick, rugged drawings as well as for more refined and developed studies (Figures 1.12 and 1.13).

Black conté crayons come in three degrees of hardness: HB (hard), B (medium), and 2B (soft). Additionally, there are four variations of the earth-red color known as sanguine, a brownish tone called bistre, and white. Conté crayon pencils are also available in each of these colors (Figure 1.11).

Like compressed charcoal, conté crayon erases poorly, although light lines and tones will yield to vigorous rubbing with a firm drawing or drafting eraser (see the discussion of eras-

Figure 1.11
Clockwise from lower left: round soft pastel stick; harder (Nupastel) pastel stick; pastel pencil; red conté crayon pencil; and red and black conté crayon sticks. Available in a wide assortment of colors, soft and hard pastel sticks and pencils produce images of both the most rugged and the most delicate kind. Conté crayons, available in a number of reddish and brown tones as well as black and white, possess a more velvety texture than pastels, due to their slightly waxy composition.

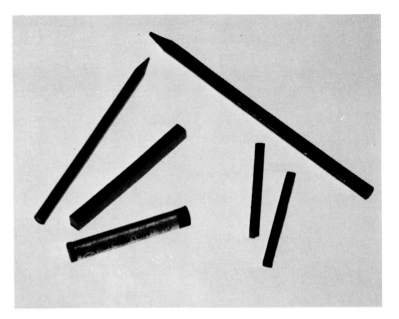

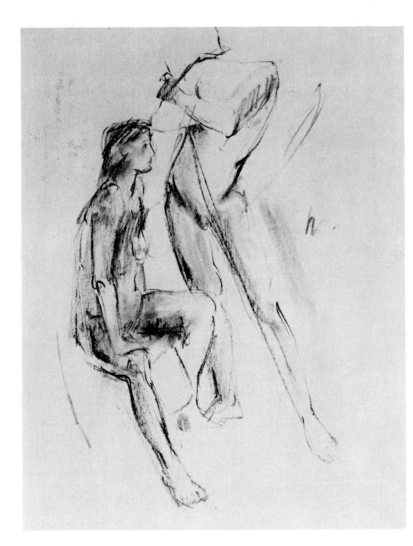

Figure 1.12
Judith Dinham (private study)
(*student drawing*)
Conté crayon. 24 × 18 in.
Courtesy of the artist

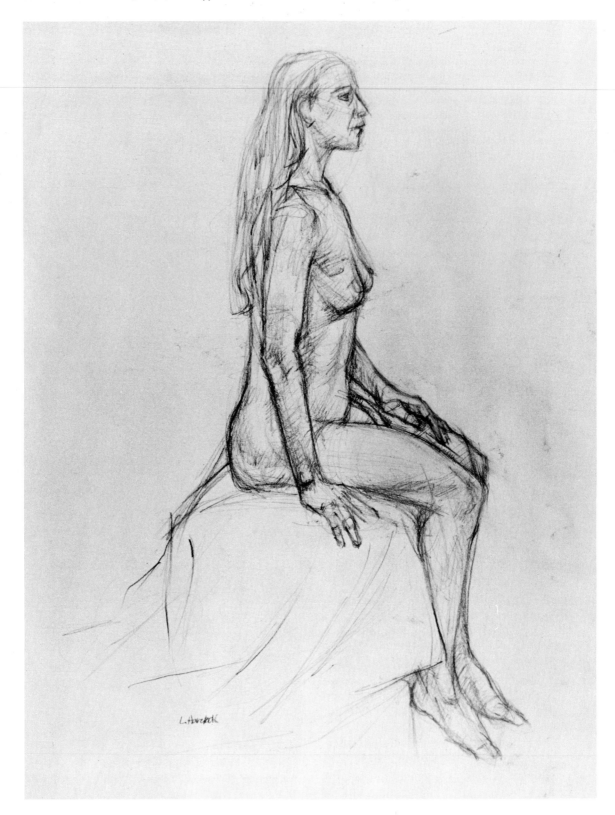

Figure 1.13 (*student drawing*)
Satu Ojanen
The Art Institute of Boston
Conté crayon. 24 × 18 in.

ers on page 33). Conté crayon can be used on a wide variety of paper surfaces, including fairly smooth ones. When brushed over with water the strokes dissolve readily, producing rich, dark tones.

Using Chalk, Pastel, and Conté Crayon. Like the red and black conté crayons, the various all-purpose drawing chalks (including compressed charcoal) closely resemble the natural red, brown, and black chalks used by the old masters and are often employed to achieve similar effects. However, their versatility is well suited to the wide range of effects demanded by some contemporary modes of expression (Figures 1.14 and 1.15). In addition, these can be diluted with water (or other fluid media) and intermixed, drawn over with other media, and used together with pastel.

The pastel stick is handled in much the same manner as any chalk or conté crayon. Each of them produces tones by either hatching or

rubbing. But since pastel is decidedly softer than other chalks, less pressure is necessary for laying down strokes. Because only enough binder is used to hold the pastel pigment particles together in stick form, the problem is to find a way for these particles to lodge among the hills and valleys of the surface. This requires a surface with a fairly pronounced tooth. Such a surface permits many layers of richly textured pastel deposits. Once the valleys of the surface have filled with pastel, further applications will not adhere well. If additional work is to be done over heavy layers of pastel, these areas can be improved by either gently dusting them with cotton or by lightly brushing them with a clean, round bristle brush, such as those used for oil painting. A light application of fixative also improves the surface tooth of heavily pigmented areas.

Very dark tones, and especially black, should not be used for the initial linear drawing

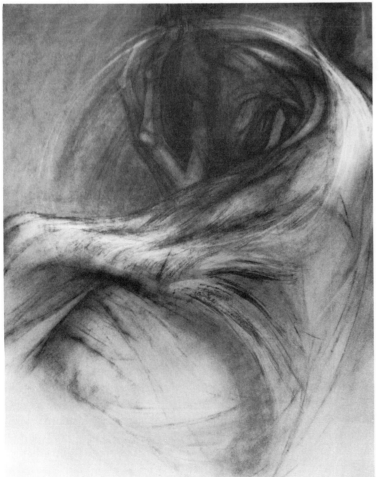

Figure 1.14 (*student drawing*)
Rochelle Allen, Utah State University
Conte crayon and chalk. 24 × 18 in.

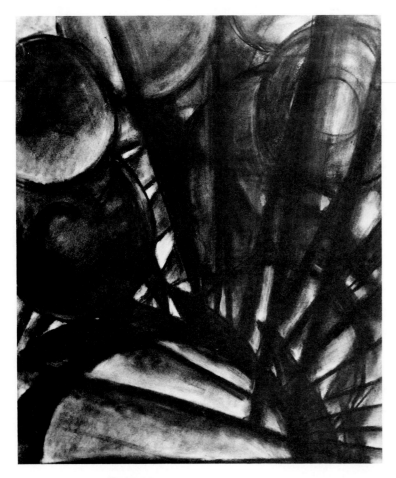

Figure 1.15
ARTHUR G. DOVE (1880–1946)
Abstraction, Number 2
Charcoal. 17⅝ × 10½ in.
Collection of the Whitney Museum of American Art, New York
Photo: Geoffrey Clements

when beginning a pastel work in color. Such works are best begun with lines in some light color such as yellow ochre, a pale blue or green tint, or any other light color that will aid in the form-building and color character of the intended image.

For all their differences, pastel and graphite are alike in that their freshness is easily lost when extensive blending and smudging occurs. While some blending (often with the fingers) is a common practice, pastel works are usually better developed by cross-hatching and by broad, painterly strokes.

Beginners sometimes overuse the lighter pastel tints, which results in works wanting in both value contrast and color richness. To overcome this tendency, it is necessary to apply hatchings in strong hues that together produce the desired color and tone through their optical mixture. In general, pastel is best handled by working from more intense colors to more muted ones and from bolder value contrasts to more moderate ones.

Extensive smudging and blending of pastel not only weakens a work's freshness, it often produces a muddy brown or gray color that further dulls the results. But when pastel is applied in dense, variously hatched strokes, even areas comprised of **complementary colors** maintain a fresh and attractive appearance.

Because of pastel's dry nature, a considerable amount of dust is created when working. Tilting the easel slightly forward prevents the dust from settling on lower portions of the paper. Although no poisonous pigments go into its manufacture, pastel should be used in a well-ventilated room, since inhaling any finely powdered substance may be harmful.

Pastel combines well with fluid media. It is compatible with casein, watercolor, gouache, and oil paint, and there is a long tradition of such mixed-media combinations. Upon examination, such works usually show pastel to be drawn over the paint, rather than left to show between layers of paint.

While all chalks require fixative to protect them from smudging, using more than a light fixative spray on colored pastel works will seriously darken them. Pastel is best protected by framing in the manner described earlier.

Crayons

The wax- or oil-based media available for drawing range from the familiar crayons of childhood to more sophisticated, apparently lightfast materials in both pencil and stick form (Figure 1.16). Completed drawings in any of the wax- or oil-based media do not require protection by fixative. This being the case, they are well suited for use in the sketchbook and for out-of-doors drawing. But like works in pastel or chalk, they cannot be cleaned and should be properly stored or framed.

Several brands of colored wax-based pencils, such as Prismacolor, Spectracolor, and Verithin, allow for drawings that range from those of a spontaneous and assertive kind to works of great precision (Figures 1.17 and 1.18). Being wax-based, such pencils seem to glide across the surface with less resistance than any other abrasive medium, giving a more calligraphic

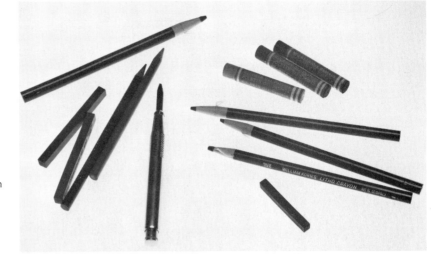

Figure 1.16
Clockwise from upper left: a brown china-marker pencil; three oil-crayon sticks; three litho crayon pencils in differing degrees of hardness; a litho crayon stick; a mechanical holder for a variety of wax-based leads; two wax-based pencils of different colors; and two wax-based drawing sticks. Such materials, because they do not smear, greatly expand the range of sketchbook drawing.

Figure 1.17
NATHAN GOLDSTEIN (1927–)
Page from a Sketchbook (1982)
Black, brown, and reddish colored pencils.
6¾ × 8¾ in.
Collection of the author

Figure 1.18 *(student drawing)*
Hilary Heyman, Arizona State University
Prismacolor and graphite. 30 × 22 in.

richness and fluency to spontaneous drawings, and a special elegance to more fully realized ones.

Although complete erasures of bold strokes are impossible, very light lines and tones can be almost entirely erased, and working from light tones to dark ones—at least in drawing studies of a precise nature—is a wise course.

One group of fatty-based materials, developed for use in the graphic process of lithography, has been popular among artists. Black lithography crayons and pencils (Figure 1.16) come in several degrees of softness, but are as a group more greasy and handle more broadly than wax-based pencils. A black lithography ink called tusche is also available. It too has a waxy base. All are soluble in turpentine or mineral spirits. Although a high degree of precision is possible with these materials when they are used on the lithography stones for which they were designed, used on paper they make rather broad, grainy lines more suited to sketchy works of short duration than to sustained studies. How-

ever, the harder degrees do permit quite a subtle and focused treatment (Figure 1.19).

Another group of colored pencils and crayons is water-soluble, a feature that extends its range of uses. Caran D'Ache is one brand name in this medium. Water-soluble pencils are available in a limited but serviceable number of colors. Little is known about their permanence, and the washes produced by the addition of water lack the richness of watercolor but give an attractive, gentle quality that some artists welcome.

Oil-based crayons such as Craypas or Pentel or Grumbacher oil pastels should not be confused with, or used in conjunction with, traditional pastel. Oil-based crayon is soluble in turpentine, which enables a user to change linear strokes to washes of colors that may be blended. More nearly a painting than a drawing medium, these soft-textured crayons are excellent for works of a bold or sketchy nature, but are less suited to sustained or precise techniques (Figure 1.20).

Figure 1.19

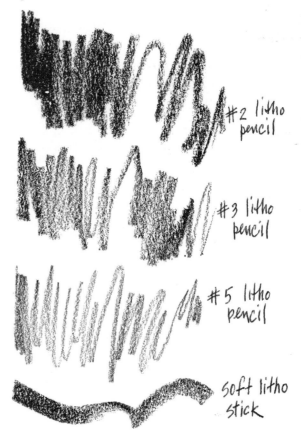

#2 litho pencil

#3 litho pencil

#5 litho pencil

soft litho stick

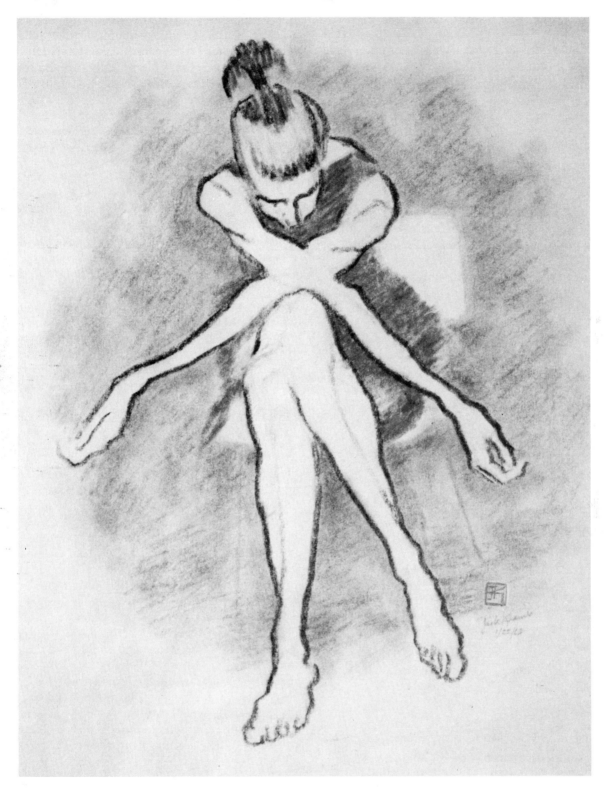

Figure 1.20
JACK KRAMER (1923–1983)
Seated Woman with Arms Crossed (1963)
Oil pastels and wax crayon. 16⅜ × 14 in.
Estate of Jack Kramer

Using Crayons. Because crayon marks are very difficult to smudge or blend unless dissolved in a suitable solvent, the technique for achieving desired values and colors is cross-hatching. However, because erasures are nearly impossible, artists usually work from lighter to darker tones when making an extended **monochromatic** drawing and, when drawing with color, work from paler to richer hues. A degree of erasure is possible by scraping the paper with a single-edged razor blade or a penknife, but care must be taken to avoid roughening the drawing surface.

Some artists use crayon's resistance to erasure to good advantage by beginning a drawing with a sparse and faint schematic sketch of their subject's main features, using vine charcoal or graphite. Here the rule should be: The fewer the guidelines, the better. Once this underdrawing has guided the artist in establishing a *basic* drawing in crayon, the few faint guidelines are erased with little or no affect on the crayon lines, and the crayon drawing is then developed to the desired state.*

Crayon drawings are also begun by dipping the tip of any type of crayon stick or pencil in its suitable solvent, a tactic that produces bolder, more painterly effects. Such drawings can then be developed further by brushing on additional solvent, or by adding more dry crayon strokes. Crayons as a group, because of their wax- or oil-based binders, are less amenable to mixed-media combinations than are other dry drawing media, but nonetheless are occasionally used in this way. For example, a drawing begun with, say, oil pastel, is washed over by watercolor or ink washes creating "islands" of such washes shaped by the resistance of oil to water. Or a drawing begun in sepia or black ink may be carried further by hatchings in colored pencil.

FLUID MEDIA

The physical effort required to produce lines and tones with any of the fluid media is plainly less than is the case when using any of the dry media, which, as we have seen, produce marks by the friction of abrasive action. The relative absence of resistance when applying wet media

is sometimes a problem for the beginner, who finds it difficult to control the easy flow—the immediacy—of the pen or brush. While chalk or pencil may need to be prodded toward an energetic calligraphy, the pen or brush must be restrained from "running wild."

Pens and Inks

The designation *pen and ink* is sometimes applied to drawings made with tools other than, or in addition to, the modern steel pen or the reed and quill pens favored by so many of the old (and some contemporary) masters. Any pointed tool can serve as a pen: A twig, a paper tortillon, the sharpened end of a brush handle, even an eyedropper or cocktail stirrer, or indeed any other object that can be dipped in ink to produce marks can be used for various linear and textural effects. Although the wide assortment of available pens discussed below meets virtually every drawing need, it is instructive to explore these more unorthodox means of applying ink. Here, however, we will concentrate on the three basic types of pen: the traditional dip pen, the fountain pen, and the ballpoint and fiber point pen.

Dip Pens. Today, the mainstay of dip pens is the steel pen point. Although examples of steel pen drawing date back to the Renaissance (Figure 1.21), it was not until the early 1800's, when their uniform manufacture ensured the availability of particular types and styles, that steel pens came into popular use. The wide selection available ranges from extremely flexible pens that produce lines varying in width from an almost invisible thread of ink to over 1/8 inch to rigid mapping and lettering pens that produce fairly uniform lines in differing widths (Figure 1.22). The many types of pen points (and papers) and the individual needs of each user make it impossible to recommend specific pens. Most artists favor a flexible pen such as the crow quill, which produces a fine line with little pressure, and broader lines with increased pressure. Other versatile and popular pens are shown in Figure 1.22.

Some steel pens lack the warm, animating traits of the reed and quill pens. These older instruments respond well to a paper's surface character (especially more rough-grained papers), their somewhat pliant tips "riding" the paper's hills and valleys with ease. The harder tip of the steel pen is more likely to make its

*The kneaded eraser works best for this procedure, as it can be used with greater precision and less disturbance to the crayon marks or surface tooth. See page 33.

Figure 1.21
ALBRECHT DÜRER (1471–1528)
Grotesque Head of Man
Ink drawing.
Reproduced by courtesy of the Trustees of the British Museum

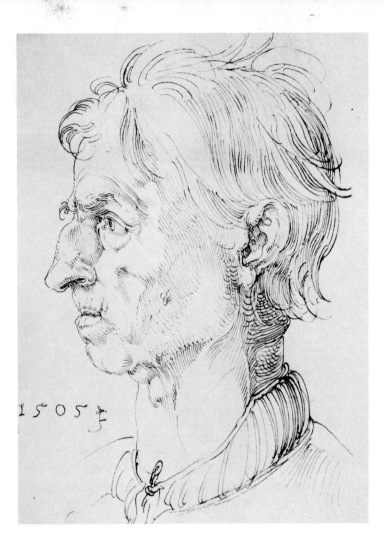

Figure 1.22
Clockwise from lower left: a Hunt extra fine nib (#512) in a shaped holder; a Hunt finest nib (#104) in a small plastic holder; an Esterbrook oval nib (#668) in holder with a cork grip; a Hunt crow quill nib in a small plastic holder; a bamboo reed pen, sharpened at both ends; a length of balsa wood, shaped to a point at one end; a bamboo skewer; and an assortment of pen points, some of which appear in the holders at left. Experiment with a variety of kinds of pens to find those that best suit your drawing needs.

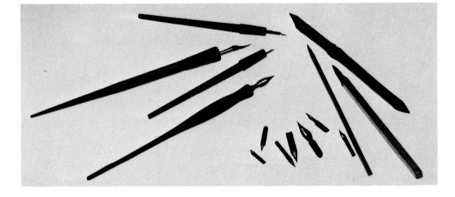

own flat "road" on rough-grained papers, losing some of the tactile and visual benefits of the interplay between tool and terrain, and is more prone to spatter ink by becoming snagged on uneven surfaces. However, on smooth papers, and when fine lines or close hatchings are required, the steel pen's free-flowing, incisive character exceeds those of the reed or quill pen.

The reed pen is among the oldest drawing instruments used with ink. Found along some river banks and marshes, the hollow, tubular reeds are dried, cut to a comfortable length, and sharpened to a point at one or both ends (Figure 1.22). Bamboo reed pens are commonly available in art supply stores.

The reed's woodlike, absorbent point wears down quickly and must be resharpened often. Users soon learn to shape the point that best suits their needs (Figure 1.23).

The reed pen differs from all other types

17

in that some ink is taken up into its spongy walls through capillary action. Once the dipped pen has run dry, increased pressure forces out this "reserve" of ink in the form of light, chalk-like lines, as shown in Figure 1.24.

The quill pen, made from the heavier pinion feathers of the goose, crow, or swan, is light to hold and requires almost no pressure in use. The hornlike, tubular wall of the quill, being far thinner than that of the reed, allows a much finer and more flexible point to be cut (Figure 1.23). The quill pen responds to the slightest inflections of the hand and can produce both fine and broad lines by subtle changes in the pressure of the stroke (Figure 1.25).

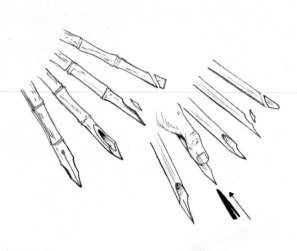

Figure 1.23

Figure 1.24
REMBRANDT VAN RIJN (1606–1669)
Nathan Admonishing David
Pen and brush with bistre. $5^5/_{16} \times 9^{15}/_{16}$ in.
The Metropolitan Museum of Art, New York, Bequest of Mrs. H. O. Havemeyer, 1929, The H.O. Havemeyer Collection.

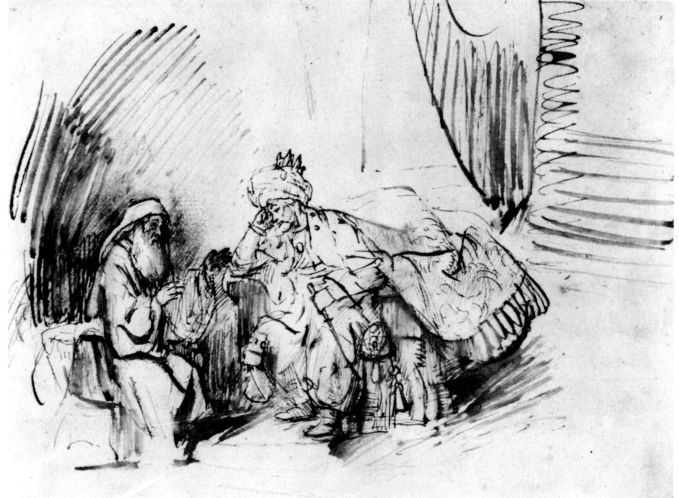

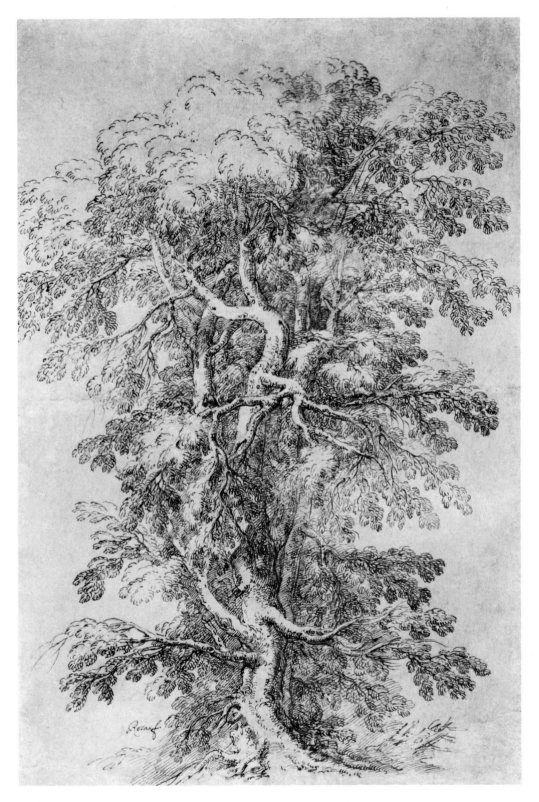

Figure 1.25
SALVATOR ROSA (1615–1673)
A Large Tree
Pen and brown ink on brown paper.
23¹⁵/₁₆ × 16¼ in.
The Metropolitan Museum of Art, New York, Rogers Fund,
1911

Figure 1.26
From left to right: one of many popular drawing fountain pens, designed for use with washable inks; an India ink fountain pen with a retractable nib that is submerged in the ink when not in use; and a stylus type of fountain pen nib, the pen alongside. Such portable pens are of great convenience for outdoor sketching.

Fountain Pens. There are two basic types of fountain pens. One features the traditional type of flexible nib that provides a variety of line widths; the other, a tubular, styluslike nib that produces an unchanging line width. The latter pen, often used for technical or mechanical drawing purposes, imparts an etchinglike quality not easily attained by other kinds of pens. Both types of artists' pen are usually designed to take an assortment of treaded or clip-on nibs, which allows the user to change nibs when necessary, a feature that greatly expands the use of these instruments. Some brands, such as Pelikan, offer pen barrels that will accept either type of nib (Figure 1.26).

Most fountain pens designed for artists' use require a water-soluble ink (see Inks, later in this chapter). If these instruments are thoroughly washed every few weeks by flushing the ink chambers with water, they are relatively trouble-free and give good service. While fountain pens designed to use India ink, a dense, waterproof ink, are available, the drying properties of this type of ink make such pens prone to clogging unless frequently washed (Figure 1.26). Two clear advantages of the fountain pen are the generous ink supply it holds, and the ease with which it can be carried about. Its main disadvantage is that clogging is sure to occur if the pen is left filled and unused for long periods.

Ballpoint and Fiber Point Pens. These two types of pens are serviceable additions to the range of drawing tools for the artist. The limited line variation of both and, in the case of the ballpoint

pen, the relatively weak tone of the black (or other colored) ink, are regarded as disadvantages by some artists. Others welcome the almost invisible thinness of the ballpoint's lines, which permit the user to gradually build up "clouds" of subtle cross-hatchings with a delicacy impossible to achieve with other types of pens. The effortless gliding of the ballpoint pen, especially on a smooth surface, tends to promote a flowing, rhythmic line, and works well in executing intricate linear details (Figure 1.27).

The (usually nylon) fiber pens, even those claimed to produce very fine lines, cannot match the line delicacy of the ballpoint (or most other pens). This type of pen is better employed for quick sketches, where its bolder line and easy flow are advantageous traits.

Inks

All inks are made by combining a liquid or dry pigment, a binding agent that also holds the pigment in suspension, and water. Water-soluble inks use a water-soluble binder such as rabbit-skin glue, and waterproof inks use a binder such as shellac, which does not dissolve in water. Typically, black waterproof inks are more dense and opaque, but recently a number of waterproof inks of thinner consistency have been designed for use in artists' fountain pens. Inks come in a variety of permanent and impermanent colors, including white. Users should check a manufacturer's catalog to see whether a particular ink is colorfast or not. Some brands of

Figure 1.27 (*student drawing*)
Diane Clement, private study, Newton, Mass.
Ball-point pen. 14 × 17 in.

ink, such as Pelikan, produce a variety of permanent colored inks. The several colored inks used in ballpoint and fiber point pens are colorfast, but are usually available only in cartridge replacements, not in bottles.

One of the oldest inks is the Oriental *sumi* ink, made of carbon, a water-soluble binder, and water, and shaped into blocks. When the ink block is rubbed on a slate inkstone containing a small amount of water, either an ink paste or an ink liquid is produced, depending on the ratio of ink to water.* Today, sumi ink is also available in paste or liquid form. It is a rich, black ink that produces excellent washes of tone when added to water.

Earlier drawing inks, such as *sepia*, a rich brown ink, originally made of the inky substance from the sacs of cuttlefish, and *bistre*, a yellow-brown ink once made of fireplace soot, are now artifically made. India ink is a generic term for a drawing ink that uses carbon or lampblack pigment, and a shellac binder that renders the finished drawing waterproof. It has a heavier consistency and a more velvety feel than most water-soluble inks because of the solids in its composition. These solids and the shellac binder cause dried ink deposits to form on the pen point, which should be carefully scraped from time to time with a penknife, or immersed

*To make a similar black ink in the studio, see, James Watrous, *The Craft of Old Master Drawings* (Madison: University of Wisconsin Press. (1957) p. 86. This excellent book also provides readers with formulas for making chalks and crayons, as well as other inks.

in commercially prepared pen cleaning solutions. At the end of a drawing session, all instruments that have been in contact with India ink must be thoroughly washed with soap and water.

Using Pens and Inks. Because most beginners are more familiar with abrasive media than with fluid media, it is useful to spend some time with all three types of pens, practicing hatchings, stipples, and various curving lines, first on smooth papers, and then on some rougher ones, using either dip or fountain pens. It is important to accept the easy flow and immediacy of these pens and utilize rather than resist their fast and calligraphic character (Figures 1.28 and 1.29). Although very precise drawing is possible with the medium of pen and ink (Figure 1.30), beginners should first experience its great range of linear and textural possibilities.

Extended drawings are sometimes begun using a graphite pencil to make some prelimi-

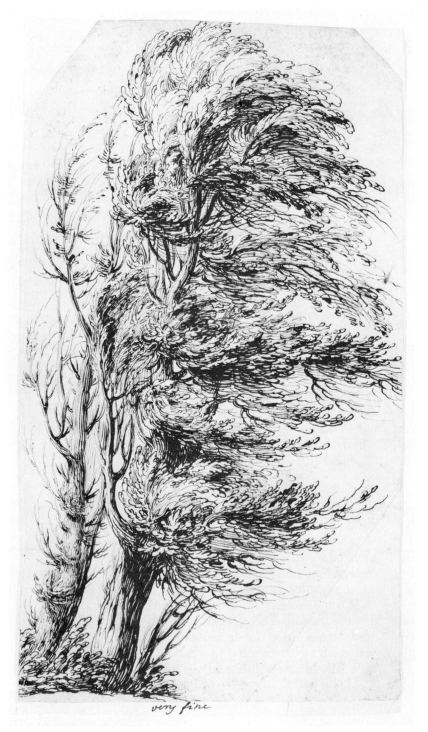

very fine

Figure 1.28
JACQUES DE GHEYN II (1565–1629)
Clump of Trees
Pen and ink. 13 ¾ × 7 ¹⁵/₁₆ in.
Courtesy Museum of Fine Arts, Boston, Francis Welch, Lucy Dalbiac Luard, and Abbott Lawrence Funds

Figure 1.29
ISO PAPO (1925–)
On the Outskirts of Boston
Pen and ink. 8 × 10 in.
Courtesy of the artist

nary diagrammatic notations that are erased once the pen and ink drawing is underway. The danger here is in carrying the pencil drawing too far, causing the beginner to merely trace the pencil lines with pen and ink. This usually produces lifeless results. But the use of a few temporary pencil guidelines can help establish the general scale, shape, and perspective of a subject's parts, enabling them to be more directly and accurately drawn with the pen. Indeed, many master drawings show ink drawings to be over rough, preliminary underdrawings in pencil or chalk.

Dip and fountain pen and inks can be drawn into barely damp surfaces, which slightly soften and spread the lines, or into wet areas, which cause the lines to spread in various (seldom controllable) patterns. Inks can be diluted with water to produce fainter tints of the colors used, and can then be drawn over, using the ink full strength. Pen and ink drawing is compatible with most dry and wet media, but will not hold well when drawn over graphite, chalk, or crayon. Normally, pen and ink provides the first "layer" in mixed-media works.

Establishing volume and space tonally with pen and ink is largely a matter of cross-hatching. The results of such (usually) dense hatchings sometimes resemble the technique of etchings developed by drawing only with the etching

needle (Figures 1.31 and 1.32). Sometimes such hatchings are more freely drawn and are better described as a kind of controlled scribbling, or they may consist of short, broken lines and dots, a more rarely used procedure called **stippling**. Both of these techniques can be seen in Figure 1.33.

When using pen and ink for the first time, many students find it easier to begin with the ballpoint pen (including the inexpensive disposable kind). Capable of producing finer lines

Figure 1.30 (*student drawing*)
Joseph M. Harris, Pratt Institute
Ink. 20 × 24 in.
Photo: W. Andrew Kettler

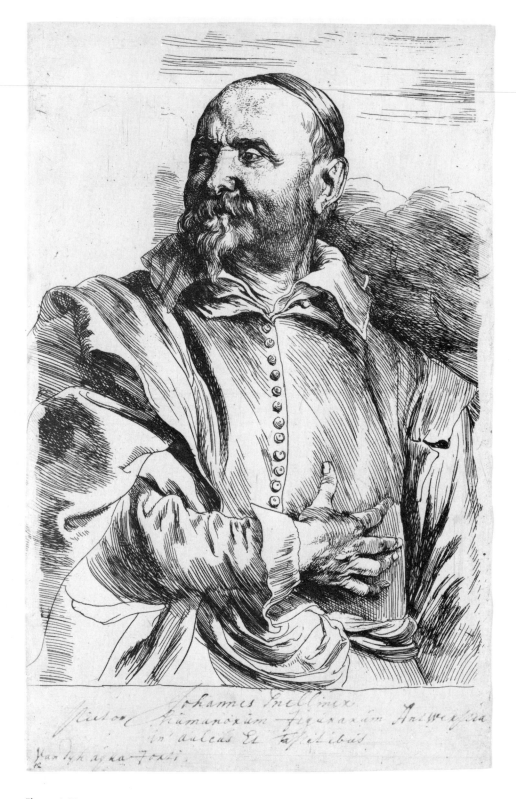

Figure 1.31
ANTHONY VAN DYCK (1599–1641)
Portrait of Jan Snelling
Etching, First state. 9⅝ × 6⅛ in. sheet
Courtesy Museum of Fine Arts, Boston

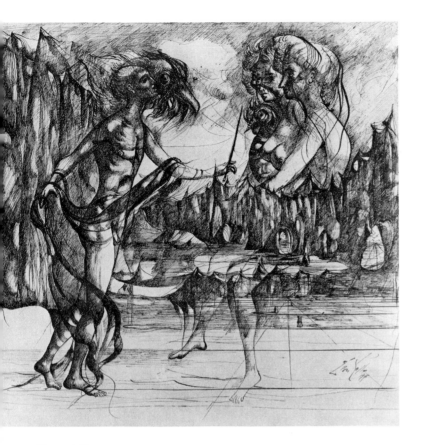

Figure 1.32
LEON KELLY (1901–)
Magic Bird (1945)
Ink. 9 ¾ × 9 ¼ in.
Collection of the Whitney Museum of American Art,
New York, purchase
Photo: Geoffrey Clements

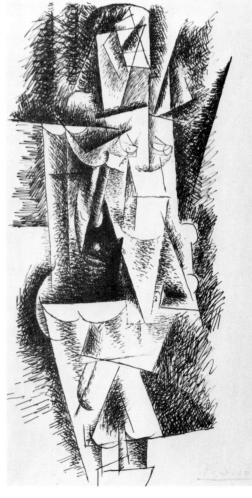

Figure 1.33
PABLO PICASSO (1881–1974)
Standing Nude (Mlle. Leonie) (1911)
Pen and ink, traces of pencil. 12½ × 7½ in.
The Museum of Modern Art, New York
Promised gift of Mrs. Bertram Smith

Figure 1.34

than the finest steel pen, especially on papers with a moderate tooth, it enables the artist to exercise more control over a drawing's development. Contours can be more easily "fine-tuned" by slight changes and darkenings of the nearly invisible ballpoint line, and values can be more gradually built up than is possible with the steel pen. The ballpoint's finer lines (although it is capable of producing quite bold lines as well) permits more "layers" of subtle cross-hatching to be drawn before the hatched lines "fill in" to entirely hide the paper's tone. In fact, the ballpoint pen is an excellent tool for subtle tonal drawing (Figure 1.34). As noted earlier, the fiber point's thicker line does not permit such delicate operations, and is best reserved for drawings of a bolder kind.

Brushes

There are two basic types of artist's brushes: the stiff, coarse-haired *bristle* brush, generally made of hog bristles, but also of nylon "hairs": and the soft-haired brush, made of sable, squirrel, camel, and other animal furs. Both types of brush come in several shapes, and each shape is available in a wide selection of sizes (Figure 1.35).

The several classifications of bristle brushes, determined by shape, are

1. *Flats*: square-ended brushes; available in some eighteen to twenty sizes.
2. *Brights*: square-ended brushes, identical to flats except for being somewhat shorter in length; available in some eighteen to twenty sizes.
3. *Filberts*: slightly more full-bodied than flats and brights, and rounded at their ends; available in twelve sizes.
4. *Rounds*: long, round bodies pointed at tip; available in twelve sizes. Some manufacturers offer oversized flats and brights in sizes that approach those of the smaller house-painting brushes. Less often used are the stencil and fan-shaped bristle brushes.

Soft-haired brushes are available in the same shapes and sizes as the bristle brushes, but are simply referred to as round, flat, and oval brushes. All shapes come with both short handles (more often used for drawing with ink or watercolor) and long handles (for use in easel painting). Sizes commonly range from the tiny 000, less than 1/50-inch wide, to size 12, almost 1/2-inch wide. Some manufacturers offer short-handle brushes in even larger sizes. Finally,

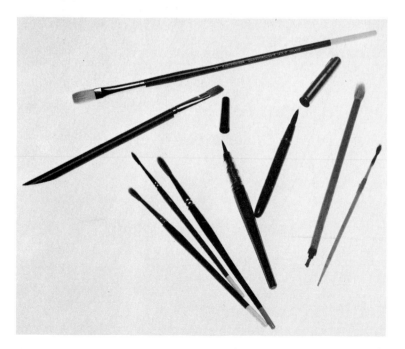

Figure 1.35
Top left: a bevel-ended sable watercolor brush. The bevel tip enables the user to remove paint or ink and to draw into painted areas. At top, a long-handled oil painting bristle brush. Bottom row: at left, three round sable brushes; two fountain "pen" brushes with caps nearby; an oriental brush; and a French quill brush taped to a stick. There are many other types and sizes of brushes suitable for drawing, but any three or four of the types shown here (in whatever size required) will serve almost every brush drawing need.

Oriental soft-hair brushes, sometimes called bamboo brushes, are excellent for producing a wide variety of calligraphic strokes.

The most versatile and popular soft-hair brush for most drawing and watercolor painting purposes is the round, red sable. Its remarkable spring and maneuverability and its ability to retain a sharp point through years of use (when well cared for, See Care of Brushes, below) are qualities unmatched by any other soft-hair brush. Handmade of hair from the tail of the red sable, these rather expensive brushes are more economical and efficient tools in the long run. Less expensive brushes will not perform as well or last as long.

Although a selection of only some six or seven bristle and soft-hair brushes will enable beginning students to experience fully the great range of uses these tools have, they should add brushes in other styles and sizes to their collection as their skills and interests develop. Even more than with abrasive media, where the right degree of hardness in a pencil or chalk greatly affects results, the right brushes—those compatible with the user's needs—are essential in drawing with fluid media.

Care of Brushes. To keep your brushes in good condition, a few rules must be observed. As soon as possible after use, wash them thoroughly with any household soap and warm water. Each brush should be washed until the lather shows no trace of color. Bristle brushes can be rotated in the palm of the hand to work the soap up higher into the bristles. Both bristle and soft-hair brushes should be squeezed to first force the lather close to the hair base, then forward toward the tip. After washing, shape the brush and allow it to dry completely before placing it in closed storage. If oil paint has been used (see Other Fluid Media, page 31), the brush should be cleaned with turpentine or paint thinner before washing it with soap.

Never allow paint of any kind to dry on the brush; this will destroy the spring and shape of any brush, even if subsequent washing has removed as much paint as possible. Avoid washing brushes in hot water, or allowing them to soak in warm water for an extended period of time. This will dissolve the glue or resin used to hold the hairs in place, causing them to fall out of the brush *ferrule*, the metal sleeve into which the hairs are deeply set. Never leave brushes resting on their tips in the container that holds the water (or, when using oil paint, in the turpentine or paint thinner). To do so can permanently destroy a brush's shape. Soft-hair brushes are especially vulnerable to this kind of mistreatment.

Using Brush and Ink. There are two basic methods of applying ink with a brush: the familiar method of loading a brush with an ample amount of ink, to be applied in whatever kinds of broad washes or delicate strokes are desired; and the less familiar *dry-brush* method, in which excess ink is squeezed from the loaded brush with the thumb and forefinger or by brushing back and forth on a more or less nonabsorbent scrap of paper until the brush glides across the paper, leaving a trail of many fine lines of ink. Sometimes such strokes take on a chalklike appearance, as in Figure 1.36. Both methods of applying ink are often used together, as in Figure 1.37.

Figure 1.36 (*student drawing*)
Renee Cocuzzo, private study, Newton, MA
Brush and sepia ink. 17 × 14 in.

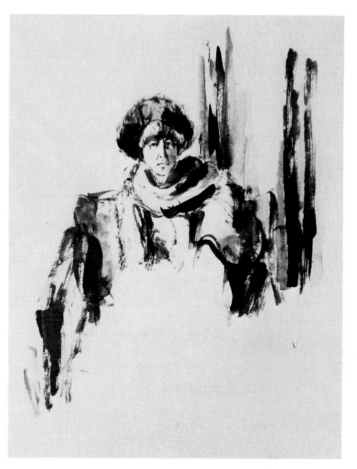

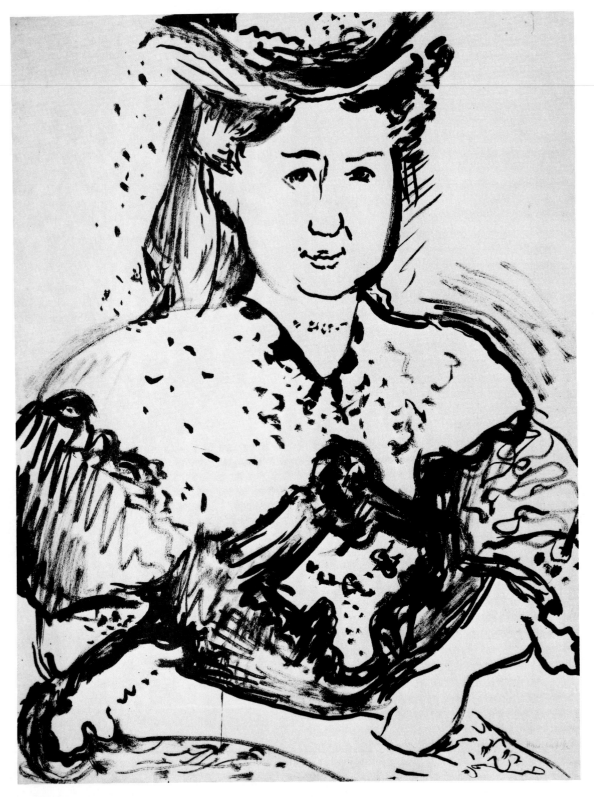

Figure 1.37
HENRI MATISSE (1869–1954)
Jeanne Manguin (1906)
Brush and ink, 24½ × 18½ in.
Collection, The Museum of Modern Art, New York, purchase

Although ink is often applied with the bristle brush, it is the soft-hair brushes that are most frequently used, and some artists employ both kinds of brush in the same work to achieve various textural effects. Ink is applied either full strength or diluted with water. Typically, brush-and-ink drawings show a fresh, spontaneous, and resolute quality, but extremely exact works are also possible in this most versatile of mediums. In fact, naturalist artists and even medical illustrators often select brush and ink (or watercolor) as their preferred medium. The point on a round sable brush, even a good-sized brush, can produce a finer line than is possible with the finest dip or fountain pen.

Brush and ink works well on most surfaces, but avoid absorbent or extremely smooth surfaces at first, since they set up unnecessary obstacles for the beginner. A paper with a moderate tooth and heavy enough not to buckle and ripple will serve best for most purposes. Fluid media shrink paper fibers, and thin papers will buckle to an extent that may interfere with completing a work or getting it to lie flat.

As with pen and ink, extended drawings of a precise kind can be started by making a sparse underdrawing in graphite, but care should be taken not to let this procedure restrict your brush drawing. Too often, brush drawings show an overcaution that stems from unfamiliarity with the medium, but sometimes the problem results from using a brush that is too small. Bigger brushes are usually more beneficial to both conception and handling. A good rule to follow is this: If your brush feels comfortable, it is probably too small. You are likely to find better, more economical graphic solutions if the brush you are using feels a little large for the task at hand. This versatile medium, the mainstay of Oriental art (Figure 1.38) and very popular among earlier artists (Figure 1.39), is well suited to most contemporary modes of expression (Figure 1.40).

Figure 1.38
WEN CHENG-MING (1470–1559)
Cypress and Rock (1550)
Ink on handscroll. 10¼ × 19¼ in.
The Nelson-Atkins Museum of Art, Kansas City, MO, Nelson Fund. © William Rockhill Nelson Trust. All Rights Reserved.

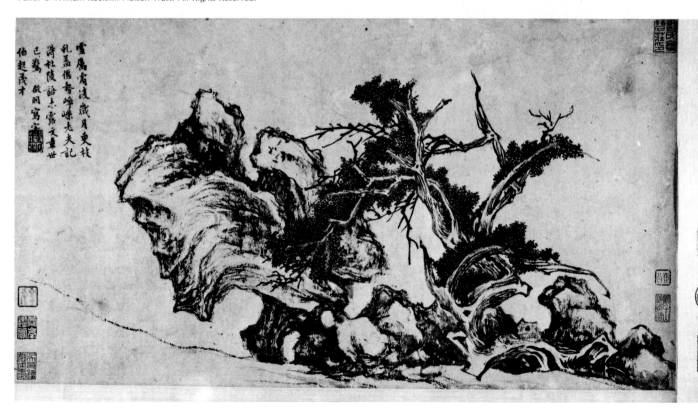

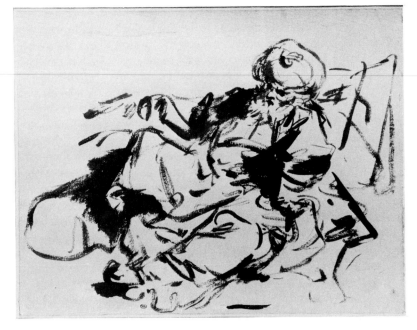

Figure 1.39
JEAN-HONORÉ FRAGONARD (1732–1806)
The Pasha
Brush and brown wash. $9\frac{9}{16} \times 12\frac{13}{16}$ in.
The Louvre, Paris
Courtesy Musées Nationaux, France

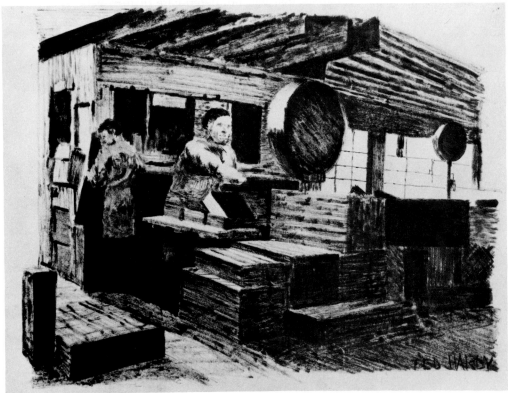

Figure 1.40 (*student drawing*)
Ted Hardy, University of Utah
Dry brush ink. 18 × 24 in.

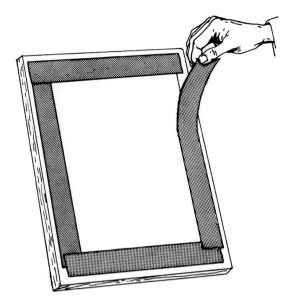

Figure 1.41

OTHER FLUID MEDIA

Although every fluid medium, including oil paint, has been used for drawing purposes (Figure 2.21), more typically artists have turned to water-based media such as tempera, gouache, acrylic, and watercolor. Of these, watercolor has been and continues to be the most popular. Watercolor is best applied with soft-hair brushes to any heavyweight paper with a moderate or rough tooth, while all other paints are applied to any heavyweight surface with either bristle or soft-hair brushes. All water-based paints are intermixable, except for ink and acrylic, the combination of which results in a wrinkled and beaded paint surface. In most mixed-media works, watercolor (or ink) is more often the first, not the last, material used. However, there are too many variables in such combinations to cite rules or procedures, and users must rely on trial and error to find those combinations (or treatments of a single medium) that best suit their interests.

DRAWING PAPERS

A paper's physical composition, weight, absorbency, and surface texture always influence the development of a particular drawing. As we transfer our responses to the paper, its submission or resistance to a particular medium—the way the paper "takes" to a medium or drawing instrument—will not only determine how we proceed, it may even affect the expressive nature and the quality of the resulting work.

The great number of types, colors, and weights of paper, and the many subtle differences of surface character within even a single type of paper, make it difficult to suggest particular brands or kinds for use with various media, but the following discussion may help in making a decision on which papers to try.

Drawing papers are classified according to surface character and weight. A paper's surface character is determined by its tooth (smooth, medium, rough) and its absorbency (non, moderate, high); its weight is determined by the weight of 500 sheets, called a *ream*, of a standard size. Thus, *newsprint*, the paper used in the publication of newspapers, is a 30- to 35-pound, smooth-surfaced, highly absorbent paper. Some of the heavier papers, used primarily for watercolor painting, weigh up to four hundred pounds per ream and are nearly as rigid as cardboard.

Most *permanent* drawing papers, that is, papers that will not deteriorate or turn yellow for a very great number of years, are made of linen or cotton rag. These *rag* papers are tough-surfaced and capable of withstanding repeated erasures and other kinds of rough handling. They are also among the most expensive papers. Other drawing papers, made of some combination of wood pulp and rag, treated by chemical preservatives, and of a more or less neutral pH (an absence of destructive acids), are also permanent, fairly durable, and less expensive. The least permanent papers are made of wood pulp, untreated by any preservative agents.

Heavyweight rag papers are further classified into three types:

1. *Cold-pressed*: Of a moderate tooth and absorbency, this paper accepts all media well. Its appealing surface makes it the most popular type of paper in use.

2. *Hot-pressed*: A hard-surfaced, smooth paper, ideal for pen-and-ink drawing of an exact nature. It is the least absorbent of the three types.

3. *Rough*: A moderately absorbent paper with a very pronounced tooth, it is least suited to fine pen-

and-ink drawing. It gives ink and watercolor washes a brilliance and sparkle not possible with other surfaces.

These three papers are sold in single sheets, in pads, and in blocks. The sheets in blocks are attached on all four sides to flatten out any buckling that may occur when water-based media are used. Papers lighter in weight than 140 pounds will buckle even with quite restricted use of water. To prevent buckling in a single sheet, soak it in cold water for a few minutes, and then secure it to a rigid board by taping it on all four sides with gummed tape (Figure 1.41). A second sheet similarly stretched on the back of the board makes warping of the board less likely; and in addition, a second sheet is then conveniently ready for use.

As with all other materials, users should experiment with a variety of paper types, in order to settle on those that best suit their creative needs. Some other common drawing papers to consider are

Newsprint: Inexpensive and impermanent, it is the mainstay in many art schools for gesture drawing and other kinds of studies with chalk and crayon media. Of a light gray tone, newsprint comes in both smooth and rough textures. It is suitable for graphite, but only the softer degrees. Being highly absorbent, it is unsuited to wash drawings. Newsprint paper yellows within a few months and begins to deteriorate within a few years.

Charcoal: A 60- to 70-pound paper of moderate absorbency, its pronounced tooth is designed to file away charcoal or pastel particles. Charcoal paper always contains some rag content, and the best is 100-percent rag. It is available in several colors as well as white. It takes any of the abrasive media well, but is too thin and absorbent for fluid media.

Bond: A generic term for a number of white, moderately grained drawing (and writing) papers. There are too many variations in their manufacture to cite any dependable characteristics. As a rule, such general drawing papers take abrasive media well, and the heavier papers can be worked on with fluid media. Such "all-purpose" drawing papers range from impermanent types to papers containing a substantial rag content. Price is perhaps the best indicator of a paper's quality. In weight, these papers may vary from thirteen pounds (typing paper) to fifty or more.

Bristol and Vellum: Heavyweight papers, they are often made of wood pulp, but the best have an all-rag content. Often sold in variously sized pads, they are a most serviceable paper for almost any medium. Of postcard weight, these papers are usually treated with preservatives and chemically whitened. Of the two, Bristol is the more hard-surfaced, ideal for pen-and-ink drawing. Vellum has a slightly grained surface that takes the softer abrasive media better than Bristol. Tough and durable, these papers give good service for the money.

Tracing: A semitransparent, nonabsorbent, lightweight paper, it has a subtle tooth much admired by many artists. Finished drawings on tracing paper must be backed by a sheet of white or colored paper, because its transparency hinders a viewer's examination of such works. It is also used to develop further a drawing placed beneath it, enabling the artist to see the original work and make desired changes easily on the tracing paper. This procedure, a commonplace among illustrators, should be used more often than it is by students, who could then more effectively adjust anatomy, perspective, composition, and other studies. The better tracing papers are permanent and some are of moderate weight.

There are, of course, many other types of paper suitable for drawing. The various kinds of printmaking paper used in making etchings and lithographs are frequently employed for drawing purposes. As a group, these are usually permanent papers, have a moderate tooth, and are moderately to highly absorbent, making some of them less suited to fluid media. Oriental "rice" papers are even more absorbent than Western printmaking papers, but many are designed for use with sumi ink and brush in a technique that takes advantage of the delicate spread of ink washes that such a surface affords. Even common kraft paper, the brown paper used for wrapping packages, provides an attractive surface and tone for some drawing purposes, and is fairly durable. Recently developed papers made of spun glass, plastic, and recycled paper products all serve various drawing interests and should be investigated.

ADDITIONAL DRAWING MATERIALS

Discussed earlier (pages 2–4), fixative is necessary to the preservation of works done in most abrasive media, and the tortillon (page 4) is a useful tool in some drawing techniques. Here, brief references to other standard tools and equipment serve as a checklist for those basic materials that outfit the artist's drawing arsenal.

Too often overlooked, the sketchbook is basic to an artist's research and development. A kind of private visual journal, it also serves as a portable studio, enabling us to examine and record subjects far from the studio and classroom. Sketchbooks are commonly available in sizes ranging from the tiny 5-by-7-inch book, which can be easily carried about in one's pocket, to books that are 9 by 12 inches in size. Papers vary from those designed for pen and ink to those intended for watercolor painting. Typically, sketchbook papers are selected for their versatility with a wide variety of media, although the papers in most are too thin for more than a light treatment with fluid media.

One convenient form of sketchbook permits the user to fill a permanent paper holder with any combination of papers cut to the size of the holder. In effect, it is a pair of spring-operated covers that can be filled and changed as needed. Called *spring binders*, such holders are available in several sizes in most stationery stores.

Erasers, usually overused to make minor changes that slow the drawing process and divert attention from a subject's main characteristics to its details, are more than correcting tools; they are drawing instruments. Erasers can lighten or blend marks, produce various textures, and when rubbed into toned passages can create light or even white lines. The *kneaded eraser*, of a gray, pliant material, can be shaped to a point for picking out small, light details, or stretched to produce a large surface for removing large areas of vine charcoal, graphite, or pastel. Its soft texture will not damage a paper's surface. When the eraser's surface is soiled, it can be kneaded to produce a clean exterior. Among the most versatile of erasers, it is especially well suited for use with vine charcoal, but is too pliant to erase entirely very dark graphite or pastel marks. These more "stubborn" marks require an eraser of a more dense and abrasive texture such as the Pink Pearl eraser, similar to those atop the common household pencil. The familiar Artgum eraser and the recently developed vinyl erasers are also capable of removing graphite and other abrasive media, and the beginner's drawing kit should have both the kneaded eraser and one capable of dealing with the removal of more tenacious media.

Drawing boards can easily be made by cutting composition board to the desired size and have the advantage of being soft enough for thumbtacks, making it easy to secure papers to them. Masonite and plywood boards (at least 1/4-inch thick) make excellent drawing boards, but papers must be attached by clips.

When using a drawing board, place it as near to vertical as possible to reduce the likelihood of distortions in your drawing. When the drawing surface slopes away at a marked angle from your line of sight, every curve and angle drawn is seen in a slightly distorted way. Ideally, drawing, like painting, should be done in a standing position at an easel. In addition to seeing your drawing surface on a plane parallel with your subject, you are far more likely to employ your entire arm and body in the act of drawing, instead of using the more pinched movements of the fingers that we associate with writing. Then, too, when drawing at an easel you are more likely to be positioned somewhat farther from the paper, an important advantage in noting discrepancies in proportion or location, and you are more likely to step back from the work from time to time, which also aids in accurate perception. Some students are impressed by how quickly an instructor, on approaching their drawing, is able to note discrepancies of one sort or another. Even more important than the instructor's sensitivity and experience in searching out such matters is the simple fact that he or she is two or three feet farther from the drawing than the student is! Learning not to "crowd" your work is basic to good drawing, and working at an easel is a first step in this important discipline.

Students needn't invest in an expensive heavyweight easel, at least not for drawing; a simple aluminum or wooden sketching easel will do. Table-top easels are also available, and if space is a problem, many easels are designed to fold away into compact units.

No drawing kit would be complete without a matknife or penknife for sharpening soft leads such as those in conté crayon, pastel, or compressed charcoal pencils. These leads often break in even the best pencil sharpeners. A knife-sharpened lead can be brought to a point by turning it upon a fine-grain sandpaper. Small sandpaper blocks are available in most art stores. Mat knives are also necessary for trimming papers and cutting mats (see "Further Technical Considerations," later in this chapter), and for **collage** studies.

Finally, an inexpensive pencil sharpener for graphite pencils; a roll of masking tape for attaching papers to boards or to create temporary borders for wash drawings, which will show clean, even boundaries when the tape is removed; brush and pencil containers made of empty coffee cans; and perhaps a small jar of opaque, water-based white paint, for covering over unwanted ink lines or blots, will round out those basic items required for the practice of drawing.

While clay is not strictly speaking a drawing medium, beginners should consider purchasing a five- or ten-pound block of an oil-based clay, such as Plastalena or Plastacine. Such a nondrying, reusable clay enables users to experience the transitory nature of edges, as the work forms "in the round." Objective studies in clay sensitize us to the **tactile** aspects of drawing. The insights gained from this sense of touch are difficult to attain in any other way, and greatly influence our understanding of volume and space (Figure 1.42).

FURTHER TECHNICAL CONSIDERATIONS

Ruling Up a Drawing for Transfer

To enlarge or reduce the size of a drawing when redrawing it on another surface, as when you wish to transfer a sketch to a canvas with a high degree of accuracy, use the following procedure:

Using an HB pencil and T-square or a ruler and triangle, rule up an accurate grid of 1-inch squares on the original drawing, as in Figure 1.43. If the original drawing is small enough, or you don't wish to cover it with ruled lines, rule up the grid on a sheet of acetate that is treated to accept ballpoint or pencil lines, and attach it securely to the drawing. To enlarge this drawing, rule up the surface you wish to transfer the original to, using a 1 1/2- or 2-inch grid (or larger, if the second drawing is to be substantially larger). A grid of lines spaced 1 1/2 inches apart will increase the size of the

Figure 1.42 (*student sculpture*)
Tony Zocchi, Art Institute of Boston
Terra cotta clay. 9 in. h.

Figure 1.43

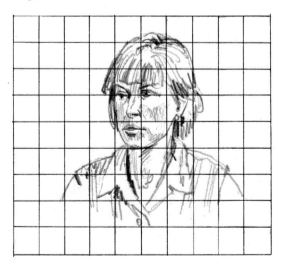

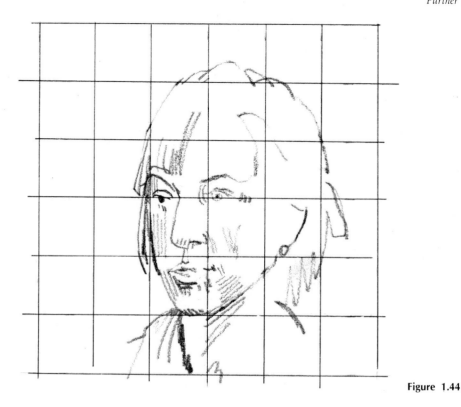

Figure 1.44

original by one-half. A 2-inch grid will double the size of the original drawing.

Placing the ruled original near the enlarged grid, begin to draw by noting where the lines of the original drawing fall in each of its squares, and place these lines in the exact locations in the squares of the larger grid, as in Figure 1.44. To reduce the size of the second drawing, use the same procedure, but make the grid you are transferring the original drawing to smaller than the grid on the original.

The grid can also be used to assist in the location of shapes and edges. Simply rule up a grid of 2- or 3-inch squares and place it behind the objects you are drawing. With the grid in place, you can easily "see" in your mind's eye the lines of the grid that would be visible if your subject were transparent. Next, rule up a grid on the sheet you will use for your drawing. If you want your drawing to be larger than the subject, make the squares of this grid larger than the squares on the grid behind the objects. Make sure your drawing surface is placed vertically, as tilting it will produce distortions. Standing about five or six feet from the subject, begin to draw by noting where the edges of objects strike the grid behind them, and place lines at these exact locations on the grid you

are drawing upon. Once the contours of your subject have been drawn, begin to work inside each form, noting where the lines on the grid behind them would be visible if you could see through them. Holding up the edge of a sheet of paper or any straight edge such as, for example, a pencil, will help you "see" the lines running through the objects, thus enabling you to locate them better in your drawing.

Masking Out

It is sometimes desirable to mask out an area of a drawing in order to apply a tone or texture freely, without having it intrude on other areas of the drawing. To do this, you can simply place masking tape over the areas to be protected, just as when you wish to apply a wash of tone to a drawing that will end in clean boundaries at the drawing's edges, as in Figure 1.45. Once the area has been drawn upon, the tape can be carefully removed. Masking fluids are available that enable the user to isolate large or irregular areas. Rubber cement is one such isolating fluid. Adhesive-backed, transparent masking film is available for masking out large areas of a work. Such sheets can be placed over

Figure 1.45

the entire drawing, and only those portions to receive additional washes, sprays, or other treatments are laid bare by cutting the film away with a scalpel-like artist's knife.

Tinting Paper

Although commercially toned paper is available in a wide variety of colors, some artists object to the mechanical sameness of such sheets. Tinting your own paper is a simple procedure and produces results that are more interesting than the uniformity of commercially prepared papers. Thin sheets cannot satisfactorily be hand-toned by washes of color, as they will warp and wrinkle. Such sheets can be tinted by rubbing them down with finely powdered pastel. Using a clean rag, dip it into a mound of pulverized pastel fragments and rub the tone on by rotating movements in several directions. Subtly changing the colors adds an interesting quality to the tint. Heavier papers, such as watercolor sheets, are best prepared by taping the sheets down on all four sides and applying the desired colored wash with a large brush. Again, adding one or two color variants to the wash produces interesting effects. Too often such washes are stronger in color than they need be. For best results, use light, more or less neutral colors. Some artists apply tea or coffee to the white sheet, a tactic that gives a subtle aged quality.

Protecting Drawings

Most drawings are made on a very fragile support: paper. Paper is prone to attack by insect pests; by mold growth, which shows up as rust-colored spots, called foxing; by high humidity or damp storage sites such as cellars; by strong light, especially sunlight; by high heat, as near radiators or over fireplaces (the latter contributing the additional destructive effects of soot); by air pollution, especially where high concentrations of sulphur dioxide are found; and even by some chemicals used in the manufacture of paper.

Although choosing properly made, permanent paper is half the battle of preservation, some of paper's enemies will attack even the finest handmade sheets, and care must be taken to avoid storing or showing drawings under the conditions noted above. To avoid exposing your drawings to the hazards caused by careless handling, the following rules are advised:*

Use clean hands to handle drawings. When lifting a matted or unmatted picture, use two hands to keep from bending, creasing, or tearing the work. Never stack unmatted drawings directly on top of each other, as they may become smeared or discolored; separate each drawing by a smooth, non-acid cover tissue. Never use any pressure-sensitive tapes (cellophane or masking tape, etc.), gummed brown wrapping tape, rubber cement, synthetic glues, or heat-sealing mounting tissues on any drawing to be preserved; instead, use an acid-free gummed linen tape intended for the safe mounting of pictures and available at many art stores and frame shops. Pictures in mats or folders should be stored in drawers or acid-free boxes, called solander boxes, to reduce their exposure to humidity, air pollution, light, etc. Wooden rather than metal cabinets and drawers are preferable, as the latter can condense moisture inside and heat up more quickly during hot weather. Never roll up drawings for storage. After even a few hours, it is difficult to flatten them out. Unused papers should be stored flat in a cool, dry area, wrapped in an acid-free paper to protect them from dust, moisture, and strong light.

*For an in-depth discussion on the care of works on paper, see Francis W. Dolloff and Roy L. Perkinson, *How to Care for Works of Art on Paper*, (Boston: Museum of Fine Arts, 1971).

Matting and Framing

In addition to a mat's protective function, matted and framed drawings look more impressive and are more easily understood within their context of fixed boundaries. Visually, a good mat is one that clears away some space from around the drawing, making it easier to experience. In a way, we don't see a good mat; its success rests in setting off the drawing to best advantage. Technically, a good mat is one that is made of quality materials. Always use an acid-free, rag-content mat board called *museum board*. It is a false economy to use inexpensive wood-pulp mat board, as it will discolor the drawing with a brown stain that corresponds with the inner edge of the mat opening. The components of the basic picture mat are the front mat (into which the picture window is cut), the back mat (upon which the drawing is placed in alignment with the picture window), the paper or tape hinges (to hold the drawing in place), and the gummed cloth tape hinge (which secures the two matboards together). These are illustrated in Figure 1.46.

To make a mat, decide on the size of the mat and, using a pencil and a T-square or a ruler and triangle, lightly rule its overall size and the picture-window area on the mat's face side. Be sure to make the window opening slightly smaller than the drawing, so that it will cover the drawing's edges. You need no more than a 1/8- to 1/4-inch margin on each side of the picture window to do this. In deciding on the mat's overall size, consider the width of each of its four margins. Normally, the top and the two side margins are made to the same width, with the bottom margin made slightly larger. For example, if a mat's top and side margins measure 3 inches in width, the bottom margin may be 3 1/2 or 4 inches wide.

To cut a mat, lay the mat board face-up on some heavy waste cardboard. Using a *sharp* mat knife and a steel-edged ruler, first cut the mat to its overall size. Next, cut the picture window. Do not try to cut through the mat board with one stroke of the matknife. A better practice is to make three or four lighter strokes, making sure the blade reaches both limits of a line so that the knife-cuts just barely cross at the four corners. Otherwise, the board of the picture window area will remain attached at the corners, where second attempts to cut through are often visible in the finished window opening. If a beveled edge is desired, be sure to place your knife at the desired angle for the entire length of each cut.

Place the picture into position on the back mat, using two small hinges as in Figure 1.46. Hinging a work in this way allows it to hang freely in the mat, permitting the paper to expand or contract without stress as atmospheric conditions change. Finally, attach the gummed cloth tape to the two mat boards as shown in Figure 1.46.

Framing a drawing not only completes its presentation for viewing, but provides considerable protection from damage. While the need for compatibility of a drawing with its frame is obvious and best left to the artist, the advice of a competent framer is helpful in avoiding certain hazards. A drawing can, for example, be seriously damaged by placing it directly against a wooden backing, where resins exuded from the wood may cause widespread discoloration. Or, mistakenly assuming that an airtight seal of

Figure 1.46

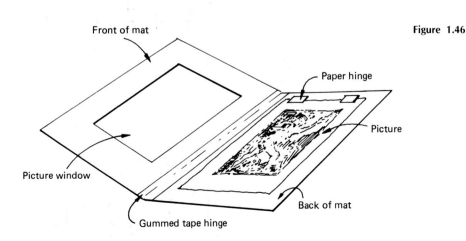

Front of mat

Picture window

Paper hinge

Picture

Back of mat

Gummed tape hinge

a frame is desirable, we might find that a sudden drop in temperature had caused a dangerous buildup of humidity within the frame.

In fact, framing is best left to the professional framer. If you are making the frame yourself, the following steps should be observed.

Using a miter box and a fine-tooth saw, cut each of the four frame lengths at an accurate 45-degree angle. Assemble one short and one long side of the frame by gluing them together and predrilling two small nail holes at the corner. Make sure this L-shape is assembled in a way that permits it to lie flat. Clamp the L-shape in a vise and drive small nails into predrilled holes. Assemble the opposite L-shape. Glue the two halves of the frame together. Check to see that the frame is a true rectangle. When the glue has dried, place the frame face-down and fit into it the glass, matted frame, and cardboard, Masonite, or stiff pasteboard as a backing material. Seal the join between the frame and the backing with a gummed sealing tape. The completed frame should look like the cross-section illustration of a framed drawing in Figure 1.47.

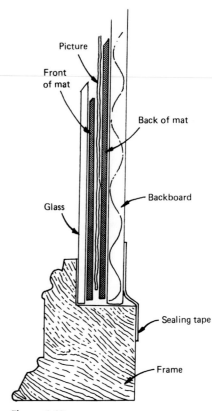

Figure 1.47

2

FIRST CONSIDERATIONS

Seeing and Relating

SEEING FORM
AND CONTENT

This chapter outlines those visual fundamentals necessary to begin the study of drawing. Later chapters will examine more fully the issues here introduced to provide you with a general sense of how artists proceed to form their images, and thus, what you should look for as you begin to draw.

Among the many challenges confronting the beginning student of drawing are two subtle but crucial ideas that deserve special attention. Indeed, until these ideas are grasped, and taken into account when drawing, little useful progress is likely. I am referring to the beginner's need to understand that (1) learning to draw is learning to see that a drawing's **form**, that is, its overall visual order and character—the way it is drawn—is as important as its *content*, that is, *what* is drawn; and (2) that drawing is a process that requires us to regard a number of matters at the same time.

All of us first come to the study of drawing with an understandable fascination with learn-

ing how to draw the people, places, and things of our outer and inner worlds and with experience in learning other skills, such as reading or mathematics, which unfold fact by fact in a sequence moving from simple to complex matters. But these two expectations—that learning to draw concentrates mainly on learning to draw various kinds of subject matter, and that the learning process is a step-by-step procedure—must be amended to recognize that a drawing's **abstract** form and **narrative** content are interdependent considerations and that drawings develop by our responding to a number of visual facts simultaneously.

Expanding your interest in *what* is drawn to include an equal interest in *how* it is drawn is a natural result of learning how much there is to see in the arrangement and nature of any subject's parts, and it develops as you learn to draw in an ever more inquiring and relational way. Considering several visual issues simultaneously, rather than regarding one thing at a time, is likely to be a demanding challenge for you, just as discussing this state of affairs is a challenge to me; for in sharing information with

you about drawing, I must necessarily proceed in a sequential manner, discussing each matter in turn. This being the case, let us remember as we proceed that most of the matters that follow are interrelated and should be seen and acted on together.

SEEING DIRECTION AND GESTURE

The most (visually) logical consideration to begin with is *direction*, a term used here to define the exact orientation in both two- and three-dimensional space of a subject, any part of a subject, or any segment of a part's edges. For example, in Figure 2.1, scissors A is oriented vertically, whereas scissors B leans slightly to the left. In A, the direction of each blade is slightly away from the vertical position of the scissors itself; in B, the right blade occupies a vertical position. Note how in each illustration short, straight lines restate the handles' curves. Such straight-line "translations" of an observed curve, whether it be the contour of a leaf or a

Figure 2.1

leg, do two useful things: (1) in getting at the "anatomy" of a curve they help us to see its undulations more objectively, and (2) in showing us the changing directions of a curve they help us to orient a curved form in a drawing more accurately.

Similar straight-line inquiries can be seen to underlie the drawings of such masters as Michelangelo, Rubens, Rembrandt, Cézanne, Degas, Picasso, and many others (Figures 2.2 and 2.3). This procedure should not be under-

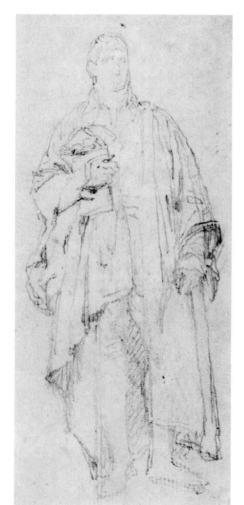

Figure 2.2
JOHN FLAXMAN (1755–1826)
Robed Male Figure
Pencil. 6 × 2⅞ in.
Courtesy, Museum of Fine Arts, Boston, gift of
Mr. Rowland Burdon-Muller and William A. Sargent Fund

stood as a technique, but as something deeper and more universal: a visually logical and universally employed *process* for effectively simplifying complex forms and turnings to see better the various directions of their axes and edges.

If, as is so often said, drawing is a process of working from the general to the specific, we might also think of it as a process that moves from inquiry and analysis to empathy and expression—from "finding" to "telling." Among the most necessary of the basic facts to find out about your subject are the various directions of **axis** and edge, if only to avoid investing time drawing a part's contours, tones, textures, and so on, only to find upon completion that your drawing of the part is oriented wrongly on the page.

If, as I suggested, drawings are best approached by moving from inquiry to **empathy**, then empathy—the ability to experience expressive features in your subject that have to do mainly with the implications of moving energies (see Chapter Four)—should not trail far behind. While it is true that we must first notice something before we can react to it, our reactions to a subject's expressive character should influence how we draw it.

Indeed, most artists begin a drawing with a search for what the subject looks like (inquiry) *and* what the subject is doing (empathy). These are two different questions, and the answers must unite to form the kinds of marks you make. Such drawings, called *gesture drawings,** may represent only the underlying first stage of a work or may stand as final statements of a subject's general appearance and character, as in Figure 2.4. Like a musical overture designed to present in brief excerpts the characteristics of the entire score to follow, a gesture drawing unites facts and feelings that present the subject's general nature, and facts about the directions of its axes and edges are an important part of its visual nature.

While the subject's directions and the moving energies they suggest are best considered together at the outset in drawings intended as more fully realized works of an objective kind, the smaller directions of axis and edge are sure to become an important early consideration as well. In general, establishing a subject's major

*See Nathan Goldstein, *The Art of Responsive Drawing*, 3rd. ed., (Englewood Cliffs, N.J.: Prentice-Hall, Inc., 1984), chapter 1.

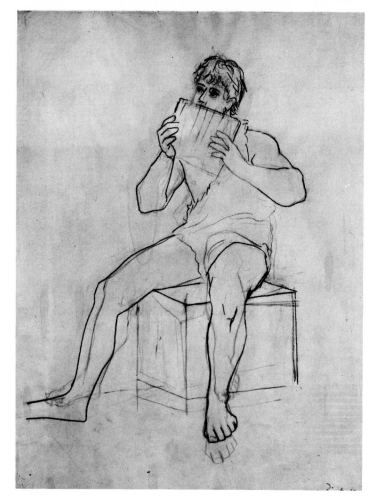

Figure 2.3
PABLO PICASSO (1881–1974)
The Pipes of Pan (1923)
Charcoal. 24¹⁵⁄₁₆ × 19⅛ in.
Formerly in The Art Institute of Chicago

Figure 2.4 (*student drawing*)
Laura Weiss, Kent State University
Charcoal. 24 × 18 in.

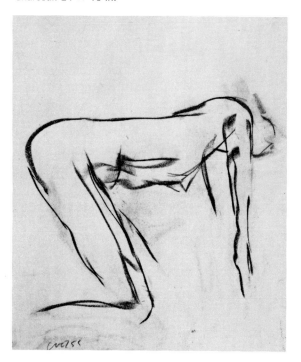

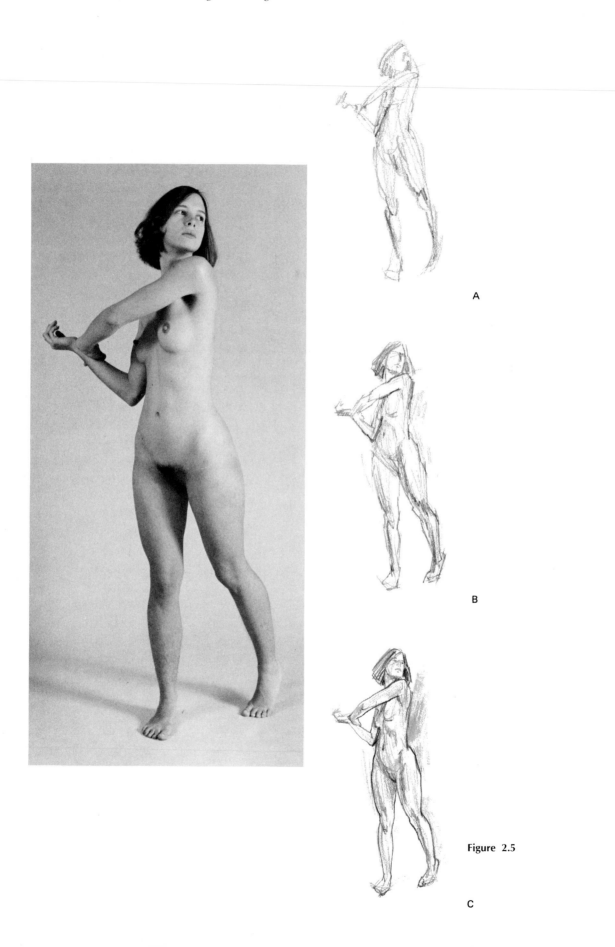

A

B

Figure 2.5

C

directions should precede the search for smaller ones, just as seeing the long axial direction of any part should precede seeing its shorter axial directions, or those having to do with edge.

The three stages of drawing in Figure 2.5 illustrate how a drawing may evolve from a search for the subject's gesture, which, as noted above, already contains some general observations about the subject's directions (Figure 2.5A), to a more fully explored search for smaller directional cues (Figures 2.5B and 2.5C). Once a drawing is brought to the stage shown in Figure 2.5B, it can be shaped further to modify the angularities, as the artist's interest moves from analysis to a more tactile and empathic state. Something of this can be seen in the drawing of the figure's arms and legs in Figure 2.5C.

Because we are discussing directional matters, the kind of drawing described here is primarily, but not exclusively, line drawing. Later on in this chapter we will turn to tonal considerations, but here tones (of a light and "foggy" kind) should be used mainly to establish gesture. A common problem for the beginning student is how to make a gesture drawing that is broad, light, and fluid enough to permit further development in line. The use of dark lines in a drawing's gestural stage tends to make students draw a subject's contours instead of its axial directions, or if the student does concentrate on seeing the arrangement of the subject's long axes, the result is too stick-figurelike. Gesture drawing is neither fast contour drawing nor stick-figure drawing. It breaks away from a subject's contours to move along its main pathways of movement and direction and does so in a spirited, generalized way, as in Figures 2.4 and 2.5A. For most beginners, this is best achieved by using the side of a small piece of conté crayon or chalk. Such a tool will help you avoid the temptation to concentrate on the subject's outlines or on any small details and will help you focus instead on drawing the important gestural actions that will later serve both as a framework for establishing more focused directions and as an influence and reminder of the subject's **dynamic** character. Some students prefer to use gray chalk or light ink wash for the gesture drawing, to keep it from getting too dark. Once established, the drawing is then developed further with black chalk, ink, or pencil.

In addition to providing the first, most sweeping directional cues, gesture drawing exerts a beneficial influence in getting us to see a subject's *entire* arrangement, not merely its small details. Too often, beginners draw in a sequential manner, carefully rendering one small part at a time. This results in a collection of poorly related segments with little unity or life. The search for gesture, however, starts us seeing the important *general* axial facts necessary for later elaboration of smaller surface details.

Like a swimmer diving into a pool, the artist drawing gesturally goes below the surface and comes back up to it. The kinds of measuring that occur at the surface have to do with more than seeing the changing directions along a form's edge, but seeing these changing directions is basic to drawing in an objectively responsive way. To better "track" such changes, stand at your easel in a position that enables you to see your subject and your drawing by shifting your eyes, not your head. This will help you to draw your observations far more easily and comfortably. Where possible, draw lines that show both the direction *and* the length of a segment of edge (Figure 2.6A).

In considering the many directions to be seen at a form's edge—directions that, when stated by short, straight lines running from one turn to another, help us to see undulating contours more accurately—we need only complete a "trip" around a form in this way to realize that we have been approaching another important first consideration, *shape* (Figure 2.6B).

Figure 2.6

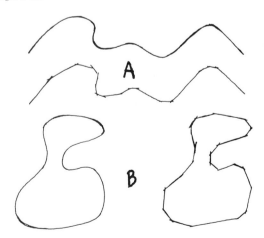

SEEING SHAPE

All three-dimensional masses *and* the spaces that separate them have *shape*—have some two-dimensional silhouette. Seeing these flat, "puzzle-piece" configurations in the things we draw is an important part of learning to draw well. In seeing the shape-actualities of volume and space, we see the "fields of play" within which our subsequent drawing of each part takes place. For example, Figure 2.7A shows an odd-looking, hard-to-define shape, but in Figure 2.7B this shape encompasses the drawing of a hand. Yet seeing this shape in 2.7B requires some effort, even though we know it to be identical to that in 2.7A. This is so because we are "programmed" to understand the world around us in terms of volume and **space**. Being able to do so is a matter of survival, and we must learn to temporarily suspend such readings of the things we perceive, to see the two-dimensional facts about our three-dimensional world.

For artists, both of these dimensions are interchangeable considerations, and both readings of a subject are necessary in order to draw it in an objective way. Drawing on a two-dimensional surface, they know that the volumes and spaces emerging on the paper as they draw are *impressions*; that the fact is they are placing marks on a flat surface, subdividing the shape of the page into variously oriented shapes and tones that suggest masses located in a spatial field of depth.

Some beginners find it difficult to make such "puzzle-piece" readings of the things they see. To help see the shapes of forms, place a small sheet of plexiglass on your easel in a position that permits you to see your subject through it. Then, using a china-marker or lithography pencil, carefully trace the subject's main outlines.

Another phenomenon that creates resistance to an easy interchange of dimensions as we observe the things we mean to draw is our tendency to regard masses more consciously than

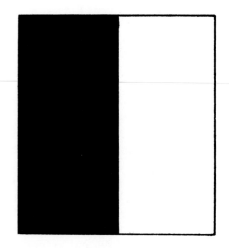

Figure 2.8

we do the spaces around them. At first, we may see the objects in, say, a still life, with a concentrated concern we don't extend to the spaces separating them. The resistance to seeing that the shapes offered by both volumes and their interspaces are equally important can be seen by our change in attitude toward the things we see as our understanding of them changes. For example, seeing Figure 2.8 as the edge of a black door showing daylight outside makes us "see" the black area as something of substance, dimensions, weight; something near to us. The white area is somehow less tangible; it is distant, weightless. If we now see the illustration as the edge of a white door showing it to be night out of doors, our reading of these two shapes changes to give the white shape substance and to place the black shape in the background. Similarly, the black vase in Figure 2.9 keeps us from seeing that this illustration can be seen as two white profiles. Once we find the two profiles, it is difficult to see the vase as more than an interspace; we concentrate on *things* at the cost of disregarding the areas separating them. While it is, in fact, not possible to hold both readings in our minds at the same time, we need to develop the skill to make such reversals, as well as to draw accurately the silhouettes that masses and spaces show us (Figure 2.10).

The shapes created by volumes are called *positive* shapes; those formed by interspaces, *negative* spaces. A drawing's balanced design and unity is partly determined by the direction, scale, and distribution of its positive and negative shapes, as we shall see in Chapter Four.

A B

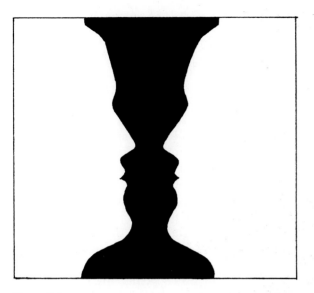

Figure 2.9

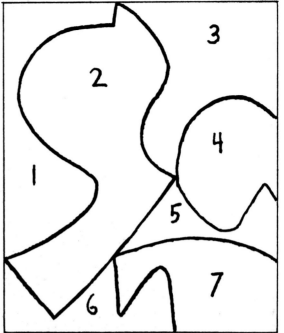

Figure 2.11

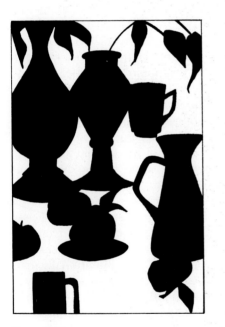

Figure 2.10

Here, however, we are concentrating on learning to see these two kinds of "flat" configurations in the forms and spaces we draw. And even before we do that, we should test our ability to record accurately the shapes *of shapes*. To help you more objectively draw the shapes "hiding" in the things and spaces around us, freely draw some simple shapes in a square, making sure they touch the square's boundaries at some points, as in Figure 2.11. Next, on another sheet of paper try to reproduce this draw-

ing *exactly*. When you are done, hold both drawings up to the light to see how accurately you were able to do this. As you draw, you will come to recognize the need for seeing *all* the shapes in the original square. Note that the three shapes drawn in Figure 2.11 have produced four additional ones. As you draw, refer to the straight-line process for analyzing curved edges, discussed previously in "Seeing Direction and Gesture" (page 40). The resulting angularities of this process can then be modified to get at the more curvilinear nature of the original shapes.

Seeing shapes objectively is important for another reason. The surfaces of most of the masses we encounter are comprised of planes, facets that collectively create a volume's three-dimensional form. Being able to see the shape of **planes**, whether we see them straight on or fore-shortened, is basic to drawing the volumes we see. For example, Figure 2.12A shows two shapes that appear to lie flat on the page; however, relocating these shapes, as in 2.12B, "lifts" them from the page to produce a pyramidal form. These two shapes, unchanged except in location, have become planes. Likewise, when brought together, the separated shapes in 2.12C become a loaf of bread, a can, and a house. Note that in 2.12D, shape 3 is a negative shape, and must be drawn as accurately as the others

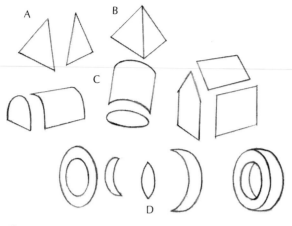

Figure 2.12

if the form and width of the ring is to be uniform. For a further examination of planes and masses, see "Seeing Planes and Masses" page 55, and Chapter Three.

SEEING SCALE AND LOCATION

At the beginning of this chapter, I noted that learning to draw is learning to see and relate a number of factors at the same time. We have already come far enough along to pause and consider that seeing the long axial direction of a part determines the various angles at which we'll draw the segments of that part's edges. And these edges in turn bring us to an examination of that part's shape, and of the shapes surrounding it. If we can regard these several factors *together* when drawing, each assists us in seeing the others more objectively.

Now we must add two more considerations: Even if we succeed in objectively drawing our subject's forms according to its directions of axis and edge and have refined its positive and negative shapes with equal accuracy, our drawing may still fail unless we consider the relative size or *scale* of one part to another and the exact position or *location* of each of our subject's parts.

To do this, we must of course continuously check our developing drawing to search out any obvious discrepancies in scale and location, comparing parts of the drawing to parts of the subject. This is best done by stepping back from the drawing in order to see all of it

and all of the subject in the same glance. It is surprising how a distance of two or three feet between you and your drawing easily reveals such errors. But we must do more, for some discrepancies of scale and location are subtle and require more specific strategies of investigation to be uncovered.

There are three important ways by which artists find misjudgments of scale and location: by *extending lines*, by *locating points of intersection*, and by *judging edge lengths*. All three of these techniques for testing the accuracy of our observations are demonstrated in Figure 2.13. Assume that 2.13A is not a drawing, but our "model." In 2.13B, dotted straight lines extended in several directions from points in the drawing strike other points in the drawing. Where these lines strike can then be compared with similar "lines" on the model, by holding up a pencil, a stick, or the edge of a piece of paper so that the ends of your measuring instrument touch the same points. For example, in 2.13B, line A strikes the stem tip of both apples, but misses the corner of the table. Line B strikes the apple's stem tip, the top of the orange, and the far right corner of the table top. If we carefully check 2.13A by holding our straight-edged object up *at the same angles* as lines A and B, we find that these "lines" strike or, in the case of the far left corner of the table top, miss the same points. Note that line C strikes the bottom of the apple on the left and the tip of the banana, and that a line running vertically from this same tip (line E) strikes the right side of the second apple. Examine lines D and F to see if they strike the same points in 2.13A. Figure 2.13C is intentionally inaccurately drawn, but the discrepancies are slight. Using the technique of extended lines, compare lines running between any two or more points in 2.13A with similar lines in 2.13C, to find in what ways the latter drawing departs from the "model."

Many artists reverse this process, first sighting points of alignment in their subject, then testing to see if these points are aligned in their drawing. This is done by the method just described, or by actually drawing light lines in the work itself. Later, such lines can be removed or integrated in the drawing's subsequent lines and tones, or can become part of the drawing's calligraphic play and design (Figure 2.14).

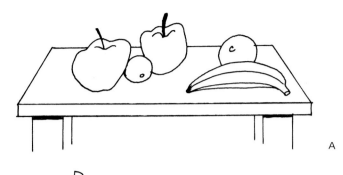

A

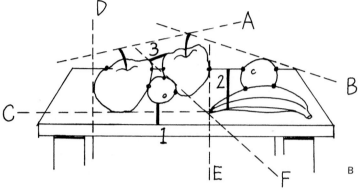

B

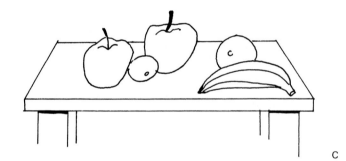

C

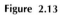
Figure 2.13

Figure 2.14
DOMENIC CRETARA (1946–)
Study for a Painting
Graphite. 24 × 18 in.
Courtesy of the artist

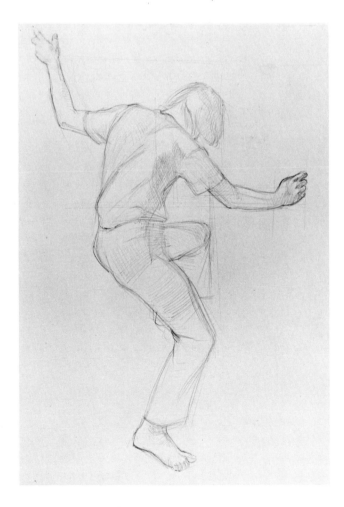

Figure 2.15

Figure 2.16

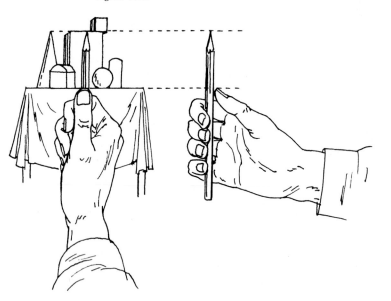

Locating points of intersection can greatly assist in improving the accuracy of our observations. Note how, in Figure 2.13B, black dots indicate the intersecting of one line by another. If we carefully examine 2.13A, we find that the same lines intersect at exactly those points indicated in 2.13B, but that in 2.13C, they often intersect elsewhere. Here, an instrument is seldom used for extending lines; rather, it is a matter of observing just where in a subject one line (edge) strikes another, and making adjustments in your drawing to correctly show the same intersections that you observe in the subject. Such points of intersection can be found even in a single changing edge by extending the directions of the edge segments, as shown in Figure 2.15.

Judging edge lengths (as well as the relative length or width of any part's dimensions) again uses a measuring instrument such as a pencil, or (an age-old practice among artists) one's own thumb. By holding your arm fully extended, simply measure any length or width you wish to determine, as in Figure 2.16, then, still holding your arm extended, check to see if this measurement matches your judgment of that length in your drawing. Note that the length of lines 1, 2, and 3 in Figure 2.13B exactly match the lengths in Figure 2.13A.

Figure 2.17 again illustrates all three devices at work. Naturally, artists seldom mark their drawings in this way, but 2.17B enables us to see the artist's visual thinking about matters of measurement.

It is the absence of such efforts to compare, locate, and **measure** that causes the poor proportions and wrongly placed parts that so beset the beginner. While the discipline to search in these three ways for the relationships of direction, size, length, and width of parts may seem taxing at first, the benefits they provide in helping us to see and state the things we draw are crucial to more sensitive objectivity. Indeed, after a while we begin to find these analytical steps too logical, natural, and necessary to disregard if our drawings are to represent faithfully a subject's observable characteristics. When we do disregard them, letting go of the concentration necessary to uncovering certain basic truths about our subject's physical facts, our drawings promptly show all the old problems and habits we really wish to be free of. Known as "lazy vision," this letting go of known means of re-

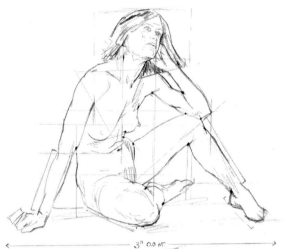

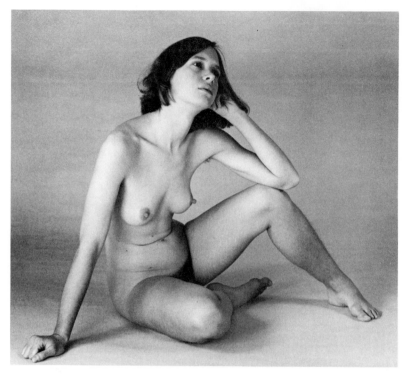

Figure 2.17

lating and judging is an "incurable" condition that lies in wait for the student or artist for whom the excitement of discovery has temporarily waned. However, if it can't be "cured," its effects can be reduced to zero by a genuine wish to experience and visualize objectively the things we encounter when drawing.

SEEING VALUE

Up to now, we have been examining those first considerations of drawing having to do with line. Whether it is the alignment of edges and parts in various straight or curved "lines," or the actual drawing of lines to establish directions of axis or edge, or shapes, or lines drawn to conform with observed points, intersections, lengths, overlappings, and abutments of parts, our concentration has been on gaining control over those things that line can express. We have been learning how to chronicle objectively a subject's "geography." Now we must consider its "topography"—the hills and valleys that make up its surface character.

Chapters Three and Four more fully explore value's great role in drawing as an agent of volume-building, design, illumination, and so on; but here we need to find some simple means that will enable us to clarify and reinforce the sense of mass and space in our drawings, and to express certain facts about a subject's terrain and environment that cannot be stated in line. And we should remember that there are no lines in nature—no thin, undulating lines that encircle or separate one thing from another. We use line to mark off the boundaries between masses and their interspaces, but what we *see* are abutments and fusions of planes, masses, colors, textures, and values. Line is the necessary and indeed the predominant device by which most drawings are formed, and along with value, is one of the two basic visual elements that in turn create the other visual elements of drawing: shape, mass, space, and texture. Consequently, when examining value we'll often need to hold in mind that values, which, after all, are seen in nature as various colored *shapes* arranged in various *directions*, still carry implications of line.

Put simply, a value is the quality of lightness or darkness of tone or tones on the surface of any form or space. The values we see are the result of two conditions: the inherent coloration

of a volume or a surface, its *local-tone*; and the nature and direction of the light falling upon a volume or a surface, its *illuminating source*. For example, an egg is inherently light; a lump of coal, dark. Their local-tones are very different. When either object is illuminated by a light striking from, say, the right side, the value of the illuminated side will be lighter than the object's local-tone, while the surfaces turned away from the light source will be darker than the local-tone. However, under most lighting conditions, the lightest value on the lump of coal will be darker than the darkest value on the egg. Therefore, when modeling a form's volume with value, bear in mind the form's inherent lightness or darkness.

Just as we saw the need to draw a subject's main directions and rhythms (gesture) before its smaller ones and a shape's major characteristics before its specific details, so we need to see a subject's major tonal conditions before searching out subtler tonal variations upon its surfaces. Some objects require little or no value to be understood. As Figure 2.18 demonstrates, simple forms possessing clear overlappings or sharp abutments of flat planes can be adequately represented by line, but forms possessing near overlappings (as in 2.18B) or rounded surfaces require values in order to be understood.

When using value, it is helpful to recognize that light rays do not bend, and therefore observed changes in a form's values reveal changes of direction in the form's surface, and not in the direction of the light rays. Therefore, when we see sudden abutments of toned shapes in a volume, as in Figure 2.19A, we understand

Figure 2.19

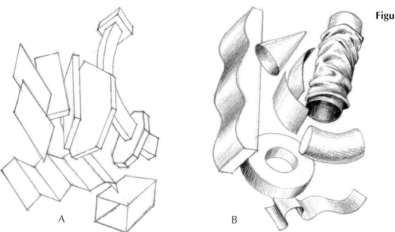

Figure 2.18

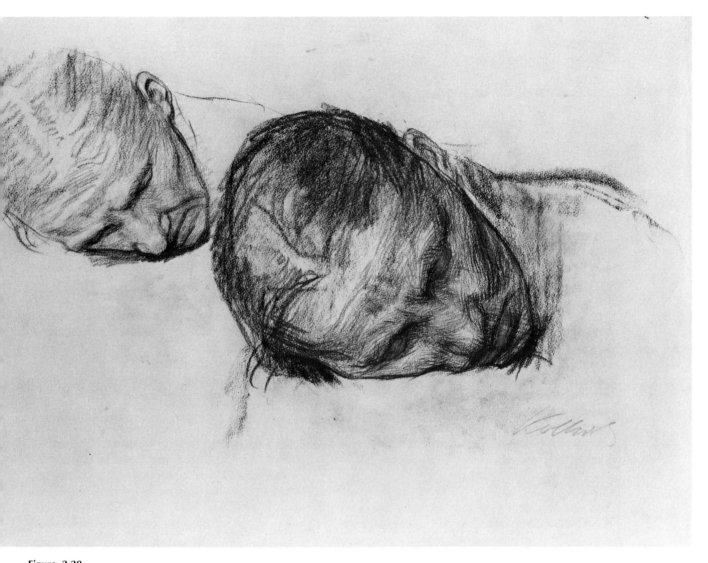

Figure 2.20
KÄTHE KOLLWITZ (1867–1945)
Two Studies of a Woman's Head (c. 1903)
Black chalk. 19 × 24¾ in.
The Minneapolis Institute of Arts, gift of David M. Daniels

its surface to be constructed of flat planes. When, as in 2.19B, we see some *gradual* changes in value, we understand the surface to be constructed of some curved planes (or "unfocused" shapes) that gently fuse together. And when a volume shows only such smooth graduations of tone as in 2.19C, we know that its surface contains no sudden changes in direction. The character of human forms, rich in their variety of angular and rounded planar conditions, can be more fully realized in tonal drawings (Figures 2.20 and 2.21), as of course is the case with

any subject whose forms offer a variety of surface conditions.

As we are examining first considerations in learning to draw, and because most of your first drawings are likely to be quick sketches, ranging in time from one or two minutes to fifteen or twenty minutes, we needn't explore in depth here the several roles of values, and ways by which they can be applied to the page (see Chapters Three and Four). As noted previously, for our purposes it is necessary to recognize that every subject offers large, general

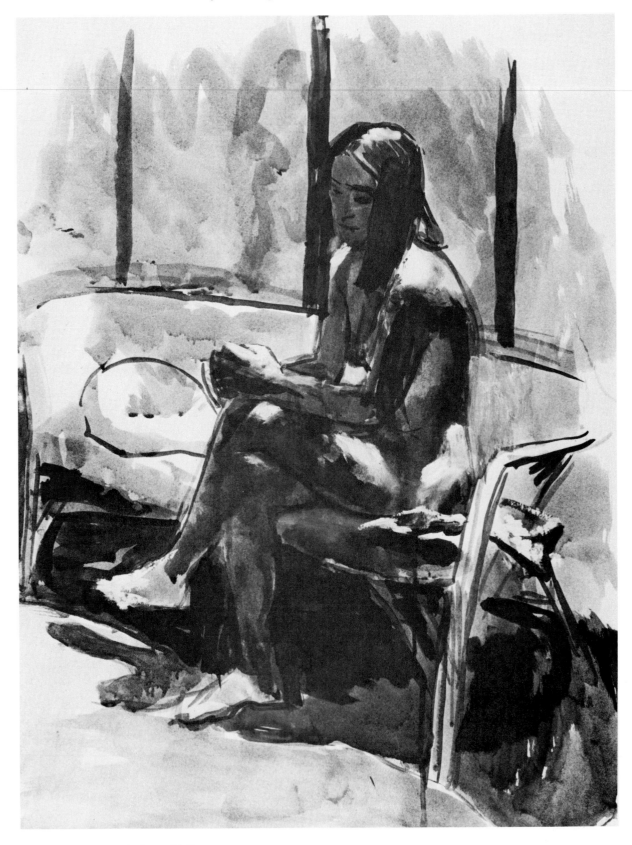

Figure 2.21 Domenic Cretara(1946—
Seated Nude Figure (1981)
Oil on paper. 20 × 16 in.
Courtesy of the artist

tonal differences in various clearly focused or vague shape configurations and that these differences should be established before attempting to sort out smaller tonal variations within them revealing minor surface changes.

In quick sketches, such large tones are best applied by using the side of a short length of conté crayon or compressed charcoal. Gradually differing widths and degrees of tone can be produced by slightly turning and/or changing the pressure on the chalk, as in Figure 2.22. In more finished drawings, where it may be necessary to remove as well as darken tones, it is best to use an easily erasable medium such as vine charcoal or graphite, although conté crayon and compressed charcoal are excellent choices when used for more powerful imagery or when tones are built up gradually.

Tonal modeling should concentrate more on explaining volume and space than the effects of illumination. Often, these two considerations work together; that is, the value changes observed in your subject reveal both the surface form and the direction and nature of the light source. But when existing light conditions do not show, by value differences, important planes and turnings, or when the light source obscures or "denies" a form's surface structure, as when a weak light or a cast shadow falls in a way that camouflages or flattens a form's terrain, you should favor introducing tones that explain the form's turnings. Light falls upon masses in an accidental and uncaring way. It is up to the artist to clarify the volume and space conditions of his or her subject.

When drawing tonally, it is useful to "bracket" a subject's tonal range by noting its lightest and darkest passages early in the drawing. Doing so helps to estimate better the degrees of value that lie between these tonal poles. Always relate the tone of one plane or area to another in order to maintain the impression of both volume and space as well as the behavior of the light.

As you apply the tones, feel that your instrument is "painting" light and dark values upon and around the subject's surfaces—that your chalk or pencil is touching the actual surfaces, much in the way that a sculptor's chisel or clay tool moves upon the surface of a work, shaping it into the desired form. For some artists, this sensation of carving the form into being is best realized by hatching or cross-hatching lines that are felt to be actually marked upon a volume's surface in directions that reveal surface changes, the lines leaving a trail upon the form's hills and valleys (Figures 2.23 and 2.24). But in whatever way you apply tones to push some surfaces back, bring others forward, and construct those major abrupt or gradual turnings that create the sense of mass and space, your tactile sensibility—the feeling that your sense of touch, moving on past your fingertips to the instrument's tip, is in contact with surfaces—is one of the strongest senses that you can bring to bear in tonal modeling.

Figure 2.22

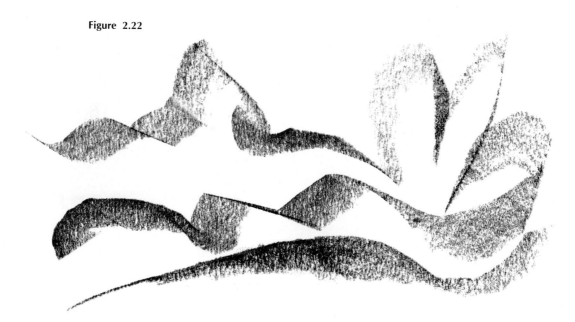

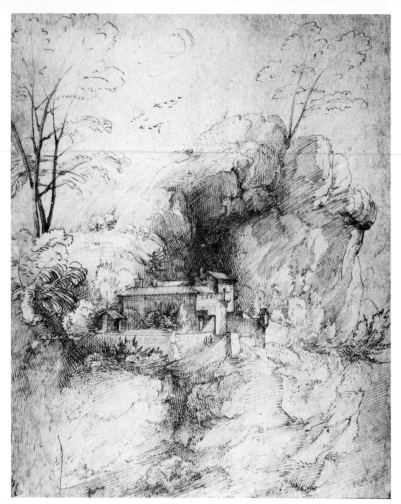

Figure 2.23
FRA BARTOLOMMEO (1472–1517)
Landscape
Pen and bistre ink
Albertina Museum, Vienna

Figure 2.24
DOMENIC CRETARA (1946–)
Seated Male Figure, Back View
Graphite. 24 × 18 in.
Courtesy of the artist

SEEING PLANES
AND MASSES

Just as every volume shows its silhouette—its shape—so do all the planes that constitute a volume's surfaces show *their* shapes. And just as we must make a conscious effort to disregard a volume's surface structure when we wish to concentrate on its total shape **configuration**, so must we resist seeing a plane's position in spatial depth in order to see its two-dimensional configuration. Remember, this ability to alternate between seeing a solid or a surface facet as two-dimensionally or three-dimensionally oriented is a major and fundamental perceptual skill, necessary to the objective analysis of any observed subject we intend to draw. Both states of the things we see are factual, measurable conditions, and each "reading" of a volume or a plane in either one of these dimensions helps us to understand better its orientation in the other dimension.

In searching out the directions of axis and edge in your subject's shapes and values and in noting their scale differences and locations, you have, of course, been forming planes and masses into being. Here, we will concentrate on those first considerations having to do with more emphatically stating a volume's structure and solidity.

The basic volume-building unit is the plane. Planes in nature may be flat or curved, and may sharply abut, as do the planes of a box or a banana, or may fuse together gradually, as in any form showing rounded surfaces (Figure 2.25). To understand better how planes form volumes, let us assume that all of our subjects' surfaces are comprised of flat planes. After all, any curved surface or movement can be restated as a series of flat planes that, when seen together, produce an overall curved direction. Like the flat and angular treads and risers of a spiral staircase, which, when taken together, form an overall coiled arrangement, regarding all gradually rounded turnings to be made up of a series of flat planes, each oriented to its neighbor at an angle that represents a segment of a curved surface (as in Figures 2.6 on page 43 and 2.26), accomplishes two things: It helps us understand a form's basic volumetric nature, and it greatly assists in judging more accurately the actual nature of a curved surface.

Figure 2.25

Searching out these major facets is not usually undertaken as a primary step in drawing; generally, it is a natural development of a drawing begun with the search for gestural and directional thrusts. Once a subject's movements and shapes have been broadly stated, we are better able to see major subdivisions in its forms. Many of these subdivisions will be seen as large tonal changes denoting major planes, as in Cambiaso's drawing (Figure 2.27).

But before attempting to locate the planar divisions of complex subjects like the human figure, or even a seemingly simple still-life ar-

Figure 2.26

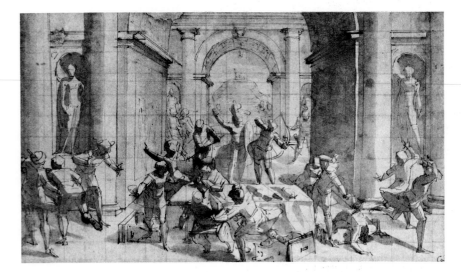

Figure 2.27
LUCA CAMBIASO (1527–1585)
The Return of Ulysses
Pen, brown and iron gall ink and brown wash,
squared in red chalk. 7¾ × 13½ in.
*The Art Museum, Princeton University, bequest of
Clifton R. Hall for the Laura P. Hall Memorial Collection*

rangement, it will be instructive to examine what we actually see when we look at such simple forms as the block, the pyramid, and the cylinder. For as we turn to consider the basic structure of volumes, it is at once apparent that we are really discussing certain basic principles of perspective. Chapter Three examines the science of perspective, a vital tool in understanding how volumes are seen to be arranged in nature. Here it will suffice to know about the principle of converging lines. This principle holds that parallel lines or edges that seem to be moving away from us, such as corridors or railroad tracks, appear to converge. If uninterrupted by other forms, such lines will meet at a point on the horizon line, as in Figure 2.28. To test this phenomenon, find an old magazine photograph of a city view or an interior view of a large room and, using a ruler, draw pencil lines that extend those edges of forms going away from you, until the lines meet. The horizon line (which is always at your eye level) will be that level at which these lines meet.

To experience this phenomenon in a drawing situation, place before you an arrangement consisting of three or four simple forms such as blocks, boxes, cylinders, and pyramids. Stand five or six feet away from your subject, where you can see three sides of each block form and two sides of the cylinders and pyramids. Using

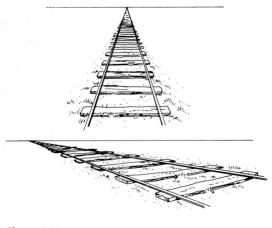

Figure 2.28

a soft graphite pencil and a large sheet of drawing paper, draw the *direction* of any edge on any of these objects. If it is a vertical edge, be sure you draw it as vertical, that is, as parallel to the paper's edge. This line, by its *direction* and *length*, will determine the scale and location of all the other lines in your drawing of that object. Continue to complete the drawing, noting the scale of each object as you establish the various directions they show. To judge better the direction of an edge, review "*Seeing Scale and Location*," pages 46–49.

Next, pretend that each object is made of

glass, enabling you to see all of its planes. Draw the lines that establish these planes, and, being mindful of the principle of converging lines, note how the directions of those lines moving back in space appear subtly to "aim" toward a point farther back in space. Draw some of these lines so that they extend beyond a junction on the object in order to underscore the converging line phenomenon, as in Figure 2.29. Keep this drawing mainly linear, using some light tones only to clarify a plane here and there as required. Make the outer lines of each form (the edges you *do* see) darker than those inner ones you understand to be present, as in Figure 2.29.

To achieve reasonably accurate results you should expect to make many adjustments, erasing freely to lengthen or reduce some lines and to adjust the direction of others. Check the relationships between lengths, directions, and angles until your drawing reflects the proportions and position of each form. Don't worry about making many erasures, or about a rough or even overworked drawing. It is accuracy, not "finish," that will give this exercise its worth.

Now replace these objects with a few of a more visually demanding nature, such as a hammer, a cup, and a candlestick holder. In drawing these, again assume them to be more

Figure 2.29

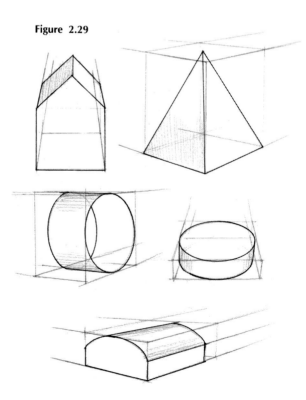

or less transparent, and draw their unseen planes lightly. Begin this drawing as you did the previous one, noting differences between the various directions, lengths, and angles of each object and between the size and location of one object in relation to another. (If you find such drawings beyond your present ability, read Chapter Three.)

Frequent practice in such **analytical** drawing (increasing the complexity of the subject-matter as you find you can reproduce simple forms more accurately) will reward you with a heightened sensitivity to how masses and their interspaces are constructed. That, after all, is central to drawing objectively the things you see. Equally important, it will sensitize you to "seeing" the planar basis of any form you are drawing, including complex organic ones, as in Figure 2.26. Recognizing such "core" forms as underlying whatever you wish to draw, whether you see it before you or imagine it, clarifies its structure and points the way to how you may show its essential volumetric character. Indeed, we cannot draw in any telling way any form whose structure eludes us.

You have perhaps already realized that seeing the first considerations having to do with planes and masses depends mainly on those first considerations already discussed in this chapter. Here I have been emphasizing the need to see the shape, location, and direction of the big planes before turning to draw smaller ones and to break away, at least at the outset of a drawing, from your retinal impressions—what you actually see—to search out these planar, constructional aspects of your subject.

It is this ability to first construct (in the drawing or in your mind's eye) a subject's major planes that best provides you with the "armature" necessary to your drawing of those more tactile and expressive aspects of the subject. Volume-revealing delineations, the tensions and pressures within and among parts, the feel of weight and texture, and the sense of your chalk or pencil moving upon the subject's terrain are all enhanced by an awareness of its basic planes and masses. Beginning a drawing like Giacometti and ending it like Rubens may be the best test of these first considerations of drawing, not in order to draw in the manner of either artist, but to see and contend with the entire array of a subject's observed and implied nature (Figures 2.30 and 2.31).

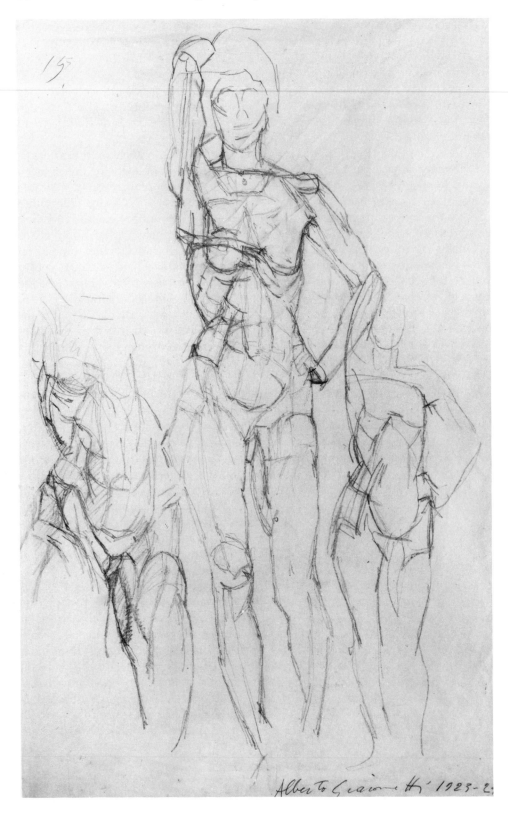

Figure 2.30
ALBERTO GIACOMETTI (1901–1966)
Three Female Nudes (1923–24)
Graphite pencil. 17⅜ × 10¹⁵⁄₁₆ in.
The Alberto Giacometti Foundation, Zurich
© Cosmopress, Geneva/ADAGP, Paris/VAGA, New York, 1985
Photo: Walter Drayer

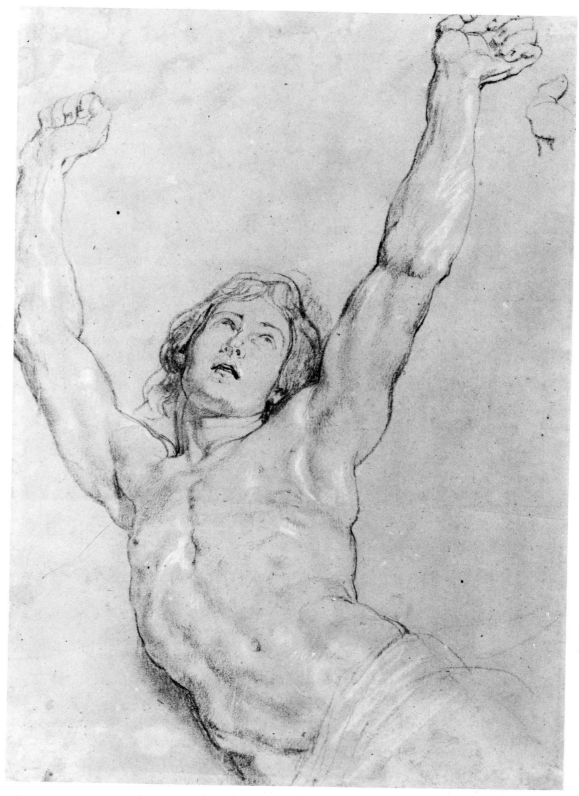

Figure 2.31
PETER PAUL RUBENS (1577–1640)
Study of the Figure of Christ
Black chalk, later outlining in charcoal, heightened
with white, reinforced at left edge of torso with brush
and thin wash on buff paper. 15⅞ × 11⅝ in.
The Fogg Art Museum, Harvard University, Cambridge, MA
Gift of Meta and Paul S. Sachs

SEEING TEXTURE

For the artist, *texture* means two things: the surface characteristics of subjects, such as metal, skin, grass, or cement; and the surface characteristics of the marks produced by the drawing medium. Too often, beginners are too engrossed with texture in the first sense. They may spend hours trying to reproduce the texture of, say, hair or skin, but show little awareness of the medium's texture, which may then appear overworked or forced away from its natural characteristics—characteristics that might better establish both illusionistic texture and fresher, more spontaneous drawings.

In any case, it is usually a better strategy to suggest, rather than to explain, illusionistic textures. An overbearing concentration on such surface effects often ''buries'' a subject's volumetric and spatial clues, resulting in highly rendered surfaces of forms and interspaces lacking in structural and spatial clarity.

Attention should focus instead on what each medium can do best. For the best way to

effect something of the textures we see is by working *with* and not against a medium's nature and range. We cannot begin too early to foster a sensitivity to a medium's textural character: to its feel, its response to the changing movements and pressure of your hand, its linear and tonal range, and its particular ''look'' on the page. Once we are familiar with its various traits and comfortable in its use, *it* will often suggest how best to show the many textures of the things we draw (Figures 2.32 and 2.33).

This is not to suggest that you shouldn't practice your hand at producing the texture of a variety of surfaces and objects. Indeed, such exercises should be done by making several drawings of the same object, using a different medium each time. How you will develop the texture of a pebble, a pine cone, or a prune in, say, pen and ink, graphite, or compressed charcoal will teach you a great deal about the use of each medium. For example, using pen and ink, lines can be made to suggest a subject's

Figure 2.32 (*student drawing*)
Marybeth Motter, Kent State University
Charcoal. 18 × 24 in.

Figure 2.33 (*student drawing*)
Craig M. Hobart, University of Colorado
Pastel and charcoal. 18 × 24 in.

texture by the way you treat the contour, as in Figure 3.34 (page 81). But in establishing these textural effects, avoid weakening your drawing's clarity of volume and space.

Other experiments in creating textures might include *rubbings*. These are done by placing the drawing paper on a textured surface such as wood, concrete, canvas, or even wire screening, and rubbing upon the paper in the desired places, with graphite, conté crayon, or compressed charcoal. This enables you quickly to establish textures that would take far longer to render.

SEEING AND THE BRAIN'S HEMISPHERES

In examining the first considerations of drawing, I have frequently noted the importance of seeing the direction, length, or width of a part or an edge. I have asked you to note the degree of angle formed by two lines or edges, the scale and location of one part when compared to another; or to judge the darker of two or more values, the shape of a negative enclosure, or the tilt of a plane in space. A number of scientists and artists believe that the ability to make such observations resides in the brain's right hemisphere. And while no one would disagree that creativity in general and drawing in particular require all the brain's resources to compare, sort, abstract, analyze, organize, and express, there is some value in any mode of approach to drawing that helps us better to apprehend the scope and nature of this elusive skill.

While there is as yet no definitive confirmation of the theory that there exists a strict separation of brain functions, with the left and right hemispheres of the brain performing highly differing roles, the recent interest in this concept among artists and scientists is useful in providing us with yet another frame of reference to help sort out those of our responses that assist us in seeing a subject in an objective way

from those intrusive ones that "blind" us to important measurable and relational actualities before us.* It is useful to the extent that it supports and sheds new light on how we may better cope with the age-old basic challenge for those learning to draw (and for those of us who teach drawing) to separate matters of interest to our functional eye from matters of interest to our creative eye.

Functional vision is concerned with the logical and rational, with daily tasks and the dangers of living in this world. A familiar boulder near our home seems stable and safe (unless there is a landslide or we run into it with a car). We have long ago noted that the boulder is large, rounded, sits at an inclined angle, and is near to the road. It is a useful landmark in finding our way home at night. But our interest in it is functional; we have seldom, if ever, studied it "for its own sake." If asked to draw it from memory, we may in fact show something of its general size and appearance, but our drawing is unlikely to show the boulder's specific shape, mass, orientation in space, or its location and scale in relation to other nearby forms in the scene. To do that, we would have to have cared enough to note these facts in the past, and they are of interest to our creative eye: the relating, comparing, holistic, intuitional, and empathic way of seeing something. Unless we are able to see the boulder with our creative eye, drawing it while it sits before us will not improve our drawing much. Whether we refer to these two ways of understanding what is before us as functional versus creative perception or the "two-brain" concept, their purpose is to shed light on how we may better concentrate on first considerations with fewer distractions. For to draw the boulder or anything else, we need to know that our functional, rational interests, and our relational, creative interests can (and do) conflict with each other, but can be made to cooperate.

Put simply, the two-brain concept holds that we use the left hemisphere of the brain for sequential, verbal, logical, and analytical functions; and the right hemisphere of the brain for spatial, metaphorical, nonverbal, **relational** ones. For example, adding a column of figures, planning a shopping list, or expanding your vocabulary are left-hemisphere functions; while de-

signing a costume, dancing freely, or rearranging your room are mainly right-hemisphere functions.

The value for art students in sorting out these two ways of responding to a subject is in clarifying for themselves which facts about the subject are relevant and which are not. For example, in drawing a hand, of what use is the left-brain (functional) fact that the thumb is bent without seeing the thumb in the right brain (creative) context of the scale of the rest of the hand? Or how is our visual understanding of the hand advanced by our left brain's thinking of the terms *thumb*, or *bent*, without our right brain's recognition that the entire hand points downward (Figure 2.34)?

With our right hemisphere "leading the way," we are less aware of time, or even of our drawing's *goal*—we are less *product oriented*. Instead, we are engrossed in relating, constructing, connecting, and in allowing intuitional, empathic choices to have a say in the drawing's formation; we are more *process oriented*. In this creative state, we are more likely to see both our subject and our emerging drawing in a dynamic as well as relational way. Which of us hasn't begun a project that, once underway, set off ideas and hunches about how we might proceed, and become engrossed to a degree that left us quite unaware of the time or even of the practicality of the effort *or* the result? Somehow, the process of combining, changing, playing, and forming—of creating—seemed reward enough. These are mainly right-brain interests.

For the artist, getting into this right-brain "attitude" means changing from the kinds of practical (functional) thinking that gets us through the day to a more open, relaxed, and visually curious (creative) mode. You must suspend thinking of the *names* of your subject's parts or seeing them in a sequential way, as when, for instance, one draws a tree by finishing each branch before beginning the next. Suspend any temptation to identify with the importance, the history, or even the function of your subject. Instead, try to experience an intimate, empathic, even physical contact with the forms of your subject, feel that your drawing instrument is actually touching edges and surfaces—that your eyes themselves, in moving along edges and upon the subject's changing terrain, touch the form.

You may find left-brain thoughts intruding, urging you to "get on with it." The intel-

*See Betty Edwards, *Drawing on the Right Side of the Brain*, (Los Angeles: J. P. Tarcher, Inc., 1979).

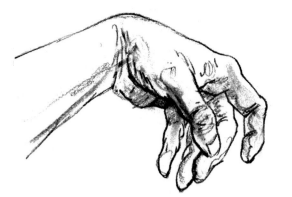

Figure 2.34

Figure 2.35

lectual (left) part of the brain is quickly bored with anything it identifies by name or function. Once an object's or a part's identity, use, and general character is established, it wants the eye to move on, to find more; it wants the eye to be a scanner, a scout. After all, like "all creatures great and small," we have been programmed over millions of years to see danger, to find food, and to note advantage. And our sight is a key sense in these survival matters. Resist this appeal by the left hemisphere to save time and to be practical, logical, and *visually uncaring* about relationships of direction, scale, and location within and among the things you see.

Interestingly, when we concentrate on *interspaces* instead of the objects that define them, it is easier to utilize the right-brain attitude. This may be because our more pragmatic, rational left hemisphere finds little of interest in the spaces separating the things it wants to identify. Whatever the reason, you can prove for yourself that concentrating on negative shapes, as noted previously in this chapter, improves objective judgments about their actual two-dimensional configuration (Figure 2.35).

Another kind of reversal further supports

the need to see with our more creative, relational eye. You will probably draw any familiar object more accurately if you view it from some unusual angle. Try drawing a teakettle, a lamp, or a shoe that has been placed upside down or at some foreshortened angle: The very fact that it is now more unfamiliar and you are less easily able to rely on prior knowledge about the object promotes the inquiring, right-brain attitude that finds such puzzles interesting.

While left-hemisphere qualities of analysis, planning, and logic are essential to good drawing, it is the relational, right-hemisphere interests that should take the lead in the drawing process. The resulting drawing will then have been formed by your sense of touch as well as logic; by empathy as well as intelligence; by a sensitive openness to the way things arrange themselves and relate to each other as well as notions about how they may be different. In this way, a fuller experience guides your judgements and feelings, and the marks, forms, and resulting drawing will reflect this more complete involvement. But when our logical (functional) left brain leads the way, our relational (creative) right brain seldom gets to participate in the drawing process.

3

STRUCTURE AND SPACE

Constructional Considerations

Webster's dictionary defines the terms *structure*, as "something arranged in a definite pattern of organization." For the artist, "a definite pattern of organization" means two things: (1) the organization of the marks on the page and (2) their organization into units that give the impression of volume and spatial depth. Objectively oriented drawing especially, then, concerns both two- and three-dimensional organizing—structuring.

Two-dimensionally, our drawings must achieve a balanced and unified structure in the arrangement of their lines and tones, of their positive and negative shapes, of their textures, and of the visual forces—the dynamics—that these elements generate (as we shall see in Chapter Four). Three-dimensionally, our drawings must likewise show a balanced and unified structuring of their masses in a convincing field of spatial depth, and must further show at least the constructional essentials that enable us to understand the volumetric nature of their masses. Figure 3.1 demonstrates a sound resolution of both two- and three-dimensional structures, as the analysis in Figure 3.2 illustrates. However,

in this chapter and the one following, I will use the term *structure* when referring to the constructional aspects of volume and spatial depth and the more familiar terms *composition* and *organization*, when referring to the more general "pattern of organization" of both two- and three-dimensional considerations in drawing.

In this chapter, then, I will concentrate mainly on those structural considerations of volume building that create the impression of solidity and space. In the following chapter I will examine both two- and three-dimensional composition. But bear in mind that while I separate these two kinds of structure in order to show more clearly the nature of each, in the act of drawing you must hold both considerations in mind at once.

BASIC PERSPECTIVE PRINCIPLES

We saw in Chapter Two that the basic volume-building unit is the plane and that "translating" curved surfaces into flat, planar ones assists us in seeing the basic nature of such rounded forms

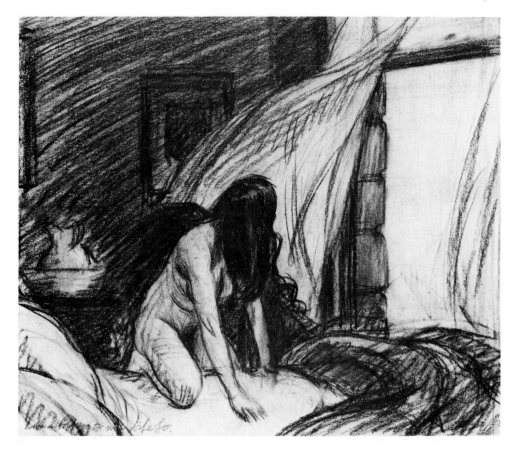

Figure 3.1
EDWARD HOPPER (1882–1967)
Drawing for etching Evening Wind (1921)
Conte and charcoal. 10 × 13¹⁵⁄₁₆ in.
Collection of the Whitney Museum of American Art, New
York, bequest of Josephine N. Hopper
Photo: Geoffrey Clements

Figure 3.2

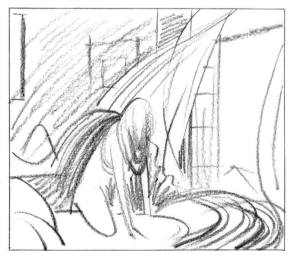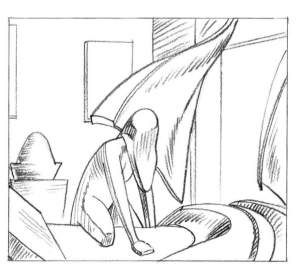

more objectively. To understand better how planes arrange themselves in space, we must now examine the basic principles of *linear perspective*. Developed during the Renaissance, this system differs from other perspective systems, such as those devised by ancient Egyptian and Oriental artists and by medieval European artists, in that it is based on what forms actually look like when we observe them from a fixed position, with one eye closed.

The most elemental principle of linear perspective is that of *overlapping*. When a plane or a form interrupts the contours of one or more other planes or forms, partly hiding them, we perceive the overlapping plane or form to be nearer than those it overlaps. Thus, seeing less than the entire form of an object because its shape is partly hidden by another suggests that object's position in the spatial field.

In Chapter Two, we also saw how parallel lines moving away from us appear to converge and meet at a point on the horizon line. Now we must review and further explore perspective's role in drawings of an objective mode, for it not only helps to convey the impression of solidity and spatial depth, but in arranging volumes to show the nearness of some and the distance of others, creates the viewer's orientation to what is seen in the drawing.

The study of perspective is simplified by the recognition that virtually any form we wish to draw, no matter how large, small, or complex, can be envisioned as placed in a blocklike container or cage, as in Figure 2.29. As this illustration demonstrates, some of the volumes show one set of converging lines, while others show two sets. In the first instance the volumes are drawn in *one-point perspective*, and in the second, in *two-point perspective*. To understand the difference between one- and two-point perspective, we'll start by using a block form as our subject.

A block (or the form it may contain) confronts us in a one-point perspective position when, as in Figure 3.3A, one of its surfaces faces us directly, that is, when this surface is at a right angle to our line of sight, as in 3.3B. When a block is turned so we face one of its corners, as in 3.3C, we view the block in two-point perspective. In the one-point perspective position, the block shows only one set of converging lines that meet at a point on the horizon line; in the two-point perspective position, the block shows two sets of lines meeting at separate points on the horizon line.

If we look down upon a block placed on the ground or on any horizontal surface, the horizon line will be located above the block, as

Figure 3.3

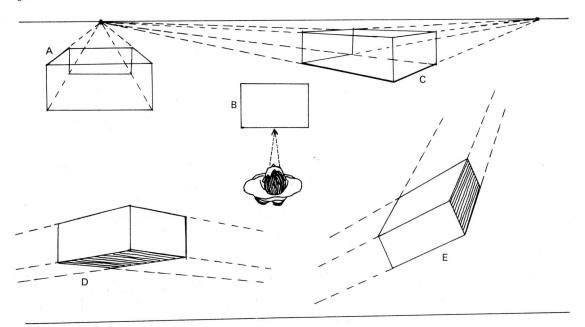

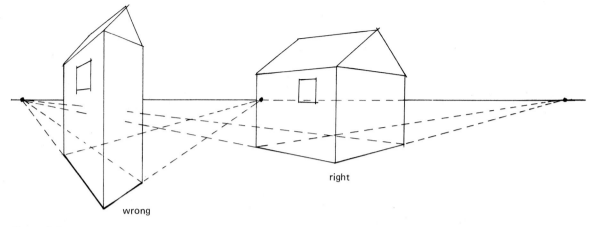

Figure 3.4

in 3.3A and 3.3C. If we look up at the underside of a block oriented parallel to the ground, the horizon line will be located below the block, as in 3.3D. Normally, the lines representing the abutments of the four side planes are drawn as *true* parallels—we show no convergence of these lines. This is still the case when a block is not viewed in an upright position, but at some angle (3.3E).

When drawing a volume in two-point perspective, be sure to locate the two points quite far apart, since placing them near each other results in diamond rather than block forms (Figure 3.4). Three-point perspective occurs when we look up (or down) at a tall structure such as a tower, or when we look into a long shaft. In these cases the vertical lines of the tower or shaft do appear to converge (Figure 3.5). Once this principle of convergence is understood, you can more easily draw (or check the accuracy of) objects in the positions you see or wish them to occupy, as in Figures 3.6 and 3.7.

The principle of converging lines also aids in the drawing of rounded forms, for any form can be "boxed." To see a circular form or plane in an *unforeshortened* position, that is, as having a true circular shape, we must be centered on its horizontal and vertical diameters—on the circle's center. When totally foreshortened, a circular shape (or any other shape) will of course be seen as a straight line, as in Figure 3.8. Viewed from any other angle, a circular shape appears as an ellipselike shape, growing more narrow in width as it approaches total foreshortening (Figure 3.8). Bisecting a true ellipse on its long

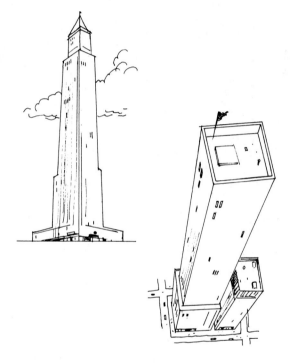

Figure 3.5

axis produces two equal halves. But bisecting a foreshortened circle in this way produces a slightly fuller curve in the half nearest the observer, as in Figure 3.9. In drawing foreshortened circles or arcs it is important to remember that they are not seen as true ellipses, although they are sometimes referred to as such in this chapter.

The angle of a foreshortened circle is determined by its long axis. When such an ellip-

Figure 3.6
JUDITH ROODE (1942–)
Approach-Avoidance 3
Charcoal pencil. 30 × 40 in.
Courtesy of the artist

Figure 3.7 (*student drawing*)
Gayle Picard, Montserrat School of Visual Art
Charcoal. 18 × 17 in.

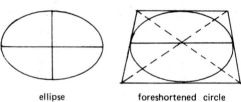

Figure 3.8

tical shape or form is in a vertical position, its axis will be vertical. When it lies upon a horizontal surface and is centered on the viewer (one-point perspective view), its long axis will be horizontal. All other positions will show the long axis inclined to some degree, as in Figure 3.10.

Placing a circle, sphere, ellipse, cylinder, or any other round-bodied form at the desired angle is made easier by first drawing its square, cube, or blocklike container at the desired angle, as in Figure 3.11A. To draw the elliptical end plane of a cylinder at a right angle to the cylinder's body, the long axis of the ellipse must be shown to be at a right angle (90 degrees) to the cylinder's long axis (3.11B).

The principle of convergence is at work in two other visual phenomena: *relative scale* and *relative distance*. Relative scale concerns the decreasing scale of forms known to be the same or similar in size. The decreasing scale of a row of trees or lampposts suggests the near or far position of each member (Figure 3.12). Relative distance concerns the decreasing distance between forms known to be about the same distance apart. Thus, the decreasing distance between the trees and lampposts in Figure 3.12 suggests their evenly spaced positions as they go back into the spatial field.

ellipse foreshortened circle

Figure 3.9

Figure 3.10

Figure 3.11

Figure 3.12

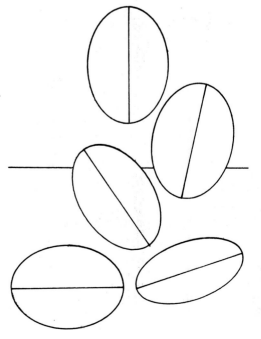

ADDITIONAL PERSPECTIVE INFORMATION

To locate the exact center of a plane turned away in some direction from your line of sight, simply draw diagonal lines from corner to corner, as in Figure 3.13A. Using this device, you can also locate the exact center of any foreshortened form by drawing the form in its foreshortened container (3.13B).

When drawing from your imagination, the same subject can be shown from different elevations by raising or lowering the horizon line, as in Figure 3.14. When drawing an observed subject, be sure to note which of its forms are located above the horizon line (your eye level) and which are below it. Recognizing the spatial placement of parts in relation to your fixed position is important in knowing how to proceed in establishing their mass. Always imagine the position of the form's container to help you better assess whether a form is above or below your eye level and to see its angle in space, as in Figure 3.15.

Linear perspective affects the shape and size of cast shadows, which always "flee" in the direction away from the light source. When forms are illuminated by a nearby source of light, such as a candle or a lamp, their cast shadows will radiate from a point at the *base* of the light source, as Figure 3.16 shows. Here both the light source and the base of the light source determine the direction and length of the cast shadows.

When forms are illuminated by sunlight, the radiating effect of the light rays is far less evident because of the sun's great distance. Figure 3.17 shows how, under these conditions, the sun and *its* "base" (the point on the horizon line directly below the sun) determine the di-

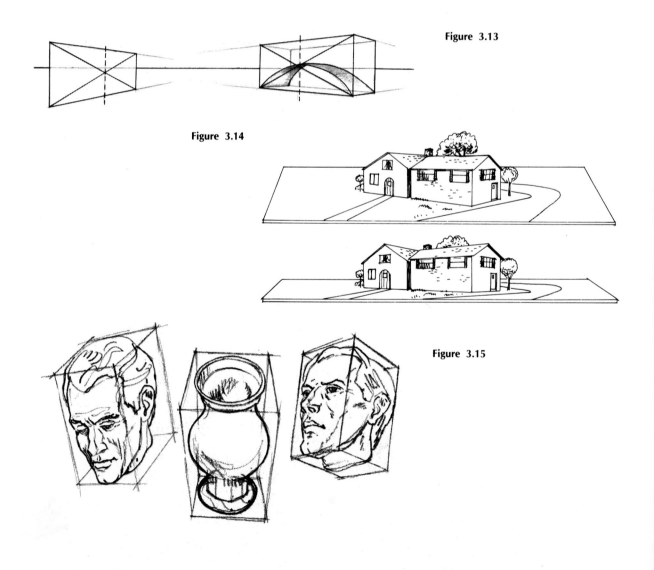

Figure 3.13

Figure 3.14

Figure 3.15

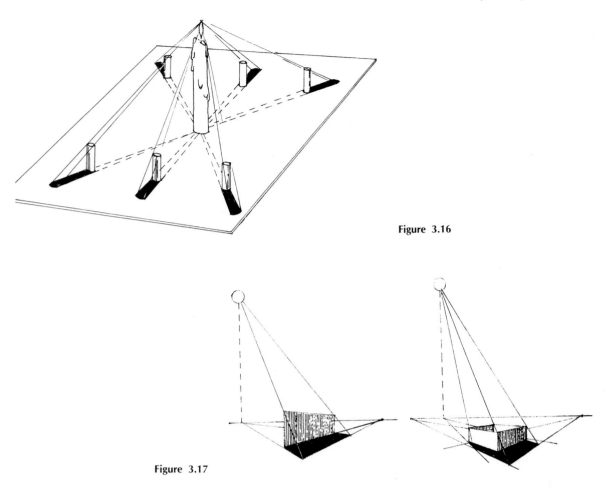

Figure 3.16

Figure 3.17

rection and length of cast shadows. Note that in the case of a shadow cast by a block (or any solid) seen in two-point perspective, the shape and size of the cast shadow is affected by the principle of converging lines, as well as by the position of the sun. Now there are *three* vanishing points that affect the cast shadow: The vanishing point of the shadow's lines dictates the *direction* of the block's shadow, and the other two vanishing points and the sun's height determine the shadow's shape and scale.

The foregoing review of some basic perspective principles, helpful as they are when drawing something observed (and vital as they are in drawing something envisioned), must not be allowed to replace objective visual experience. Whether your subject is before you or on the screen of your imagination, perspective is a poor substitute for deliberate, discerning observation (or in the case of envisioned works, choice). It is best used as a system of checks on objective perception or, in the case of a complex

envisioned image, to assist you in establishing those basic relationships of scale and location of parts in a spatial field.

If, as discussed throughout the previous chapter, you are always guided by what you actually see, rather than what you know or believe to be the case about a subject's shape and orientation in space, and if you avoid drawing one thing at a time in a piecemeal maner, your drawings will reflect good relationships of scale and location—they will be in perspective.

Perspective principles are information for the left-brain hemisphere—for our functional, rational mind—and thus can play a useful supporting role, adjusting what your relational eye has misjudged. But it is in the nature of the right brain's abilities to provide "correct" perspective simply by the sensitive accuracy of an involved eye responding to comparisons and associations—responding in a holistic way to directions, lengths, angles, points of intersection, shapes, and locations. When you are observing in this engrossed and objective mode,

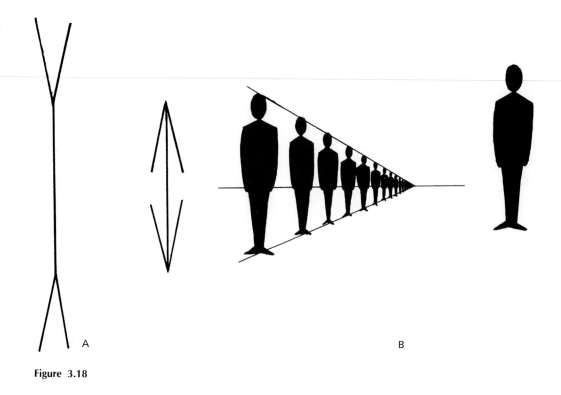

Figure 3.18

not only will your drawing's perspective be "true," but so will the proportions of each of the parts that make up your drawing.

Faulty proportions are mainly the result of a sequential approach and of optical illusions. When our functional vision is applied to the problems of drawing, each segment of a work is completed in isolation, with a lingering interest on parts we especially enjoy seeing and drawing but with little interest in relating any part to any other, that is, in making just those objective visual inquiries and connections that would reveal important structural and proportional facts.

Optical illusions are traps for the functional eye, traps our relational eye can *see*. For example, the vertical lines in Figure 3.18A are identical in length, and in 3.18B the figures on the far left and right sides are identical in size. Seeing what we expect to see can fool us. We should approach our subjects with no preconceptions, only with a caring, curious, and inquiring eye. For the artist, reality is not a confirmation of the functional eye's expectations, but of the more unfamiliar, more unexpected, and often more extraordinary aspects of the things around us that are waiting to be seen.

THE CONSTRUCTIONAL ANALYSIS OF VOLUME

Once we have established a part's direction, scale, and location, we can turn to inquiries about its basic planar structure. It is no exaggeration to say that the ability to draw a block, that simple six-sided form, in its transparent state, is the key to being able to analyze the structural character of all other volumes. To do this well when there is no block placed before us, we need to unite both our rational and relational interests. We need to fuse intellect and visual inquiry because we are now moving past the questions posed in objectively drawing what we see to questions aimed at understanding the planar nature of the things we envision. First, we need to select, at least in some general way, what forms we mean to draw. What is our subject to be? Then we need to ask, "How are these forms to be constructed, and what are their major planar components to be?" We need answers to these questions for two reasons: first, to be better able when we begin our drawing to sort out the features that explain the **formal**, fundamental architectural "pattern of organization" from the superficial and structurally un-

important features of our envisioned forms, such as textural and tonal niceties; and second, to be better able to understand the structural essentials of those forms we will observe to draw.

Let us begin with the block. As Figure 3.19 demonstrates, this basic mass can be shown at various angles, adopt a variety of proportions, be segmented, bent, or even twisted on its own long or short axes. Before proceeding further, fill a page with line drawings of blocks in every variation you see in Figure 3.19, plus any others you can conceive of. Draw each of these variations in two or three different positions; Each new view presents new problems of analysis. The curved block, for example, didn't seem too difficult to figure out in the side view, but the foreshortened view was a different story! Note that Figure 3.19 shows most of the forms as somewhat transparent; we can see the planes that would normally be hidden in a solid mass. In constructing your variously shaped and turned

forms, think of them as translucent, faintly showing all their planar surfaces.

In the section entitled "Seeing Planes and Masses" in Chapter Two, I suggested you make similar "translucent" drawings from objects placed before you. Then you had to discern objectively those directions, angles, and shapes you could see, and imagine those you could not. Now you have to "see" them all in your mind's eye; you must call on your rational, conceptual abilities as well as your relational, perceptual ones. Making these block variations transparent may seem more difficult than drawing them as solids. In fact, such a "see-through" approach, enabling you to establish junctions between lines and to tell quickly when parallel lines are diverging instead of converging, aids the process of constructing these forms. Make sure these block-variations are comprised of right angles at the ends and of planes that do not change their widths, as in Figure 3.20.

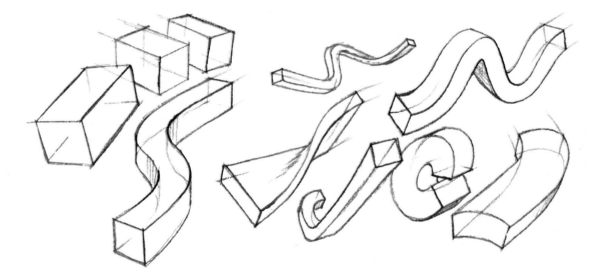

Figure 3.19

Figure 3.20

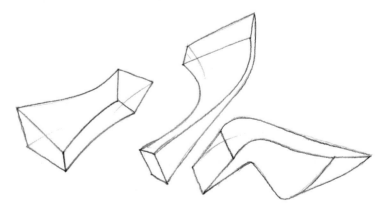

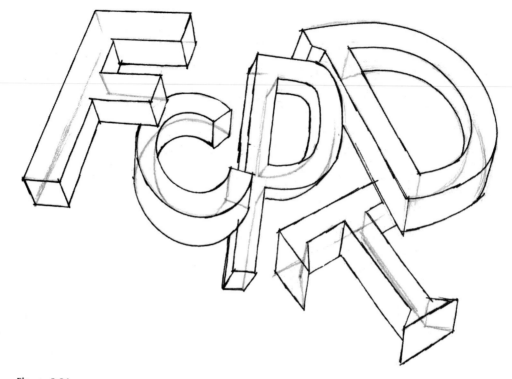

Figure 3.21

Once you are able to invent such constructions with some ease, fill another page with drawings of straight and curved blocks representing various letters and numbers, as in Figure 3.21. Note that the lines drawn to show normally unseen planes are very faint. To draw them as boldly as the rest of the lines would make such drawings confusing for the viewer.

Next try to combine straight and curved blocks with some pyramidal ones. The pyramid is constructed of four identically shaped triangles. To practice drawing these from various views, you can begin by lightly indicating the "container" that would hold them, as in Figure 3.22. Note how diagonal lines on the block's top plane establish the pyramid's apex. Figure 3.23 demonstrates how such combinations of blocks and pyramids may appear. Notice that now even fewer of the lightly drawn "inner" lines are visible. There are two reasons for this: First, by the time such complex forms can be conceived and convincingly drawn, fewer of these lines are necessary—we can construct masses with less aid from such construction lines. Second, these more complex drawings would become hopelessly confusing if every inner plane were shown, and such lines are often erased after they have served to help establish a vol-

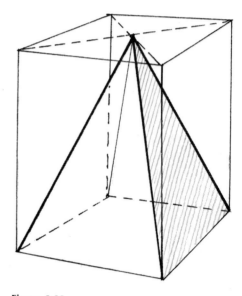

Figure 3.22

ume's basic structure. Note that where volumes are shown as solids some hatched values, mainly on curved surfaces, further **model** the forms.

With the introduction of value as a volume clarifier we come to an important consideration in the modeling of masses of an organic nature: namely, *line to plane*. By this I mean the turning

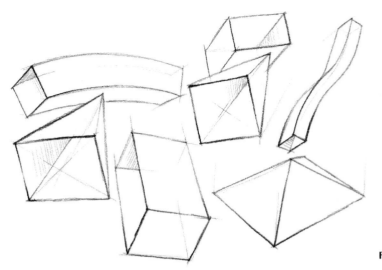

Figure 3.23

of an edge inward to become a plane. Many organic or complex forms—the human figure certainly being one—reveal that their contours are actually made up of overlapping masses. What starts out as a segment of a form's edge (a totally foreshortened plane) "enters" the form where it turns toward us, showing a (usually) small surface plane that "dies out" or blends into the form's surface, as in Figure 3.24. Although contour lines are able to define volume at a form's edges and imply something of its inner terrain, a single line cannot represent an entire plane, however small; it is this restriction that gives rise to the use of such hatchings as can be seen in Figures 3.25 and 3.26.

A useful exercise in developing a sensitivity to such line-to-plane passages, as you further train your mind and eye to conceive (and thus analyze the flat and curved planes) of more complex organic forms, is the "soft form" drawing. These invented images, like those mentioned above, make excellent sketchbook exercises. Going back to the simple block form, imagine one to be made of any pliable material such as clay or dough, or as wrapped in a heavy canvas cover. Draw this block as it would appear if you tied it with rope. This will create a system of more rounded masses, which are rather well expressed by the string itself. Plan also to include some folds, as in Figure 3.27A. If we then select a light source and, using graphite pencil, model those curved planes turning away both from the light *and* from the form's edge, the impression of rounded volume is strongly reinforced, as in Figure 3.27B. This illustration

Figure 3.24

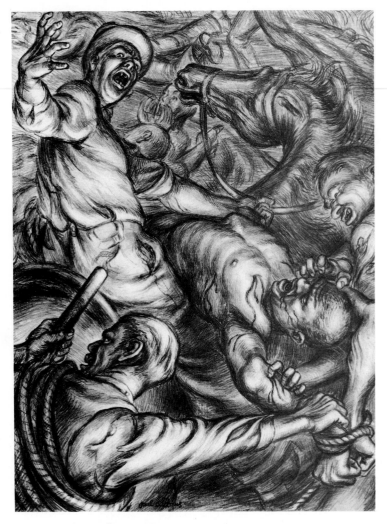

Figure 3.25
PAUL CADMUS
To the Lynching! (1935)
Pencil and watercolor. 20½ × 15¾ in.
The Whitney Museum of American Art, New York
Photo: Geoffrey Clements

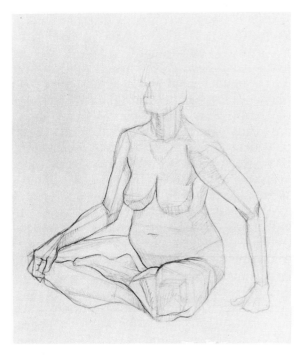

Figure 3.26 (*student drawing*)
The Art Institute of Boston
Graphite. 20 × 17 in.

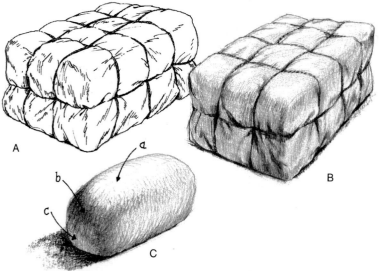

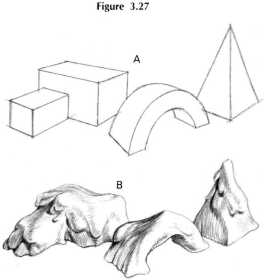

Figure 3.27

Figure 3.28

demonstrates an often-seen effect of light on rounded forms: the reflected light. As the term suggests, a reflected light is a ray of light that, having struck a surface, bounces off in another direction to strike a nearby surface. When a reflected ray of light strikes a rounded form on the side turned away from the main light source, it weakly illuminates that side. This creates a situation in which a rounded form's darkest tone is then not seen at the edge furthest from the light source, but somewhere between it and the weak reflected light, as in Figure 3.27C, where *A* indicates the area illuminated by the light source; *B*, the form's darkest area; and *C*, the reflected light. By using some subtly toned reflected lights in modeling your invented forms, more convincing impressions of mass occur. Such modeling gives the effect of light-filled shadows and avoids dark, leaden shadows. In fact, when drawing tonally it is best not to think in terms of light and dark, but of light and less light. However, you should avoid using reflected lights, especially bright lights, on *every* form, since this produces a theatrical and garish effect.

Next draw several imagined blocks, arches, and pyramids in some arrangement, as in Figure 3.28A, and then "melt" them somewhat, as in 3.28B. Again, hatched lines (also called structural lines because of their volume-revealing ability) are the necessary means for showing what cannot be expressed fully by contour lines. Note that drawings such as those shown in Figure 3.29B also provide ample opportunity for drawing line-to-plane passages.

The purpose in suggesting the use of hatched tones instead of tones produced by rubbing or blending graphite is to get you to think of a plane's direction, its tilt on a form's surface. Applying "clouds" of rubbed tone evades this issue. Usually, such structural lines hatchings are drawn in the direction of a plane's *short* axis, especially upon foreshortened and/or rounded planes, as in Figure 3.29. However, there are no "rules" governing the direction of the hatchings on the forms we draw, as long as these masses of structural lines do not conflict with a flat or curved plane's direction in space. Figure 3.30 demonstrates how effective such modeling

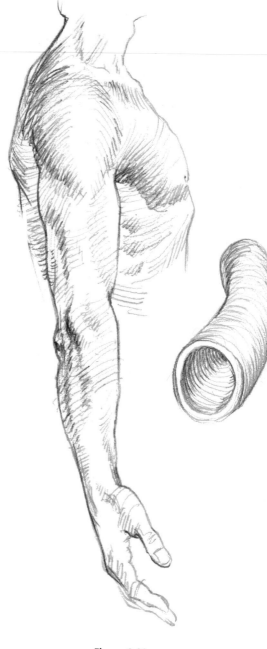

Figure 3.29

Figure 3.30
SIMONE CANTARINI (1612–1648)
Half-Figure of a Youth with Right Arm Raised
Red chalk, a few white highlights, on beige paper.
13³⁄₁₆ × 10⁷⁄₁₆ in.
The Metropolitan Museum of Art, New York, Rogers Fund,
1969

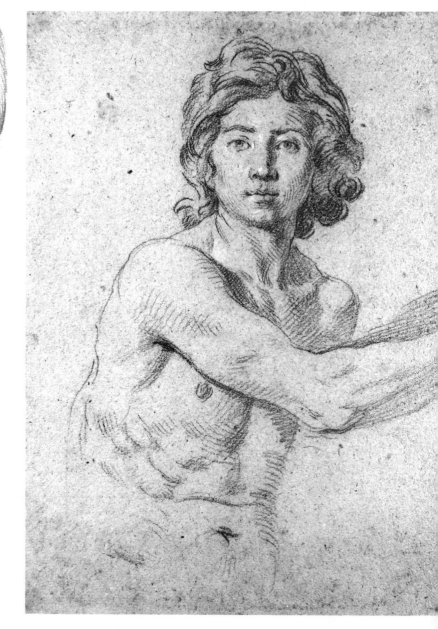

can be. This procedure is suggested here not as a drawing technique (although artists such as Michelangelo, Cézanne, and Giacometti favored such an approach to drawing), but as an effective *process* for examining the constructional character of our subjects.

A further step in sensitizing yourself to *experiencing* the surface terrain of the forms you invent is next to return to the drawings you have made according to the examples shown in Figure 3.28B, and slowly draw continuous lines around the forms, feeling that your pencil actually touches and moves upon the hills and valleys of the object itself, leaving a trail as might be left by a bug dipped in ink (Figure 3.31). Such *cage* or *cross-contour line* drawing demands that you strongly identify with changes of direction in a form's terrain. Something of this empathy with a form's surface changes is at work in the soft-form drawings, where the rope reveals the undulations of the volume (Figure 3.27B).

In doing these drawings, you have, of course, been modeling rounded volumes of a sometimes complex kind. But let us turn now to inventing more "pure" rounded forms. To do so, we must again return to the simple block. Remembering that any form can be placed in its block container, first draw several translucent blocks, as in Figure 3.11A (page 69). Next draw the kind of cylinder that each could contain, and model the turning (side) plane of each, as in Figure 3.32. Note that the structural hatchings can go around or along the side plane, and that each elliptical end plane is at a right angle to the cylinder's long axis. Note, too, that these foreshortened circles are formed by having them touch the center of each of the four lines that represent the container's end plane. As with the earlier drawings of arrangements of blocks, such cylinder drawings can be comprised of variously shaped and bent cylinders and can be drawn in the soft-form manner previously described.

Figure 3.31 (*student drawing*)
Susan Jager, Kent State University
Charcoal. 24 × 18 in.

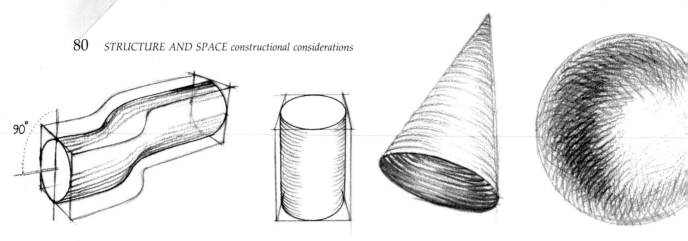

Figure 3.32 **Figure 3.33**

Next draw some cones of various kinds, as in Figure 3.33. Note that the cone's base, like that of the cylinder's end plane, is determined by the ellipse touching the center of each of the lines that make up the container's end plane, and that the cone's apex is located by diagonal lines crossing at the container's opposite end plane. Again, invent drawings comprised of several cylinders and cones arranged in some combination you find interesting, and model them in their "pure," soft, and "melting" states.

Finally in this series of invented volume drawings, model a spherical volume. Even here, we should start by drawing its container; this time a square *shape* will serve. As Figure 3.33 illustrates, the structural lines that model a sphere may move in any direction, as long as they stay upon the turning surface. A ball of yarn, for example, shows that lines may move on a sphere in any way that turns with the form.

In requiring that you decide on the masses you will invent *and* on the flat and curved planes that will express their structural nature, all of the foregoing exercises are designed not only to sharpen your visual thinking but to put you in touch with every kind of surface-modeling challenge you will ever meet as an artist. To put it another way, anything else you will ever see and draw will only be variations and combinations of what you have already invented and drawn.

But the observed subject is so intimidating that even though you have already experienced virtually every kind of drawing challenge, drawing those objects you actually see seems sometimes to be unmanageably difficult. This is partly so because, in the invented drawings, *you* decided what each form's proportions, location, and structure would be. Now, you must

respond to *given* conditions, to structural and measurable facts in front of you. Partly, too, the forms we see, in being illuminated and variously toned colored objects of differently molded configurations, seem to "hide" their structural nature from us. Both reasons are alike in their demand on you to "figure out" what is essential to the structural nature of what you see, and to do so in a relational way. Now it is no longer a matter of inventing, but of discovering the gesture, directions of axis and edge, angles, shapes, points of intersection, planes, and so on. We are then back to making drawings entirely in a relational, empathic, and holistic way. However, your journey into the realm of invented volumes made you confront and puzzle out basic structural situations similar to those you will meet in the next series of drawings, and that experience may help you to analyze better the objects you see.

Let us begin by drawing some objects whose structural character is incisive and not too complex. Place before you a manufactured object such as a wrench, pliers, a nutcracker, or any tool or utensil that has clearly abutting planes and is not too complicated in its parts or design. Using graphite pencil, make this drawing at least twice the size of the object. It is easier to construct the drawing's smaller planes in this scale. Begin by lightly drawing its overall gestural action and then settling on its main long axis (or axes). Next, establish the many directions that its edges show, taking the time to extend lines, search out edge intersections, note the shape-actualities of the parts *and* the negative shapes or interspaces.

Once you have established a rough sketch of the object's general features and have checked its exact orientation in space, you may wish to enclose its main parts in whatever blocklike con-

tainers would most appropriately fit each part, as in Figure 3.34A. Now is the time for including perspective considerations to help you see where your judgments of axis or edge may have gone awry, and to more firmly "lock" the drawing into an overall system of converging sets of lines. Where necessary to understand better a part's basic planar structure, draw it in a schematic, transparent mode.

Continue to locate smaller planes and to first establish curved edges by small segments of straight lines. Once you feel confident that the drawing's masses and interspaces reflect the directions, shapes, and proportions of those in the object (and that requires a conscientious search for these relationships), many of the drawing's more schematic lines can be erased, and its parts can be drawn as solids, using values to further clarify mass and location, as in 3.34B.

There is a clear and orderly appearance to such machine-tooled objects. The flat planes abut sharply, the curved ones do not waver. Their unseen planes are usually easy to understand, and are often predictable. This is far less the case in drawing more organic kinds of subjects. For your second drawing, use any object made

Figure 3.34

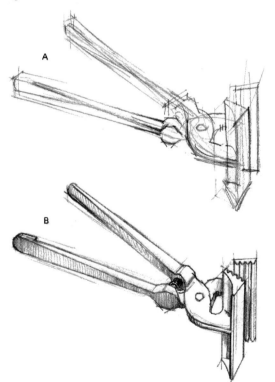

of leather. Hats, shoes, boots, jackets, handbags, or gloves all serve as useful intermediate kinds of subjects; they retain some of the features of more purely geometric forms and possess many of the features of organic ones.

Place the object some four or five feet away in a location where a single light source (preferably daylight) falls gently upon it, clearly revealing its surface changes. Again, plan your drawing to be larger than the object. After searching out its gestural character and its main axial directions, continue drawing by mainly straight lines to establish the object's edges and shape-actualities. Now your use of blocky containers and transparent passages should be more selective, being restricted to larger units of the subject, or where you are having difficulty seeing the exact tilt or basic geometric basis of a part. Do not hesitate to walk around to see parts hidden from your view of the object, since this often shows you why the planes you do see are arranged as they are. Rely more now on extending vertical, horizontal, and diagonal lines from one point on the object to another, to see if these directions match those in your drawing.

Resist the temptation to draw your retinal impressions, but "break through" the object's surface to see the planes that a more "roughhewn" version of the volume might show (Figure 3.35). Also, resist introducing values in the drawing's early stages, and "getting on" with the drawing (which is a functional, left-brain

Figure 3.35

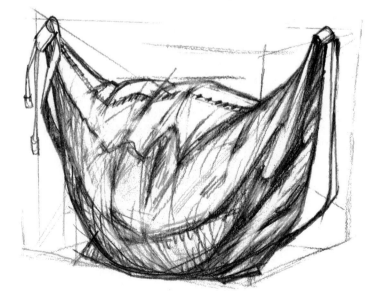

urging). The longer you can hold the drawing to lightly drawn, tentative lines that establish the shapes and relative sizes of the planes, the better. Again, note points of intersection, and make adjustments in direction, shape, or scale as soon as you find each discrepancy. Recheck areas you earlier decided were accurately drawn, making sure to step back periodically in order to better judge proportions.

Because you have been using more straight than curved lines and have been concentrating on seeing planar shapes and abutments, the drawing may appear rather schematic and angular; it is, after all, a drawing of the object's structural conditions rather than its surface effects of texture, illumination, and small, subtle surface turnings. At this point you should consider the drawing to be a kind of armature, a scaffold that will support a more tactile use of line and tones that will further clarify the location of planes and parts in space. If your drawing has darkened with the application of many lines, erase any that are not vital in their armature role. Using a kneaded eraser is best for this operation, since it will not affect the paper's surface. You may even wish to lightly erase the lines you mean to keep, setting the stage better for the last phase of this drawing exercise.

To shift from the more analytical "underdrawing" to a more empathic and expressive mode of seeing the subject, let us temporarily adopt a drawing "policy" that will enable you to show more clearly the nearness of some parts of your subject and the distance of others. It is a drawing process that many students and artists instinctively employ, at least in passages of a work, and calling attention to it here may define it in a way that will make it a more readily available strategy. It is what I call "the dark line near, dark tone far" approach to volumetric clarity. In this drawing mode, the two "rules" are these: (1) Every line that overlaps another is drawn darker and heavier than the line it overlaps; and (2) Every overlapped form is drawn darker than the overlapping form, near the overlapped area. These two effects can be seen in Figure 3.36. Note that the nearest forms or parts show quite bold lines, and that the forms or parts furthest back are all toned to some degree. As with any drawing "policy," an overbearing use of these tactics may appear rather self-conscious and forced, but as a means

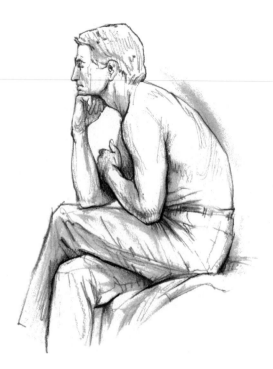

Figure 3.36

of sorting out a complex of forms it is often useful.

Your use of line now should be deliberate, slow, and tactile as it moves over the lighter, more schematic lines of your underdrawing, which first established the object's shapes. Now you want to feel the rise and fall of the surface form and record every swell and valley. Remember to thicken the contours moving over other contours. As you do this, you will come to some line-to-plane passages. No matter how you see the light to be falling on the object, show the plane area as having a light tone drawn with subtle hatchings, as in Figures 3.25 and 3.26 (page 76). When you turn to applying tones, again disregard the light on the object and show every overlapped form as darker than the form above it, as in Figure 3.36. When this stage of the drawing is completed, continue to develop the form tonally, now referring to the way the light source explains the surfaces. However, retain those tones you drew in accordance with the overlap mode of modeling. Finally, try to show, by emphasizing line or tone, areas in the object that show tensions or pressures among the folds, as when parts appear to be pulled or

pressed down upon. This imparts the sense of inner activity resulting from the weight and arrangement of the parts that make up the subject.

When you are able to control the several stages and steps of this demanding exercise, try to apply them to more challenging subjects such as arrangements of drapery (3.37) or the human figure (3.38).

As the last exercise shows, understanding volume and its interspaces requires both rational analysis and relational caring. We need the objective reasoning and the discipline to keep us seeing into a subject's form to find its planar fundamentals, and the holistic comparing and empathy to keep us seeing into the subject's arrangement and proportions, and into its unique turnings and tensions. Good drawing demands both the head and the heart.

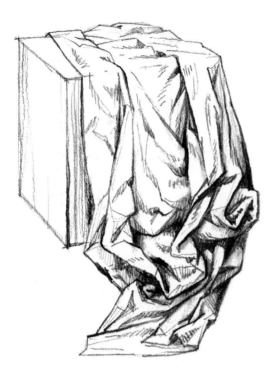

Figure 3.37

Figure 3.38
John Lanza
Study of the Figure
(*Student drawing*)
Graphite. 24 × 18 in.
Courtesy of the artist

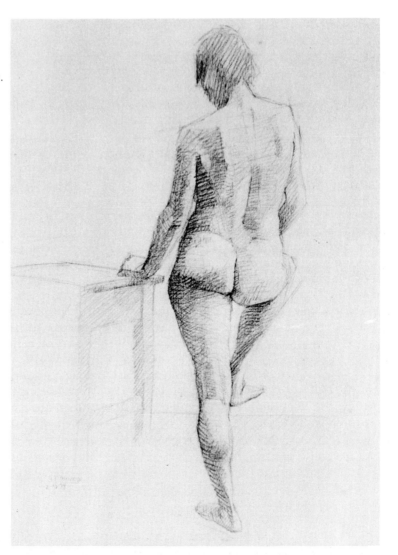

4

THE RELATIONAL LIFE OF THE ELEMENTS

Compositional Considerations

In the previous two chapters, the term *relationship* dealt mainly with comparisons of directions, lengths, shapes, and so on. You were asked to relate the tilt, size, or location of one part of a subject to another part in order to establish objectively in your drawings the arrangement and character of each subject. Seeing such measurable relationships between a subject's parts, and between it and your drawing, is basic to sound representational or **figural** drawing, but so are relationships of another kind. These exist among the visual elements themselves—among a drawing's lines and values, the two fundamental elements of drawing—and among the visual elements they in turn create: the shapes, masses, spaces, and textures by which our images are formed. These relationships exist in your drawing rather than in the subject, for they are born of the process of mark-making—are inherent to it. Whatever the medium, the subject matter, or the purpose of a drawing, the interaction of its elements is always an important part of a drawing's **dynamic** content, that is, its total visually expressive nature.

Some relationships based on suggestions of movement, such as the calligraphic action in flowing hair, the branches of a tree, or a winding path, or the grid arrangement of a bookcase or a stack of wood, are readily evident in some subjects, as are strong relationships having to do with shape, value, and texture. But often the artist sees only hints in the subject of various associations among the elements and enjoys a great deal of latitude in choosing what to emphasize and what to subdue in the "raw material" of his or her subject. What *is* chosen is largely determined by the artist's theme, as Figures 4.1B and 4.1C show.

These relationships are essentially **abstract** in nature; the elements "call" to each other on the basis of similarities and contrasts among themselves that take part in the drawing's figural content only indirectly, but nonetheless importantly. In fact, it is through the play of abstract relationships that a drawing's depictive expression is amplified and its marks organized into a harmonious whole. It is the means by which the artist forms the drawing, to quote Webster's dictionary again, into "a definite pattern of organization."

Drawings made without regard for the re-

lational play among the elements are not without such relationships, for they are inherent in any (even random) collection of marks on a page. Such drawings are seriously diminished in clarity and order, however; for the unintended, random associations that then occur will usually intrude on intended purposes. For example, a drawing's intended center of interest may be robbed of its importance by a harsh clash of values elsewhere in the drawing, or by a powerful diagonal movement that attracts the viewer's eye more than does the intended focal point.

Such "runaway" relationships, by intruding on depictive meanings and on compositional balance and unity (see "Compositional Structure," page 92), can be destructive forces. But when harnessed to a drawing's representational theme, such abstract energies can strongly reinforce it in their own dynamic terms, by enacting and evoking what the drawing's narrative content describes.

Relationships are always based on similarities of some kind, but they require differences to reinforce them. For example, several

Figure 4.1

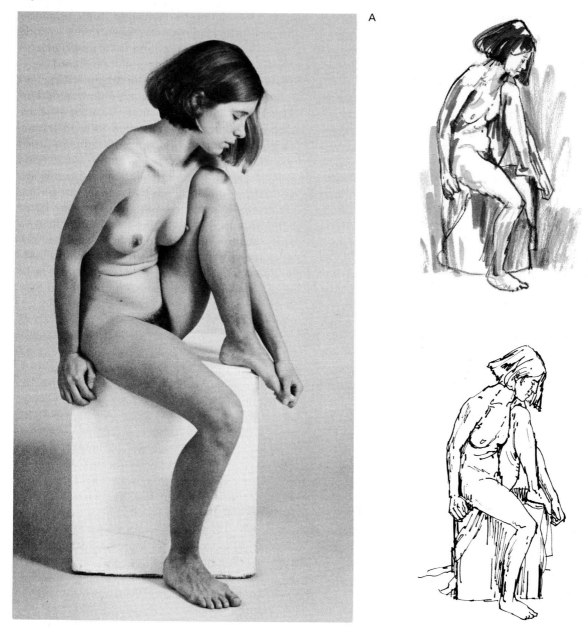

A

B

C

values in a work may relate by their light tone, but their lightness will be a stronger uniting factor if they are seen in contrast to one or more darker tones. Or a line may be long in relation to the page, but will appear longer in the company of much shorter lines.

A single vertical line on the page will contrast with the "emptiness" of the page, but relate with the vertical borders of the page. A diagonal line of the same length and character as the first, and drawn across it, will relate to the first line in all but direction. Another similar line crossing the vertical one in the opposite direction creates a harmonious pattern of directions and interspaces that unites the three lines, although it contrasts with the first two in direction (Figure 4.2A). But three similar lines, differently arranged in direction and location, may be tension-filled and fail to unite (Figure 4.2B). Of course, symmetrical solutions, as in 4.2A, are not a necessary condition for balance and unity. Asymmetrical arrangements, as in 4.2C, are usually more interesting, provided they achieve equilibrium and unity on the page. When similarities strongly overpower contrasts, as in 4.2A, the result is boredom. When contrasts overpower similarities, as in 4.2B, the result is imbalance and disunity. Good drawings avoid both extremes. Their contrasts may threaten, but should not succeed in destroying, balance and unity.

As you may have already surmised, if the few lines in these three "drawings" are capable of organization or chaos, then the many more lines and values of our drawings, and the other visual elements they create, must offer nearly limitless possibilities for relating and contrasting in ways that will help or harm our imagery—and they do. To see how the elements relate, let us examine them one by one and then see something of the ways they may interplay in our drawings.

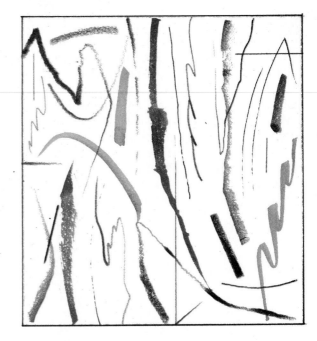

Figure 4.3

THE ELEMENTS

Line

Universally, line is the primary, most versatile, and the most pervasive element in drawing. Every drawn line has a specific length, direction, value, and texture and a specific location on the page. Line is a visually concise means of interrupting or dividing the picture plane, showing overlap, defining contours, and establishing directions of axis and edge. In hatchings, it can produce numerous values and is rich in its textural and expressive range.

Our acceptance of (and need for) line as the fundamental means of forming our images sometimes blinds beginners to the fact that line as such does not exist in the physical world. In drawing, it is best to understand line as an abstract device for symbolizing the things we see or envision, which relate to or oppose each other according to similarities and differences in their direction, location, length, thickness, value, texture, and calligraphic behavior, as Figure 4.3 demonstrates. Note how some lines are related to each other by some characteristics and contrasted by others.

We also sense "lines" in nature when forms are seen in various straight or curved arrange-

Figure 4.2

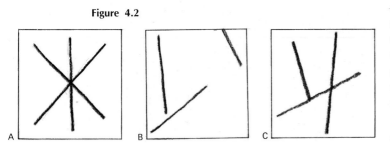

ments, as in the "alignment" of trees or furniture. We speak of cars "lining" the road and of the skirt's waistband being "in a line with" its hem. Such lines, sensed in virtually anything we may view as well as in the sharp abutment of differing values, planes, or colors, show why line, although absent as an actual, physical boundary around the things we see, has such a pervasive influence on perception and consequently on how we draw.

Value

After line, value is the most important visual element in drawing, for, as noted earlier, it is with line and value that all the other elements are produced. In drawing, values are produced either by deposits of some medium such as chalk, pencil, or ink washes, the particular tone being determined by the pressure of the chalk or pencil or by the mixture of ink and water; or by closely placed hatchings in these or any other media that create the optical effect of a tone (Figure 4.4). The particular value of such optical tones is determined by the density of the hatchings.

Whichever method is employed, or however they are combined, changes in value are the only means for showing how light striking forms explains their surface structure. Only through value can we show the local tone of objects, that is, the inherent lightness or darkness of the things we draw. An object's local tone is of course affected by the light falling upon its surfaces, but is separate from it. No matter how strongly a light source may illuminate it, an egg's local tone remains light, a plum's, dark. Only through the use of values in drawing can such facts be sorted out.

Unless they are fused or too subtly graduated, areas of tone create shapes. When such shapes are arranged to suggest an object's surface planes, volume is produced. Textures also result from the artist's treatment of tones, that is, the artist's particular manner of applying the medium.

Value, then, can exist in the massing of lines and in shape, volume, and texture. It is also an effective means of representing both two- and three-dimensional space (Figure 4.5). Value's ability to make dissimilar parts relate and similar ones contrast is an important compositional device. As Figures 4.6A and B show,

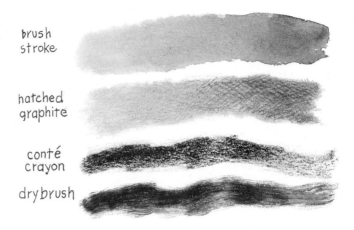

brush stroke

hatched graphite

conté crayon

drybrush

Figure 4.4

Figure 4.5 (*student drawing*)
Renee Cocuzzo, private study, Newton, MA
Brush and sepia ink. 18 × 12 in.

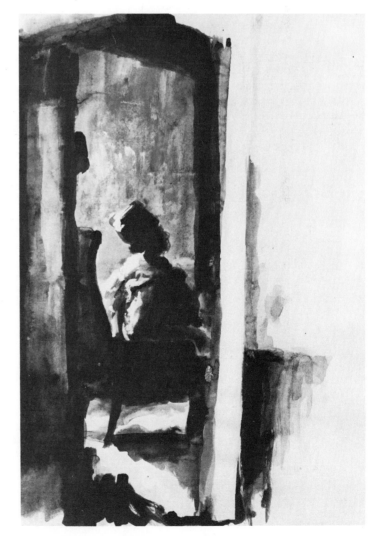

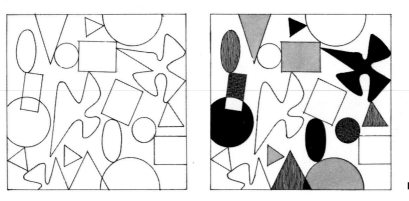

Figure 4.6

Figure 4.7
WALTER MURCH (1907–1967)
Study for The Birthday (1963)
Crayon, pencil, and wash. 23 × 17½ in.
Collection of the Whitney Museum of American Art, New
York, Neysa McMein Purchase Award
Photo: Geoffrey Clements

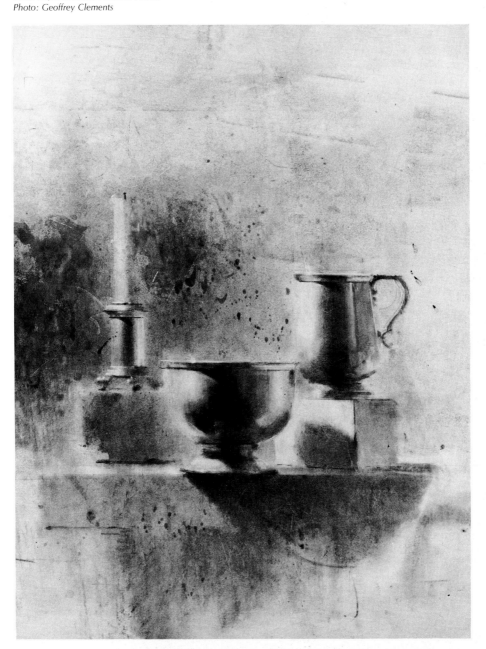

value can greatly modify the composition of a line drawing by creating visual groupings and alignments. When used for purposes of illumination, values can unite forms of differing structure and silhouette by darkening each on the side turned away from the light. Finally, value, like line, is a powerful agent of expression, amplifying a drawing's mood by the way it is used (Figures 4.7 and 4.8).

Figure 4.8
MAX BECKMANN (1884–1950)
Carnival in Naples (1925, reworked 1944)
India ink with brush, black crayon and chalk. 27⅛ × 43⅛ in.
Courtesy of the Art Institute of Chicago, gift of Tiffany and Margaret Blake

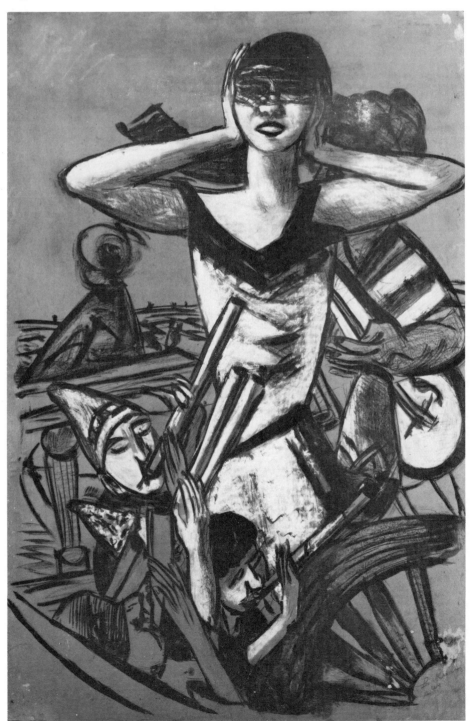

Shape

All volumes and interspaces have shape, have some two-dimensional configuration. For beginners, perceiving the ever-present element of shape is often difficult. Used to seeing their world in terms of volume and space and usually wanting to emphasize these properties in their drawings, they concentrate on a subject's masses and interspaces to the exclusion of seeing the silhouettes that all volumes and spaces possess. In drawings, positive and negative shapes by their configuration show direction and suggest movement on the picture plane. As Figures 4.7A and B demonstrate, shapes will relate or contrast on the basis of scale, character, location, and value.

Shape is an omnipresent element in drawing. Indeed, when we begin a drawing, the size and shape of the surface chosen represents our first shape judgment—one that will influence all our subsequent decisions concerning shape. All shapes, of course, are produced by line or value, or by a combination of both. They can be textured, change value within their boundaries, or be plain and unvarying. Shapes can be geometric or organic in character, and can be open or closed. Closed shapes are those entirely bounded by line or composed of tone or by shapes arranged to show an enclosure. Open shapes are those showing breaks in the linear or tonal enclosure. As Figure 4.9 demonstrates, shapes also reveal expressive force when some shapes appear active or aggressive and others passive and still.

Texture

The element of texture exists at two levels: the textures inherent in the medium (or combination of media), such as the rough, grainy look of chalk or the sharp staccato of small pen-and-ink strokes; and the recognizable ones that the artist suggests, such as wood, metal, or hair. Additionally, the texture of the surface drawn upon influences the textural character of the marks and the imagery. The tendency in recent trends in drawing to allow both shape and texture to "rise" to the surface of the picture-plane makes it important to recognize that emphasizing textures often has the effect of reducing the viewer's awareness of three-dimensional mass and space.

Differing textures can intensify each other. Whether they be the textures of a medium itself, or of a material or decorative surface pattern, such as tree leaves or shirt stripes, textures, by opposing and enhancing each other, produce visual contrasts that can play important organizational roles. By activating passages of a drawing, textures contrast with simpler, "emptier" passages producing various groupings of such

Figure 4.9

Figure 4.10

"busy" and simple areas. Note how textural differences and similarities produce associations and contrasts in Figure 4.10.

Volume and Space

Volumes and their interspaces are also visual elements, and their arrangement in the spatial field they occupy is an important compositional consideration. Volumes relate or contrast to each other by their scale, value, direction, location, and *weight*. In drawing, all volumes suggest two kinds of weight: *physical weight*, the sense of gravitational pull on a solid mass; and *visual weight*, the sense of forces acting within and upon a mass that have the effect of calling attention to it, and that can stabilize, relate, or

contrast it to other masses, planes, or interspaces in the pictorial field.

Unlike physical weight, which pulls masses downward, visual weight can pull them in any direction, as in Figure 4.11, where the rush of volumes is toward some collison point near the top of the page. As much as anything else, visual weight has to do with eye-appeal—with the importance of a volume within the drawing's compositional order. In this sense, visual weight, the importance of a (usually) moving energy in the composition, is a major factor in our response to *any* element.

In composing a drawing's volumes into some pattern of organization, we should recognize that they need to be arranged within the three-dimensional "stage" of the drawing's spa-

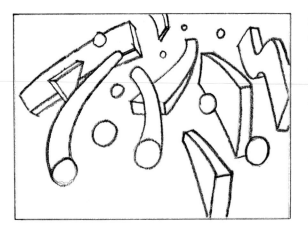

Figure 4.11

tial "cavity" as well as on the picture-plane, as in Figure 4.12. Note how, in Figure 4.12, the artist's structural hatchings in the forms of the two figures create relationships among the planes, values, directions, textures, and volumes.

COMPOSITIONAL STRUCTURE

Having examined the general nature of the visual elements that form our images, we may have a better appreciation of the fact that marks *as marks*, along with the shapes, volumes, and textures they form, have two "lives" in every drawing: They exist both as a depiction (whether figural, abstract, or non-objective) and as a system of visual expression. They are both the *what* and the *how* of every drawing. It is by the mutual reinforcement of these two simultaneous functions of marks that our drawings come alive.

All good drawings show some balanced, unified, and expressive resolution among the elements—some cohesive and harmonious solidarity of design and purpose. To bring this about, the artist must be sensitive to the relational play and the visual energies generated between the elements, for every line and tone we draw contains visual energy of some kind and relates with other lines and tones in some way, as we shall see.

In drawing, the term *balance* describes a visual state in which the arrangement and behavior of the elements achieve a state of equilibrium. Balance is a state in which every di-

rectional thrust is countered, every weight is counterweighed, and every line, value, shape, texture, and mass engaged with a number of other elements in various kinds of interdependent activity. A well-balanced drawing reveals a self-governing cycle of visual activity. For this to occur, all of a drawing's elements must show, through their interacting bonds of association and interdependence, a strong, overall union or belonging, a sense of oneness, or **unity**.

However, these states of balance and unity must emerge from the stimulating action of contrasts as well as from the union of similarities, otherwise, as noted earlier, the results will be dull. In drawings where balance and unity are achieved despite daring contrasts and subtle similarities, actions may skirt imbalance and disunity only to arrive at a sense of order and oneness that is all the more satisfying for the inventive risks taken. For example, the sharp pen-and-ink rendering of the child's legs in Figure 4.12 seems like a risky departure from the drawing's otherwise "softer" treatment, but by their shape, direction, and scale the legs rejoin the ordering of the whole. In well-composed works, we sense that their internal order is *necessary*, and that any change will destroy their organizational resolution.

Additionally, in all good drawings the relationships are arranged in a hierarchy of visual importance. That is, the artist emphasizes one or two kinds of relational activity, relying on them to carry the main responsibility for forming the drawing's order and expression. Other visual relationships will then serve lesser but still important roles, such as lending variety to the image or creating certain depictive and dynamic effects not otherwise possible. For example, in Figure 4.12, the "starburst" of limbs and surrounding forms and tones, as well as a large, page-enveloping cross comprised of the figures, the bench, and the pillar, are two major visual themes: The periodic eruption of hatchings and gentle washes of tone are minor ones.

Whether such visual themes are based mainly on line, shape, value, and so on, or on some intermixing of the elements to produce other kinds of themes, these themes are what give a work its main dynamic character. Thus it is by the behavior of the visual elements *and* the visual themes they give rise to that a drawing's expressive purpose and its balance and unity are achieved. Without these qualities of balance and unity, a work's intended expres-

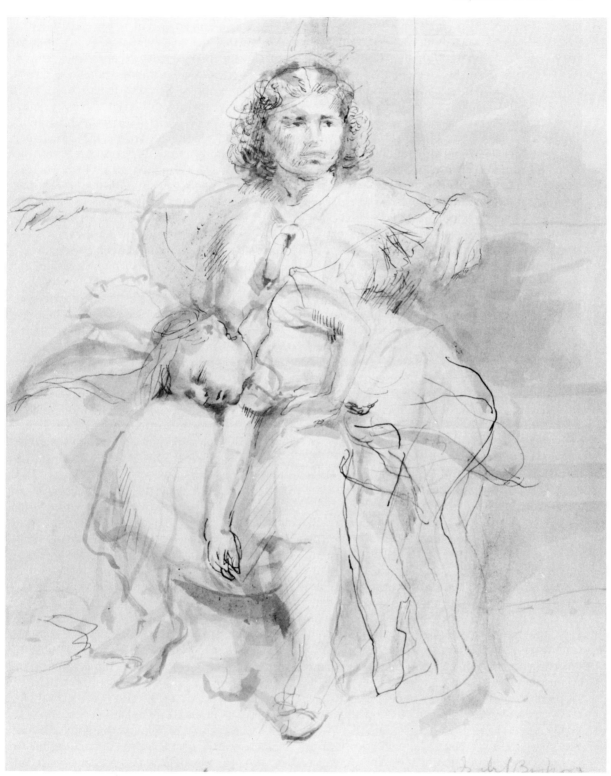

Figure 4.12
ISABEL BISHOP (1902–)
Waiting (1935)
Ink. 7⅛ × 6 in.
*Collection of the Whitney Museum of American Art, New
York, purchase
Photo: Geoffrey Clements*

sion is lost; for in art, imbalance and disunity always destroy both dynamic and depictive meanings.

To understand better how the visual relationships and themes at work in our drawings may achieve a balanced and unified state, we must first examine briefly some general categories of visual relationships. All such groupings are really more convenient than defensible, because any attempt at classifying visual relationships invariably fails to account for some phenomena too ineffable or illusive to be articulated. However, although some actions, associations, and energies elude any system of grouping, discussing those that *can* be described may help us apprehend those that cannot. As we examine the several kinds of relational play among the elements, remember that the term "element" refers to anything from a line or smudge of tone to a recognizable volume, such as a tree or a person.

All elements participate in several relationships at the same time. A single line may be engaged simultaneously with several other lines or elements in visual connections that will carry its kinship with them far across the pictorial field. In fact, the relational possibilities based on similarity or contrast between the elements are limitless. In the best drawings, their dynamic activities are capable of endless interactions.

Most visual relationships generate energies that suggest movement, or a striving for movement. A sensitivity to implications of movement, or to any kind of motion, weight, or change, is not only at the heart of what guides the artist toward compositional balance and unity, it is a matter of vital concern to each of us as we function on a daily basis. We instinctively react to real or imminent motion or change because such activity may spell either danger or opportunity. So deeply engrained is this response that even the illusion of motion or change holds our attention. In artists, this sensitivity is highly developed. Their functional "survival" eye, merging with their relational eye, makes such intense responses possible. What they actually see is influenced by what their relational eye tells them the object is "doing." We react to implications of motion at work in our subject (and in our emerging drawing) with interests that have deep roots in our psyche.

Some kinds of visual energy can be sensed even within a single element. For example, according to their *handling*, that is, the vigorous or deliberate manner in which they are drawn, some lines move quickly, as do the hatched lines in Figure 4.12. Other lines seem to move at a slower pace, as do the lines in the drawing of the child's legs. The same is true for shapes. The oval, for example, suggests a leisurely motion, but a wedge races after its own point. A gradual change in value implies a faster movement than does one that occurs by abrupt differences of tone, and a tall or curved volume moves more energetically than a squat one. Textures suggest motion too, as can be seen by the animated character of the woman's hair in Figure 4.12.

Many visual energies are generated between like elements. Consciously or not, we tend to compare lines with other lines, shapes with other shapes, and so on. Such associations occur to us more readily than do relationships between unlike elements. This is especially true when a substantial number of like elements (for example, shapes), possess strong moving energies that intensify further when we see their collective behavior, as in Figure 4.13 where oblong and circular shapes generate an almost explosive visual energy.

As we have seen, still other visual energies are generated between unlike elements. A figure's leg, a calligraphic line, and a wash of tone might all relate if the artist were to emphasize their common S-shaped movement. In Figure 4.14, line, shape, tone, and mass relate to each other by either direction or scale. Again, in Figure 4.15 the figure's hair relates to the left hand's dark shadow on the basis of their common value.

That the energies generated in a drawing animate larger visual themes can be seen by comparing Figures 4.12, 4.13, and 4.14, in which a major common theme is a central vertical action countered by an arclike movement in the upper part of each work (Figure 4.16).

Some kinds of relational energy, such as visual weight, physical weight, or tension (to be discussed), suggest that movement is imminent or inevitable rather than occurring. Other kinds of visual energies depend upon their context for a sense of motion or striving for motion. But the dynamics of direction, rhythm, and handling most create a sense of movement.

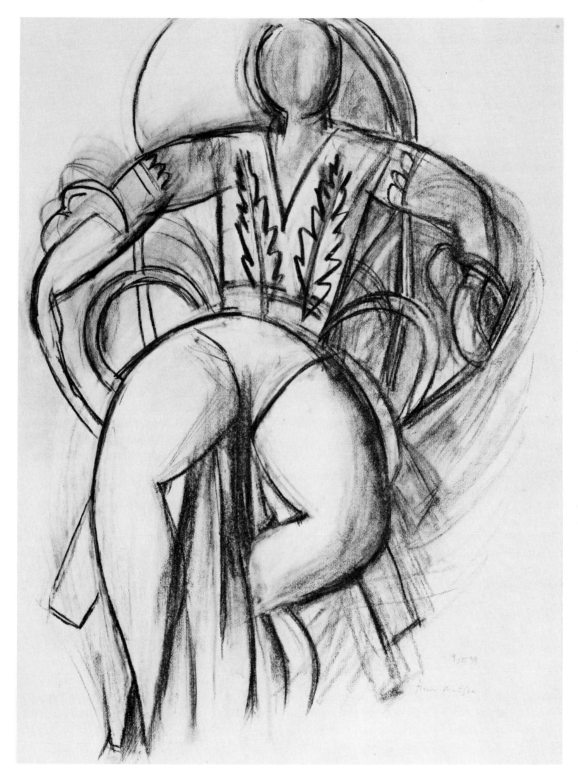

Figure 4.13
HENRI MATISSE (1869–1954)
Dancer Resting in an Armchair (1939)
Charcoal. 25 × 18⁹⁄₁₆ in.
National Gallery of Canada, Ottawa
©SPADEM

Figure 4.14
SIDNEY GOODMAN (1936–)
Model with Hands Touching Shoulders (1978)
Pencil. 24 × 29½ in.
Courtesy Terry Dintenfass Gallery
Photo: Eric Pollitzer

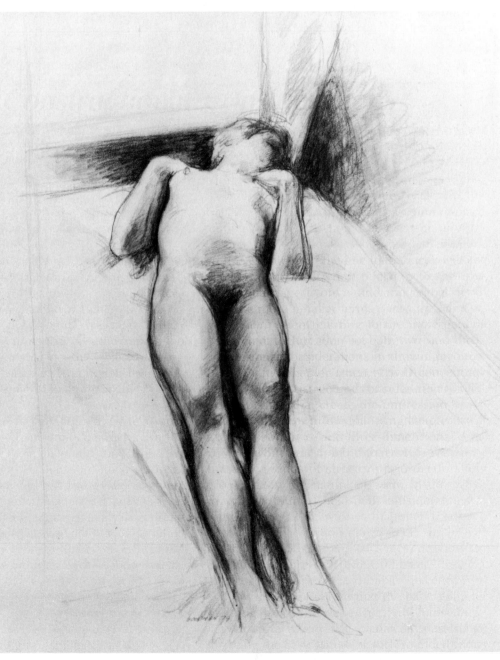

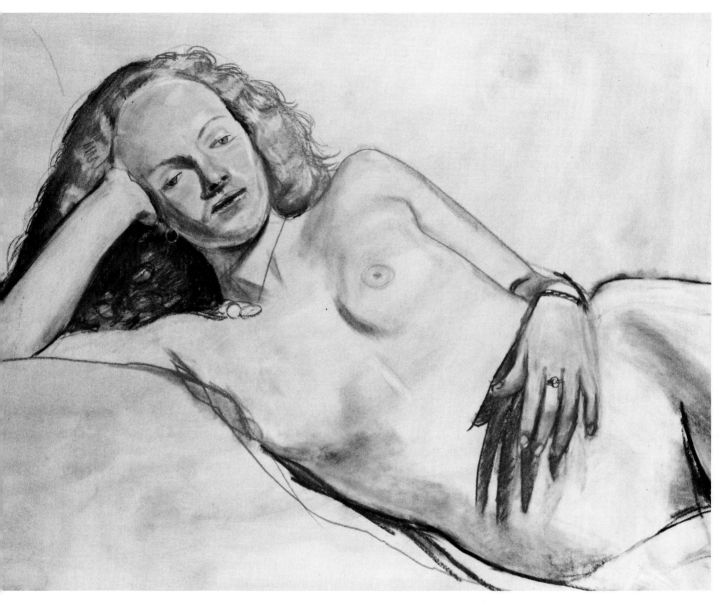

Figure 4.15
PAUL GEORGE (1923–)
Reclining Model (1979)
Conté crayon, chalk, and watercolor wash.
29 ½ × 41 in.
Collection of Jalane and Richard Davidson
Photo: Michael Tropea

Figure 4.16

Direction

We sense movement when one or more like or unlike elements moves on a straight or curved path toward an intended point on or beyond the picture plane, or moves forward or backward in a field of depth. Such actions often suggest visual or physical weight. Long lines (or a grouping of short ones as in hatchings), edges, shapes, and volumes, especially when their courses follow straight or simply curved paths, make for stronger movement. Only shapes or volumes of a circular or squarish nature or those whose form does not contain a dominant long axis are free of directed energy (except as they join together with other elements in a directed action of some kind).

When changes in value or texture agree with the direction of a shape or volume, the speed of those elements is increased. For example, in Figure 4.14 the upward movement of the figure gains force by the gradual change of the figure's overall tone from dark to light. Textures, values, and interspaces also have directional motion. Blurred elements move faster than sharply focused ones, and the movement of any element can be slowed or checked altogether by other elements that overlap or intersect it.

Rhythm

A certain directional movement in the grouping or density of the elements, a recurrent texture or degree of tonal change, or a discernible pattern or treatment among like elements all produce rhythm. Rhythm is most easily observed in the repetition of similarly directed movements among lines, shapes, or volumes. It can be sensed among unlike elements when their sameness in direction, configuration, or handling is strong enough to overcome their contrasting identities and functions. For example, in Figure 4.13 the two interspaces formed by the figure's arms, torso, and legs restate in miniature the action of the entire configuration, a central vertical crossed by a strong arc. Forming a subtle variant on this visual theme, the two legs and their surrounding drapery join in with this rhythm, giving it more force. While generally directional, rhythms can suggest a sense of beat, as does the recurrence in Figure 4.12 of a nearly circular system of beats formed by the pattern of the figures' hands and feet.

Handling

The stylistic or idiosyncratic accents and cadences of lines, tones, and shapes are a powerful source of moving (and expressive) energy. The artist's ''handwriting''—the deliberate, playful, delicate, or furious treatment of the marks—can relate unlike elements, as in Figure 4.12 where linear washes of light tone and nervous pen lines serve to unite all parts of the drawing. Similar things can be made to contrast when the style is changed for purposes of variety, design, expression, or accent, as in the drawing of the child's legs in Figure 4.12.

Partly a matter of neuromuscular coordination and partly a matter of temperament and creative attitude, the artist's handling creates a kind of visual meter that sets up a certain speed among the elements and the resulting image. Handling is always influenced to some degree by the medium and the tools employed in drawing. These materials not only affect the nature of the marks made, but, because of their various traits and limits, they even influence the kinds of observations the artist makes. Had Matisse (in Figure 4.13) used pen, brush, and ink, and Bishop (in Figure 4.12) used charcoal, each drawing would have been different in more than surface texture. The various options and restrictions these two media offer would have influenced what each artist looked for and did.

Location

The relational energies of location are produced by the similarity of like or unlike elements according to their position on the picture plane or within a field of depth. Elements that are equally distant from the center of the page may be related by their symmetrical orientation to the center, as in Figures 4.12 and 4.13. The location of the figure in Figure 4.14 can be read in two ways: In the most evident reading, it occupies the center of the page in what is then a roughly symmetrical composition. In this mode, the vertical division of the page about one-third of the way into the drawing on our left, representing perhaps a wall's ending or a doorway, lends necessary weight to the left side of the page and thus keeps the drawing from seeming too heavily weighted on the right side. But if we regard the vertical to the left of the figure as marking off the leftward limit of the draw-

Figure 4.17

ing's picture plane, then the figure is located to the left of the drawing's center where its physical and visual weight counterbalances the physical and visual weight of the bed, providing a balanced image.

The location in the pictorial field of any element, especially a shape, value, or mass, affects our evaluation of its visual weight.* In general, the farther an element is located from the center of the drawing's boundaries, the heavier we perceive it to be, and the higher it is located in a drawing, the heavier we feel it to be. In Figure 4.17, the higher of the two shapes appears heavier because it is farther from the center and higher in the format than the more centrally located shape. Additionally, any element will appear heavier on the right than the left side of a drawing. To prove this for yourself, hold up to a mirror any drawings you feel to be especially well balanced. The images will each begin to sink toward the lower right corner of the drawing. This phenomenon can be seen clearly by viewing Figures 4.12 and 4.13 in a mirror. Perhaps a matter of our reading images such as words from left to right (although the phenomenon holds true in cultures where the language is read from right to left), perhaps a matter of right- or left-brain hemi-

*See Rudolf Arnheim, *Art and Visual Perception* (Berkeley and Los Angeles: University of California Press, 1974), pp. 10–41.

sphere functions, this uneven distribution of weight in the pictorial field has been shown by Gestalt psychologists to be a universal phenomenon. We should be mindful of this in organizing our drawings, to avoid their having too much weight on the right.

Density

Clusters of elements may relate to each other by their density if the surrounding elements differ markedly in scale, value, texture, or direction. When this occurs, subdivisions are formed by such densely located elements, which are then seen as islands of activity that relate with each other even when separated far across the pictorial field. For example, the darker tones, smaller shapes and masses, and textural activity of the head and the left hand in Figure 4.15 "call" to each other mainly on the basis of their common density as it is seen against the "emptier" character of the rest of the drawing.

Visual Weight

You have seen that all elements possess visual weight in the pictorial field. Thick lines and dark values weigh more than thin lines and light values, large shapes and interspaces weigh more than small ones, and pronounced textures have a weightier presence on the picture-plane than subtle ones. Although, as noted, visual weight can press in any direction, in most instances visual weight, like physical weight, is resolved by being balanced seesaw fashion on either side of an imaginary fulcrum in the drawing's center, as in Figures 4.18 and 4.19.

Directional energies are often, but not always, the driving force behind visual weight. When they are, their directed thrusts, whether issuing from a line or two, as in the S-shaped lines that define the bedding in Figure 4.15, or from a volume, such as the S-shaped form of the figure itself in the same drawing, amplify the force of a visual weight. In this work, the bedding's lines push upward, resisting the physical weight of most of the woman's upper body. Only her bent right arm, reinforced by the visual weight of the dark wedge of the hair, succeeds in moving downward toward the left. The rest of the figure glides downward toward the right, as much the result of visual as of physical weight.

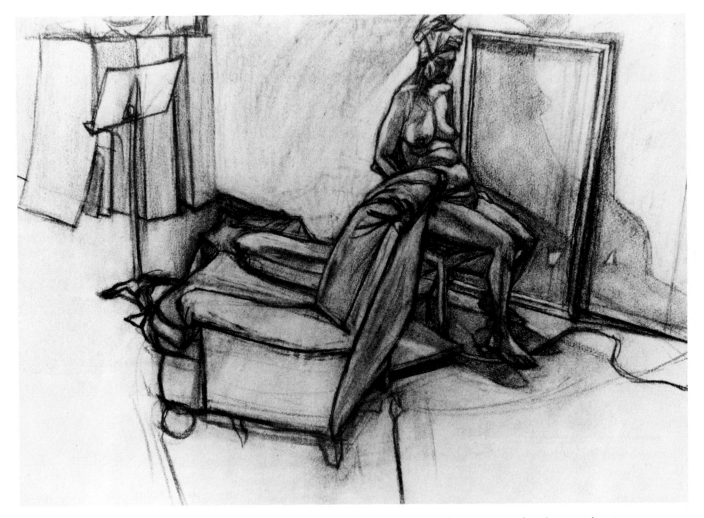

Figure 4.18 (*student drawing*) (above)
Vincent Hron, Drake University
Charcoal. 14 × 18 in.

Figure 4.19 (*right*)
EDWARD HOPPER (1882–1967)
Box Factory, Gloucester (1928)
Watercolor. 14 × 20 in.
*Collection, The Museum of Modern Art, New York, gift of
Abby Aldrich Rockefeller*

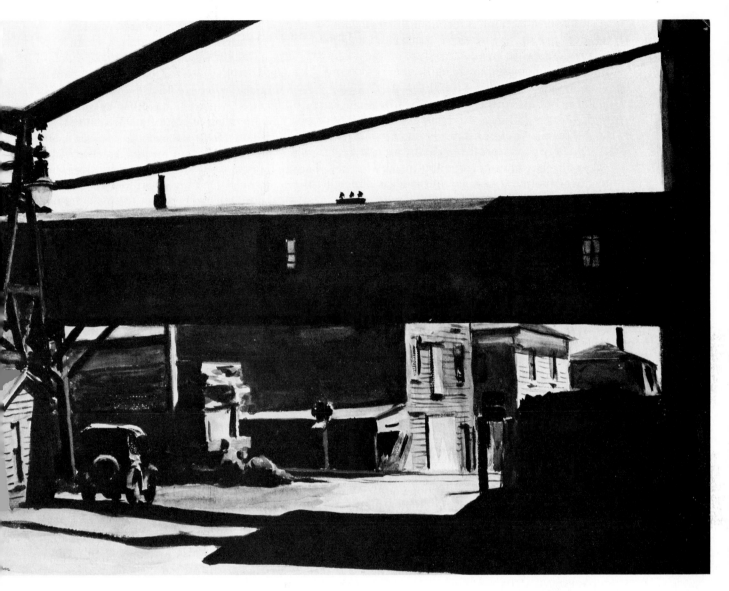

In sensing matters of visual weight, we are of course reacting to the relational play among those elements in a work engaged in such actions. The aforementioned dark wedge of the woman's hair has visual weight in part *because* it is in contrast to the tones of nearby shapes and volumes and in part *because* of its similarity to the wedge shape of the arm itself.

When visual weight results from relationships that have little or nothing to do with directional energy, it does so on the basis of eye-appeal in the drawing, as in the gray tone beneath the woman's hand in Figure 4.12, which affects the balance of forces by its contrast to the tones of nearby shapes and masses.

Tension

A frequent characteristic of other energies such as direction, location, handling, and of both visual and physical weight is tension. As used here, the term *tension* means the sense of elements striving to meet or repel each other or to alter their shape or location. When two or more elements or parts of the same element are so arranged as to almost touch, we feel their striving to complete the union. Likewise, when elements or even whole parts of a drawing are directed away from each other, we sense their "wish" to move even farther apart. Arrangements of elements that confront each other in roughly equal force produce the sense of a standoff between antagonistic energies. Thus, the two ends of an all-but-completed circle, if not too far apart, strive to complete the interrupted circular shape. Similarly, the five or six wedges of a star shape strive to pull away from their common base, each moving in the direction it points to, while their common base strives to hold them to itself. And lines formed into an H arrangement suggest that whether we see the two vertical bars as moving toward or away from each other, the horizontal bar prevents their doing either and creates a pulsating tension of forces pulling and pushing.

The elements participating in a tensional conflict of any kind suggest a shared charged field of energy between them; they seem aware of each other. It is as if such lines, textures, masses, or values do battle with each other for supremacy or for a better resolution of energies existing between them. Figure 4.20 illustrates a few tensional situations. In drawing 1, an aggressively active shape threatens a passive one. Their closeness creates a kind of tension called *closure*, a state in which two elements, while not actually touching, are so close that they read as touching or *needing* to touch. Seeing such an arrangement, we wish for more space or less but find this degree of closeness too unsettled and unresolved. In drawing 2, the black and white shapes are more evenly matched. Here again, though, we wish for a more decisive stance between them. Do they mean to touch, or not? Also, the interspace between them clamors for attention as a shape, but still hasn't entirely formed itself—another unresolved situation. By its contrast to the tone of the page, the black shape appears strong enough to "take on" the larger, white shape, but again we wonder which is the stronger.

Tensions, then, beg for some clarification of the situation between the particpants. Sensitive viewers, responding to tension-filled interactions, search for some greater resolution. For example, in Figure 4.13, the large shape comprised of the figure's legs and lower body "intrudes" on the space of the rest of the figure and of the chair. "Counter-attacking," these shapes create a tensional confrontation. But the image unites and the tension is resolved when the viewer finds a basis for union greater than those for conflict. In this case, the lower shape joins the upper one in a radiating pattern on the page, and by its strong union with the shapes of the figure's upper body it pulls ahead into a plane that enables us to see that the chair is behind the figure and not on a collision course with it.

Artists use such tensions to animate their imagery, but however daring such confrontations are, they must find some eventual union and balance. In Figure 4.20, the seven units that comprise drawing 3 are arranged in a way that creates an unresolved tension—we can't believe they will "hold." The same seven units, in drawing 4, still show tensions among them, but we feel they are interdependent in a way that unites them. Figure 4.21 shows a similar kind of "balancing act." Note that you need a little time to experience the thrusts and counter-thrusts in order to find the drawing's overall balance and unity. Note, too, that in resolving this image for yourself you are responding to both visual and physical weight conditions in the drawing.

Figure 4.20

SUBJECTS

Figure Drawing

Through the ages the human figure has held a special fascination for humankind. Representations of human forms appear in later Paleolithic painting, and the increasing frequency of the figure in the art of the Neolithic era, and later in Oriental, Greek, and Roman art, bears testimony to the deepening universal importance of the figure as a powerful vehicle of expression. In the European Renaissance, the spirit of inquiry and the rediscovery of Greek and Roman sculpture, which served as both a source of inspiration and of study, as well as an increase of artistic activity, produced important advances in understanding the anatomical and expressive nature of the figure. In encompassing all the basic forms in nature, and as a universally understood symbol, the figure continues to provide both challenge and inspiration. The best figure drawings are metaphors for addressing and expanding human sensibilities, expressions of psychological and spiritual as well as strictly visual meanings.

But it is the very fact that people are the central concern of people that presents students with a problem over and above the figure's structural complexities: the relative difficulty of maintaining their objectivity before a subject that holds so many fascinating and provocative meanings for them. All the more reason, then, when drawing the figure to adhere to those first considerations discussed in Chapter Two. Then, too, each of us knows a lot about human form, and we tend to bring this fund of stored knowledge to the studio where it often intrudes on what we actually see before us. We sometimes call on such remembered notions, especially when drawing a complex, perhaps foreshortened view of the figure, "editing" what we see. But such stored concepts are too often only cliché solutions, which seriously weaken the ring of truth that more committed perceptual efforts will achieve. Seeing the figure's gesture, its directions of axis and edge, its shapes and planes, and its tones and textures with a relational eye and by a discipline that addresses generalities before particulars is now of crucial importance, for our psychological responses to the figure clamor for attention, insisting on special con-

sideration for this very special subject. But the most eloquent consideration (and expression) we can give will come best through our most earnest inquiries and empathic responses to the actualities before us. What emerges from such encounters depends on what it is we *really* see and what it is we *really* want to do about it.

Toward this end, students must, of course, make countless drawings from the live model. Ideally, drawing sessions should be of three or four hours duration, two or three times a week. Typically, such a drawing session would begin with a forty-five-minute warm-up period of quick sketches, ranging in time from thirty seconds to five minutes. Such brief poses encourage a search for gesture and for a personal "shorthand" that will enable students to state important visual generalities quickly (Figures 5.1 and 5.2). In trying to "say it all" in a few minutes, we come in time to learn what to sort out from the "raw data" before us, concentrating on the essential characteristics of each pose.

Subsequent drawings might range from twenty-five minute poses to those lasting an hour or more and might be studies of the entire figure, a segment of the figure, or the figure in an environment (Figures 5.3, 5.4, and 5.5). In the beginning it is important to concentrate more on line drawings, especially those of an analytical kind (see Chapter Three). Early drawing sessions should emphasize a sound beginning for each drawing; we cannot finish any drawing until we know how to begin. In recent years, I have often asked the model to take poses ranging in length from five to twenty minutes without informing the class (or me) what their time sequence will be. Poses of unknown duration force the student to analyze and draw in a more assertive way.

The nude figure has been the preferred subject in drawing classes of European and American art schools, not only for universal humanistic reasons, but also for its versatility in offering ever-new volume and space arrangements; its subtle, sometimes complex but always engaging form characteristics; and for its easy integration with those other general categories of subject matter: landscapes, interiors, and still lifes. Later on, we will examine some of the visual themes that figure drawing may profitably be used to express (see "*Themes,*" later in this chapter), but here let us explore some of the various types of figure drawing.

Figure 5.1 (*student drawing*)
Louis B. Romero, Colorado University, Boulder
Compressed charcoal. 24 × 18 in.

Figure 5.2
ALBERT MARQUET
Dancing Couple
Brush and ink. 4¼ × 5 in.
Museum of Fine Arts, Bordeaux
Photo: Alain Danvers

Figure 5.3 (*student drawing*)
Harriet Fishman, The Art Institute of Boston
Vine and compressed charcoal, 24 × 18 in.

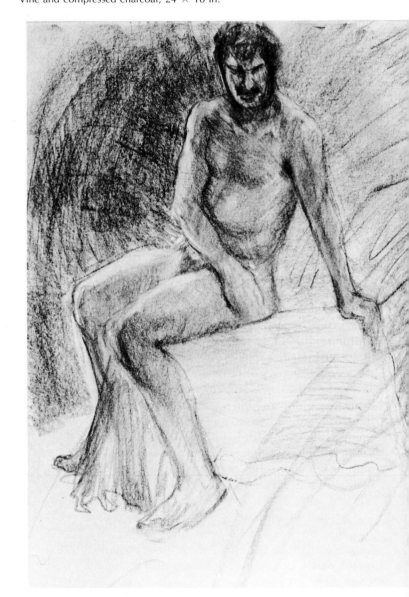

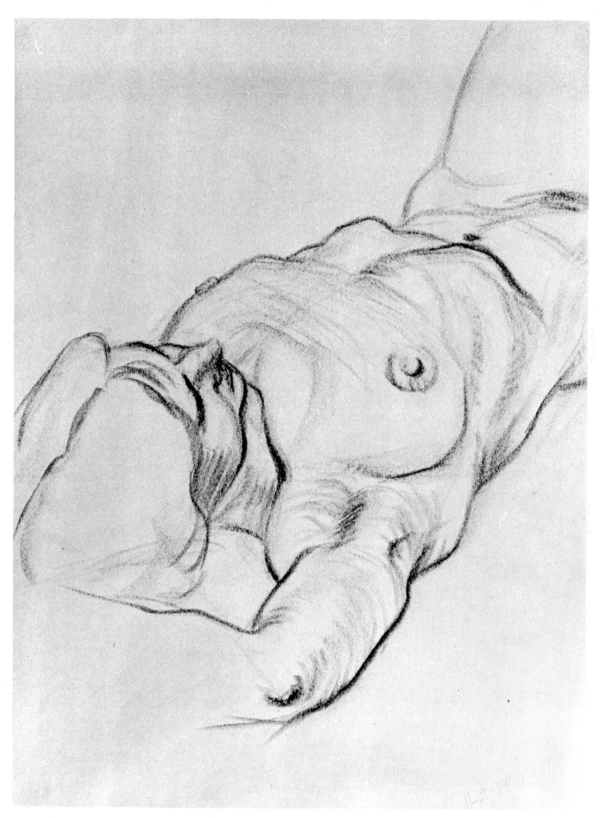

Figure 5.4 (*student drawing*)
Miguel Collazo, The Art Institute of Boston
Conté crayon. 24 × 18 in.

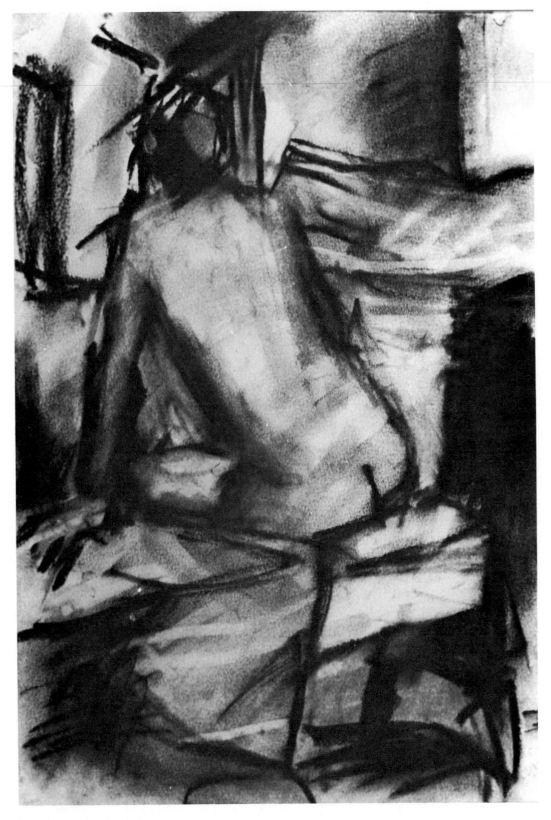

Figure 5.5 (*student drawing*)
Robert Phillip, University of Wisconsin, Oshkosh
Charcoal. 15 × 10 ⅜ in.

Figure 5.6

of masses and to the subtleties of relational seeing is more fully developed. Too often, early attempts show an overbearing concentration on the features with little regard for the "features" separating them—that is, the chin, cheeks, forehead, etc.—or for the volumetric nature of the head itself. Drawings of the human head should aim at understanding its major and secondary planes and masses and at a familiarity with certain common denominators that will usefully guide our judgments in subsequent portrait drawings. For example, the ear, despite its many variations in shape and structure, always conforms to a general arrangement of parts, as shown in Figure 5.6. One has to make numerous drawings of heads in order to know the basic nature of the features and of the terrain of the human head. It is this knowledge that enables the artist to make portrait drawings of an incisive and authoritative kind (Figures 5.7 and 5.8). Naturally, a useful source of information in developing an understanding of these forms is the study of human anatomy.

The Portrait. Although the idea of drawing a recognizable likeness holds an understandable fascination for beginners, portraiture, which demands the ability to make fine-tuned objective judgments of scale, location, contour, texture, and value, is best left for later consideration, when the artist's sensitivity to the planar nature

Figure 5.7
ANTOINE WATTEAU (1684–1721)
Studies of Women's Heads and a Man's Head
Black and red chalk, heightened with white, on buff paper. 9¾ × 14¹⁵⁄₁₆ in.
The Louvre, Paris

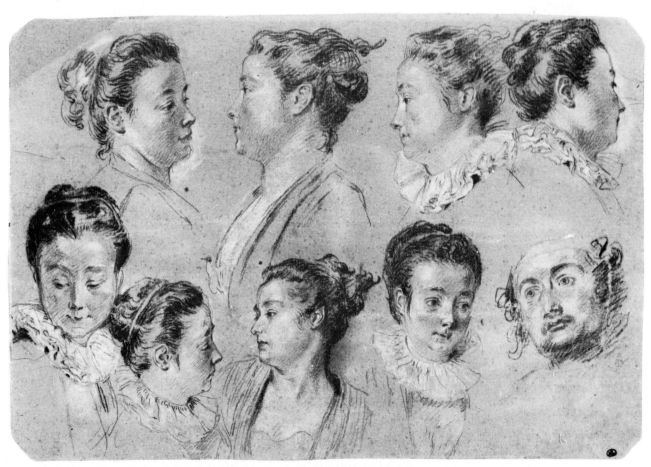

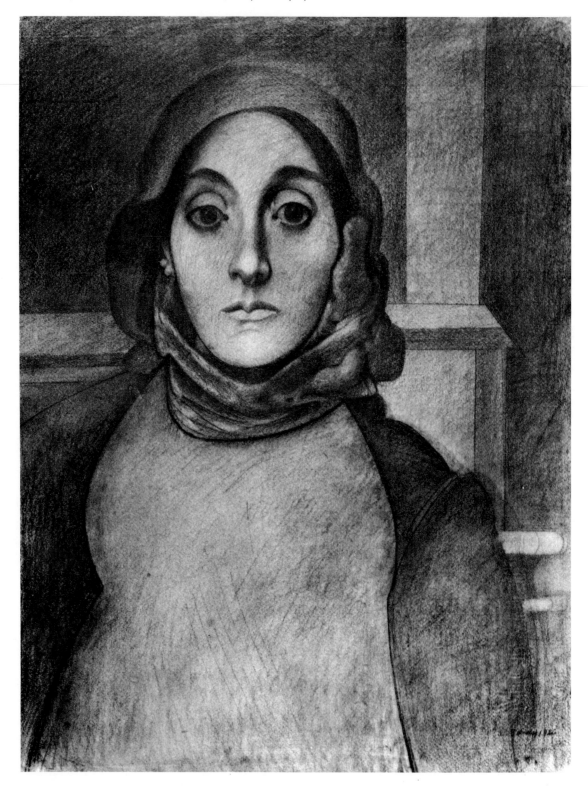

Figure 5.8
ARSHILE GORKY (1904–1948)
The Artist's Mother (1930)
Crayon. 24 × 18½ in.
Courtesy of the Art Institute of Chicago, Worcester Sketch
Fund income

Anatomical Drawings. A knowledge of anatomy is liberating, not restricting. Getting to know something of the figure's underlying masses is essential to attaining qualities of authority and economy that we associate with the best figure drawings (Figures 5.9 and 5.10).

While a course in artistic anatomy is a practical step, you may do almost as well by pursuing an ongoing study of anatomical texts and, where access to skeletons and anatomical casts is possible, by making drawings from them.

Life-sized replicas of the skull are available in some museums of science and in many model-kit shops, as are fairly accurate 18-inch-long plastic skeletons, which can be placed in a variety of poses, enabling the user to draw fore-shortened views of the skeletal parts seldom shown in anatomy books. When neither actual nor manufactured skulls or skeletons are available long enough for the necessary study and drawing, locating and taking photographs of them is a useful way to continue studying on

Figure 5.9
SIGMUND ABELES (1934–)
Reclining Figure
Compressed charcoal. 18 × 24 in.
Courtesy of the artist

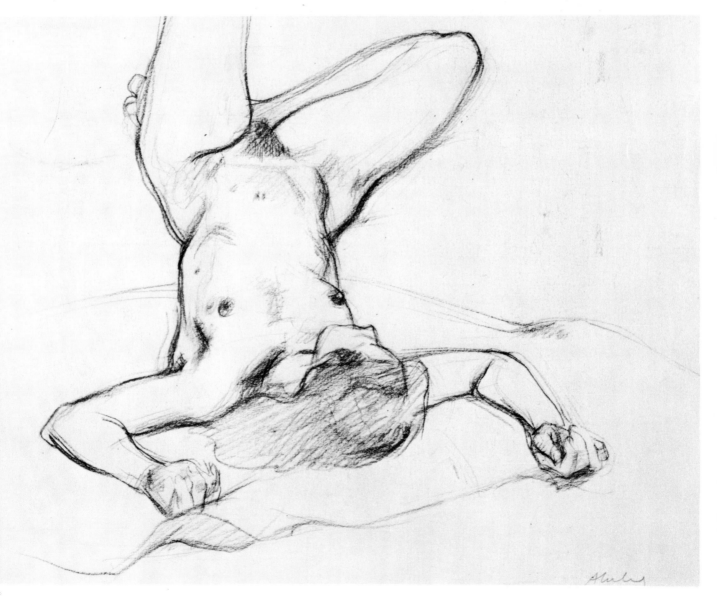

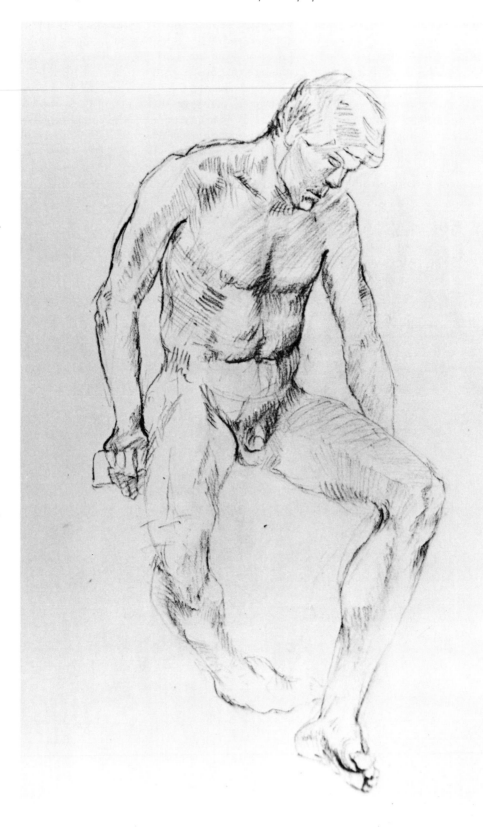

Figure 5.10 (*student drawing*)
Harriet Fishman, The Art Institute of Boston
Compressed charcoal. 24 × 18 in.

your own (Figures 5.11 and 5.12). Study of the figure's musculature, even when anatomical casts are available, should concentrate on anatomical plates, preferably from several good anatomy texts (see the bibliography), because the nature of the bony masses and the interlacing muscle forms is usually shown with great clarity, as in Figures 5.13 trough 5.25.

Figure 5.11

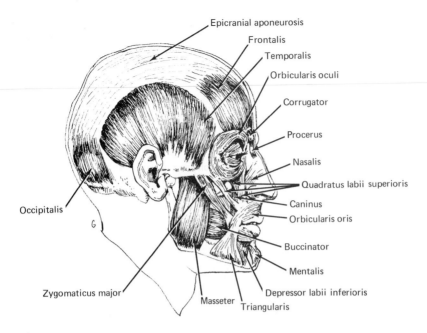

Epicranial aponeurosis

Frontalis

Temporalis

Orbicularis oculi

Corrugator

Procerus

Nasalis

Quadratus labii superioris

Caninus

Orbicularis oris

Buccinator

Mentalis

Occipitalis

Depressor labii inferioris

Zygomaticus major

Masseter

Triangularis

Figure 5.15

Figure 5.16

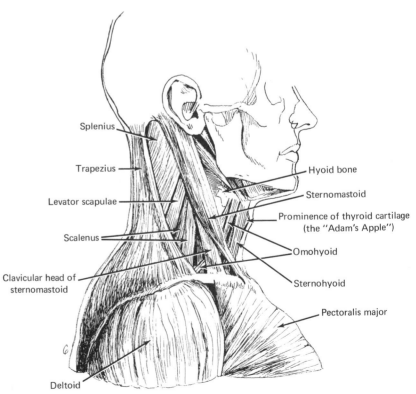

Splenius

Trapezius

Levator scapulae

Scalenus

Clavicular head of sternomastoid

Hyoid bone

Sternomastoid

Prominence of thyroid cartilage (the "Adam's Apple")

Omohyoid

Sternohyoid

Pectoralis major

Deltoid

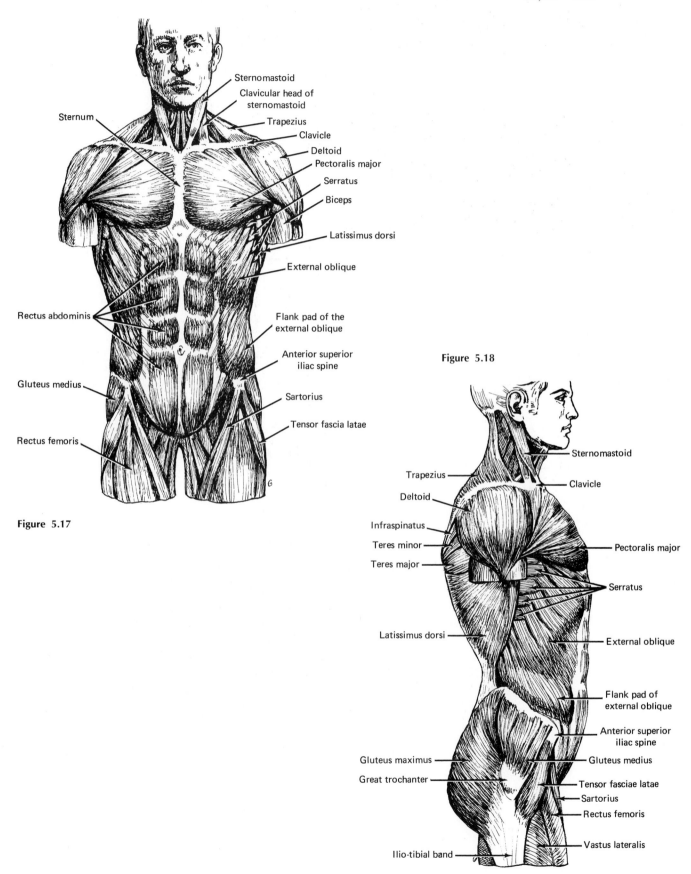

Sternomastoid

Clavicular head of
sternomastoid

Sternum

Trapezius

Clavicle

Deltoid

Pectoralis major

Serratus

Biceps

Latissimus dorsi

External oblique

Rectus abdominis

Flank pad of the
external oblique

Anterior superior
iliac spine

Gluteus medius

Sartorius

Tensor fascia latae

Rectus femoris

Figure 5.17

Figure 5.18

Sternomastoid

Trapezius

Clavicle

Deltoid

Infraspinatus

Teres minor

Teres major

Pectoralis major

Serratus

Latissimus dorsi

External oblique

Flank pad of
external oblique

Anterior superior
iliac spine

Gluteus maximus

Gluteus medius

Great trochanter

Tensor fasciae latae

Sartorius

Rectus femoris

Vastus lateralis

Ilio-tibial band

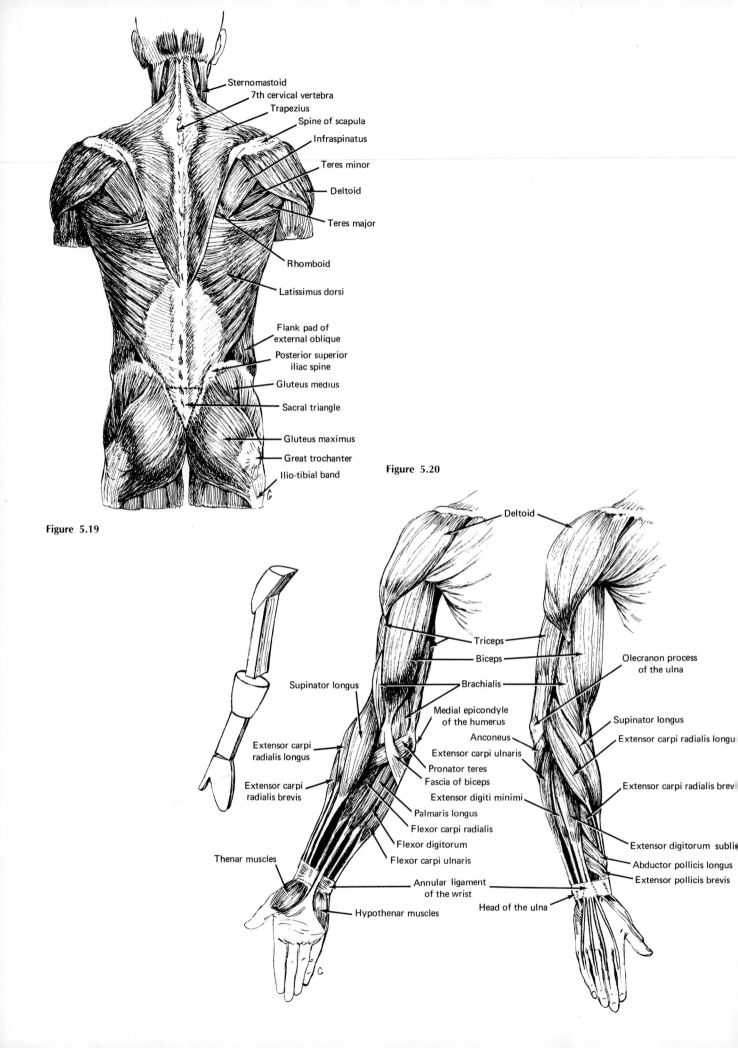

Sternomastoid
7th cervical vertebra
Trapezius
Spine of scapula
Infraspinatus
Teres minor
Deltoid
Teres major
Rhomboid
Latissimus dorsi
Flank pad of external oblique
Posterior superior iliac spine
Gluteus medius
Sacral triangle
Gluteus maximus
Great trochanter
Ilio-tibial band

Figure 5.19

Figure 5.20

Deltoid

Triceps
Biceps
Brachialis

Olecranon process of the ulna

Supinator longus

Medial epicondyle of the humerus
Anconeus
Extensor carpi ulnaris
Pronator teres
Fascia of biceps
Extensor digiti minimi
Palmaris longus
Flexor carpi radialis
Flexor digitorum
Flexor carpi ulnaris

Supinator longus
Extensor carpi radialis longu
Extensor carpi radialis brev

Extensor carpi radialis longus
Extensor carpi radialis brevis

Thenar muscles

Extensor digitorum subli
Abductor pollicis longus
Extensor pollicis brevis

Annular ligament of the wrist
Head of the ulna
Hypothenar muscles

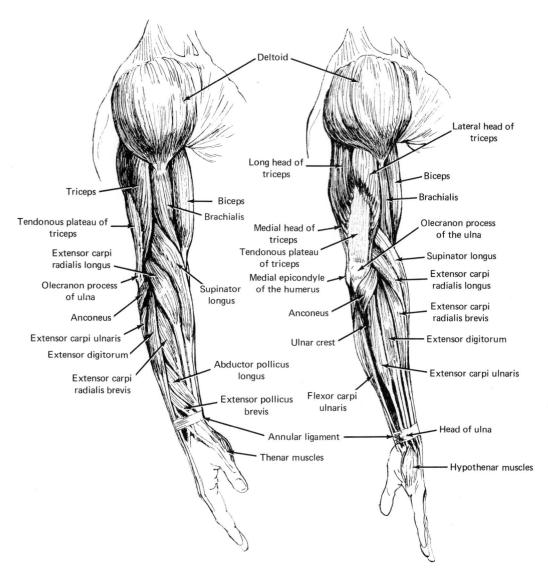

Deltoid

Long head of
triceps

Lateral head of
triceps

Biceps

Brachialis

Triceps

Biceps

Brachialis

Tendonous plateau of
triceps

Extensor carpi
radialis longus

Olecranon process
of ulna

Anconeus

Extensor carpi ulnaris

Extensor digitorum

Extensor carpi
radialis brevis

Supinator
longus

Medial head of
triceps

Tendonous plateau
of triceps

Medial epicondyle
of the humerus

Anconeus

Ulnar crest

Olecranon process
of the ulna

Supinator longus

Extensor carpi
radialis longus

Extensor carpi
radialis brevis

Extensor digitorum

Extensor carpi ulnaris

Abductor pollicus
longus

Extensor pollicus
brevis

Annular ligament

Thenar muscles

Flexor carpi
ulnaris

Head of ulna

Hypothenar muscles

Figure 5.21

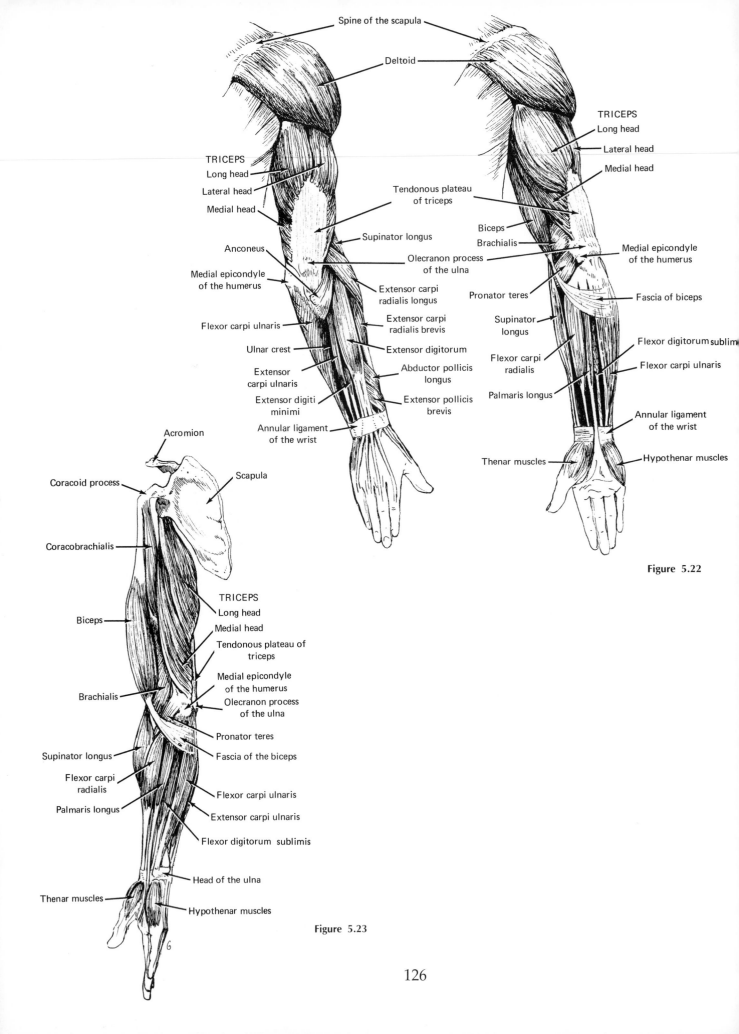

Spine of the scapula

Deltoid

TRICEPS
Long head
Lateral head
Medial head

TRICEPS
Long head
Lateral head
Medial head

Tendonous plateau
of triceps

Supinator longus

Anconeus

Medial epicondyle
of the humerus

Olecranon process
of the ulna

Extensor carpi
radialis longus

Biceps

Brachialis

Medial epicondyle
of the humerus

Flexor carpi ulnaris

Ulnar crest

Extensor
carpi ulnaris

Extensor digiti
minimi

Annular ligament
of the wrist

Extensor carpi
radialis brevis

Extensor digitorum

Abductor pollicis
longus

Extensor pollicis
brevis

Pronator teres

Supinator
longus

Flexor carpi
radialis

Palmaris longus

Fascia of biceps

Flexor digitorum sublim

Flexor carpi ulnaris

Annular ligament
of the wrist

Thenar muscles

Hypothenar muscles

Figure 5.22

Acromion

Coracoid process

Scapula

Coracobrachialis

Biceps

TRICEPS
Long head
Medial head

Tendonous plateau of
triceps

Medial epicondyle
of the humerus

Olecranon process
of the ulna

Brachialis

Pronator teres

Supinator longus

Fascia of the biceps

Flexor carpi
radialis

Flexor carpi ulnaris

Palmaris longus

Extensor carpi ulnaris

Flexor digitorum sublimis

Head of the ulna

Thenar muscles

Hypothenar muscles

Figure 5.23

126

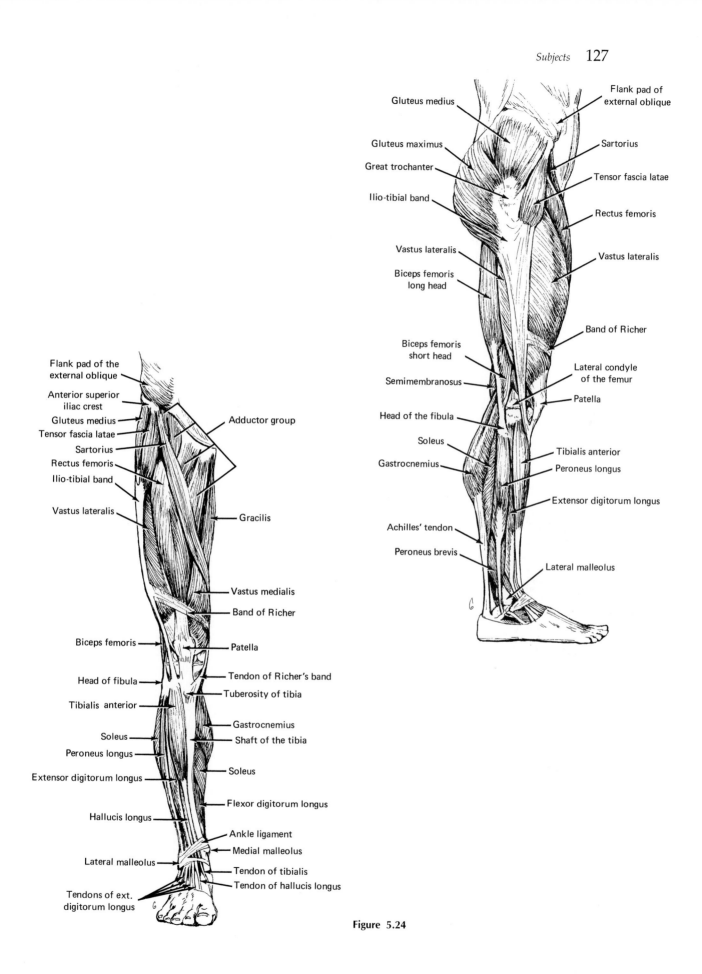

Flank pad of external oblique

Sartorius

Tensor fascia latae

Rectus femoris

Vastus lateralis

Gluteus medius

Gluteus maximus

Great trochanter

Ilio-tibial band

Vastus lateralis

Biceps femoris long head

Band of Richer

Biceps femoris short head

Semimembranosus

Lateral condyle of the femur

Patella

Head of the fibula

Soleus

Gastrocnemius

Tibialis anterior

Peroneus longus

Extensor digitorum longus

Achilles' tendon

Peroneus brevis

Lateral malleolus

Flank pad of the external oblique

Anterior superior iliac crest

Gluteus medius

Tensor fascia latae

Sartorius

Rectus femoris

Ilio-tibial band

Adductor group

Vastus lateralis

Gracilis

Vastus medialis

Band of Richer

Biceps femoris

Patella

Head of fibula

Tendon of Richer's band

Tibialis anterior

Tuberosity of tibia

Gastrocnemius

Soleus

Shaft of the tibia

Peroneus longus

Soleus

Extensor digitorum longus

Flexor digitorum longus

Hallucis longus

Ankle ligament

Medial malleolus

Lateral malleolus

Tendon of tibialis

Tendon of hallucis longus

Tendons of ext. digitorum longus

Figure 5.24

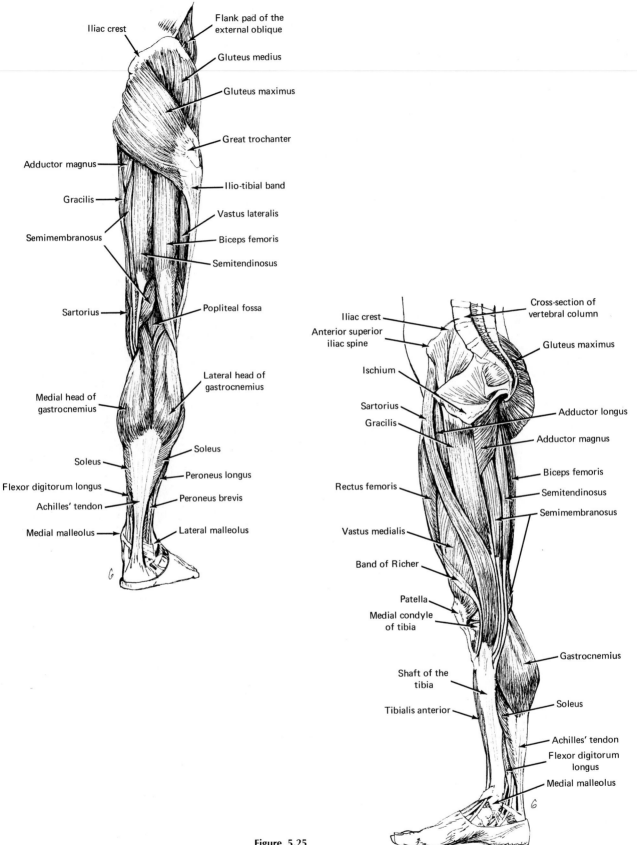

Iliac crest

Flank pad of the external oblique

Gluteus medius

Gluteus maximus

Great trochanter

Adductor magnus

Ilio-tibial band

Gracilis

Vastus lateralis

Semimembranosus

Biceps femoris

Semitendinosus

Sartorius

Popliteal fossa

Lateral head of gastrocnemius

Medial head of gastrocnemius

Soleus

Soleus

Peroneus longus

Flexor digitorum longus

Peroneus brevis

Achilles' tendon

Medial malleolus

Lateral malleolus

Iliac crest

Cross-section of vertebral column

Anterior superior iliac spine

Gluteus maximus

Ischium

Sartorius

Adductor longus

Gracilis

Adductor magnus

Rectus femoris

Biceps femoris

Semitendinosus

Semimembranosus

Vastus medialis

Band of Richer

Patella

Medial condyle of tibia

Gastrocnemius

Shaft of the tibia

Soleus

Tibialis anterior

Achilles' tendon

Flexor digitorum longus

Medial malleolus

Figure 5.25

The Figure Clothed. With a working knowledge of the figure's forms, drawing the clothed figure becomes a manageable matter. Although the nude figure is the mainstay of the figure drawing class, it is important to make many drawings of the clothed or "draped" figure. This is not only because you are likely in the years to come (whether you are in the fine or applied arts) to visualize the figure more often clothed than nude, but also because the draped figure offers a limitless range of dynamic possibilities. Clothing can amplify a figure's actions and reveal the volume of its forms, as in Figure 5.26;

depending on its styling and weight, it can create new shapes that both complement and contrast with the figure's forms, as in Figure 5.27; and it can serve as a link between the figure's forms and those of its surroundings, as in Figure 5.28.

Just as drawings of the nude figure will suggest something of the anatomical forms below the surface, drawings of the draped figure are more convincing when the artist continues to find suggestions of the figure's forms beneath the clothing. Failing to do so can result in "wooden" forms that do not show conclusively

Figure 5.26
EGON SCHIELE (1890–1918)
Portrait of the Artist's Wife, Edith (1918)
Black crayon on cream-colored wove paper. 8¹¹⁄₁₆ × 11¹³⁄₁₆ in.
The Ackland Art Museum, The University of North Carolina at Chapel Hill, Burton Emmett Collection

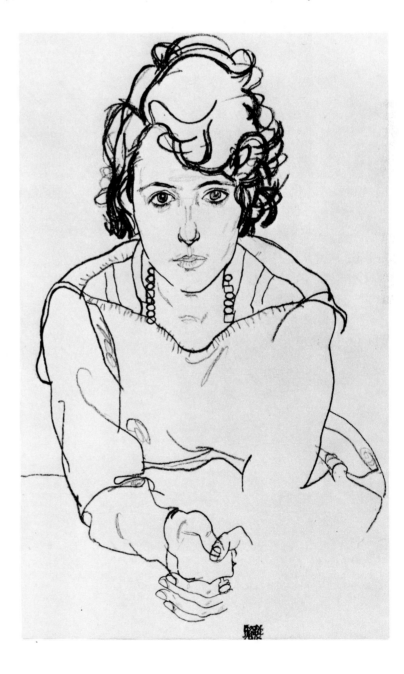

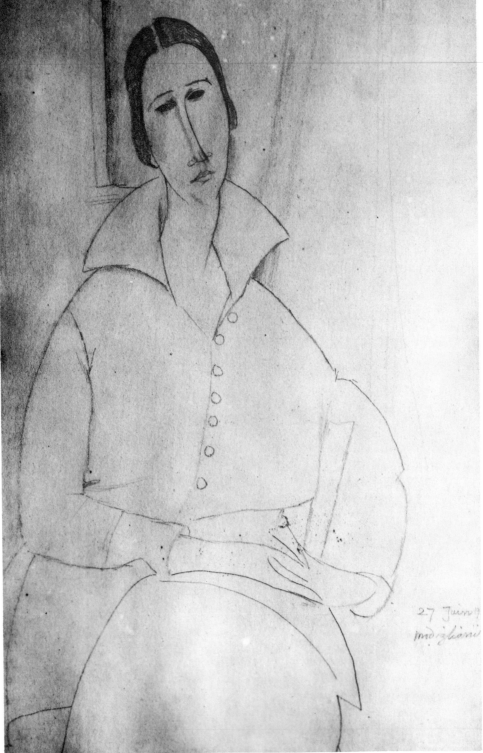

Figure 5.27
AMEDEO MODIGLIANI (1854–1920)
Portrait of Mme. Zborowska
Black crayon and pencil. 19 ⅜ × 12½ in.
Museum of Art, Rhode Island School of Design, Providence,
R.I., gift of Miss Edith Wetmore

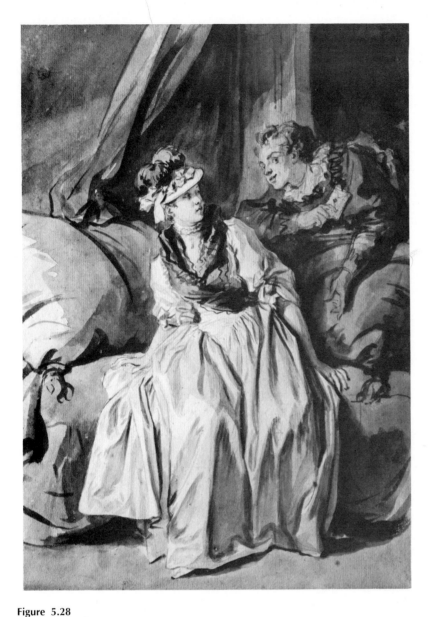

Figure 5.28
JEAN-HONORÉ FRAGONARD (1732–1806)
The Letter, or *Spanish Conversation* (1778)
Bistre wash over pencil. 15⁹⁄₁₆ × 11¼ in.
Courtesy of The Art Institute of Chicago, Tiffany Blake Fund

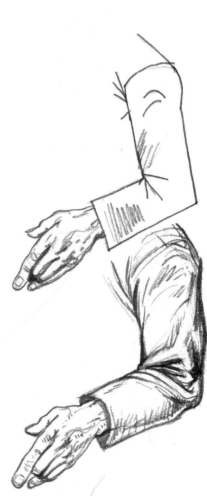

Figure 5.29

that the figure's forms continue beneath the covering material (Figure 5.29). It is, then, useful to think of clothing as a kind of loose, second skin; and of skin as a tight-fitting (for the most part) clothing. Thinking of clothing in this way can help avoid the tendency among many beginners to relax their perceptual involvement, their sensitive interest in relating and judging, when turning from the figure's forms to draw the clothing or the objects nearby. Whatever we draw should receive the same *quality* of inquiry

and caring. Some parts of a work may be more fully developed than other parts, but even the sketchiest passages should not be seen with a less caring eye.

In the best drawings of the clothed figure, the forms of both the figure and the clothing show a necessary interplay of moving actions and a "family resemblance" among their various shapes, tones, and masses. Despite their differences, we sense the greater forces that unite them (Figures 5.30 and 5.31).

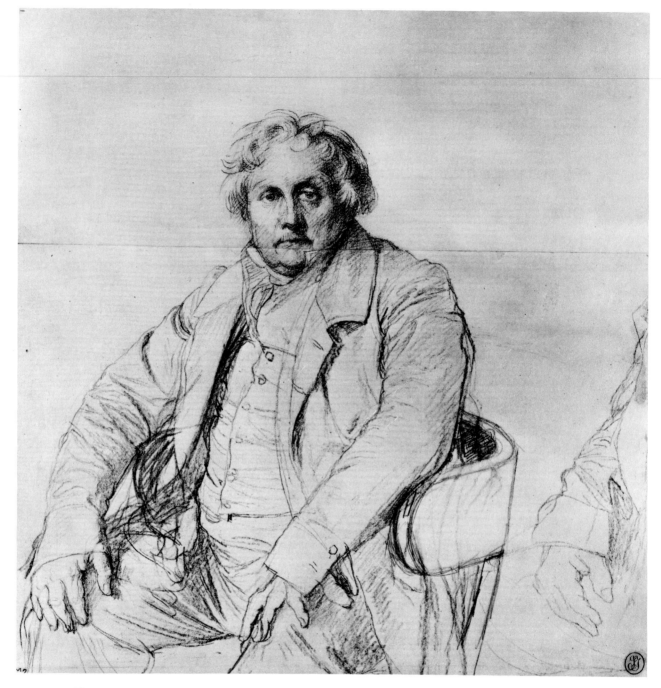

Figure 5.30
JEAN-AUGUSTE-DOMINIQUE INGRES (1780–1867)
Study for the portrait of Louis-François Bertin
Chalk and pencil on pieced paper. 13¾ × 13½ in.
The Metropolitan Museum of Art, New York, bequest of
Grace Rainey Rogers, 1943. All Rights Reserved.

Figure 5.31
HENRI MATISSE (1869–1954)
The Plumed Hat (1919)
Graphite pencil. 21¼ × 14⅜ in.
Collection, The Museum of Modern Art, New York, gift of the
Lauder Foundation, Inc.

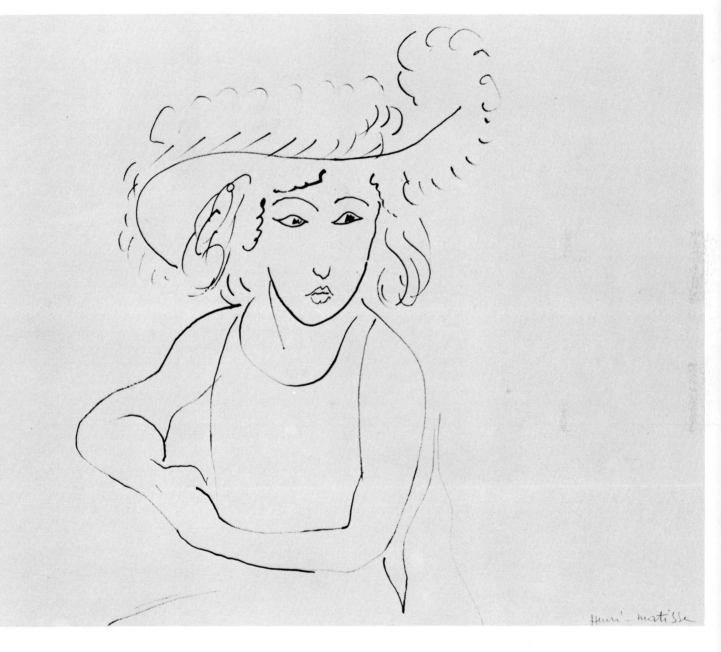

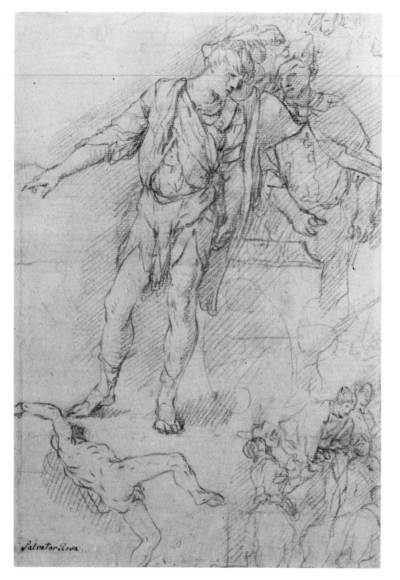

Figure 5.32
GIULIO CARPIONI (1613–1678)
Figure Studies
Red chalk. 9⅛ × 6½ in.
The Metropolitan Museum of Art, New York, Rogers Fund, 1970

Figure Groups. Although it is rare to use more than one nude model in a studio classroom, drawings of groups of nude figures can be created by having the model assume poses that offer an interesting combination of standing or seated figures. A more convincing sense of figures in a field of deep space is achieved by first drawing some of the figures large and then adding figures drawn in a smaller scale behind the larger ones. For groups of clothed figures, students can pose in clusters of three or four. Drawings of figure groupings can be developed from sketchbook notations made wherever people congregate: beaches, restaurants, parks, train stations, hotel lobbies, sports events, and the like (Figures 5.32 and 5.33).

One of the most attractive features of drawings that show two or more figures is the spirit and intensity of the movements coursing through them. Although one of the main goals in any of our drawings is to achieve balance and harmony, this challenge is especially exhilarating and demanding when the subject is people. The special importance that the human figure holds for us lends special meaning to the interplay of the elements and to the directional thrusts, rhythms, and tensions they generate. Bringing the separate, contrasting poses and parts into some greater synthesis gives such works metaphoric implications that the discerning viewer apprehends (Figure 5.34).

Figure and Environment. In drawing a figure placed within some setting, beginners too often limit their concentration to the figure alone, either showing it in isolation on the page or, when

Figure 5.33
ALEX MCKIBBEN (1940–
Two Reclining Figures
Black chalk. 24 × 18 in.
Courtesy of the artist

they do include some of the forms surrounding the figure, drawing them with less visual and empathic interest. Better drawings are more likely to result if less emphasis is given to extolling the figure's special status and more given to a sensitive experiencing of its environment. To do so is not to diminish the figure's singular importance; on the contrary, by integrating the figure and its surroundings to create a greater unity, we enlist the environment's differing character as a visual foil against which the figure's unique qualities and meanings have

Figure 5.34
REMBRANDT VAN RIJN (1606–1669)
Jacob's Dream
Pen and brown ink. 9¾ × 7⅞ in.
The Louvre, Paris
Courtesy Musées Nationaux, France

stronger expressive impact. Treating the figure in a distinct way risks isolating it from its environment, weakening the drawing's unity, and obscuring the very meanings that such special attention endeavors to express.

Drawings in which one or more figures constitute only a part of the design offer artists limitless compositional possibilities. Such works may in fact be mainly interior or landscape drawings, showing the figure to be a quite minor component (Figure 5.35). But even when the figure is dominant in the work, seeing individuals in the context of their surroundings expands for the artist both formal, dynamic opportunities, and depictive, expressive ones.

Even in the studio classroom, the model and/or students can be posed among tables, couches, plants, windows, and so on, to suggest various environments. Again, sketchbook drawings made in the presence of people in various settings, with perhaps some additional sketches of objects such as furniture or foliage, can be used as sources of information in making more extended studies of the figure in various settings. For students, making such drawings is an effective way of learning to see the similarities and differences that exist between the figure and its surroundings. The resulting insights are beneficial in two ways: They help students elevate the importance of inanimate

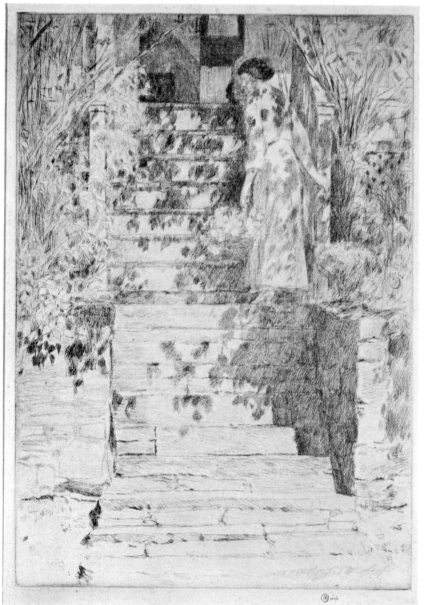

Figure 5.35
CHILDE HASSAM (1859–1935)
The Steps (*Old Holly House, Cos Cob*)
Etching. 16 × 12 in.
Courtesy Museum of Fine Arts, Boston, gift of Miss Kathleen Rothe

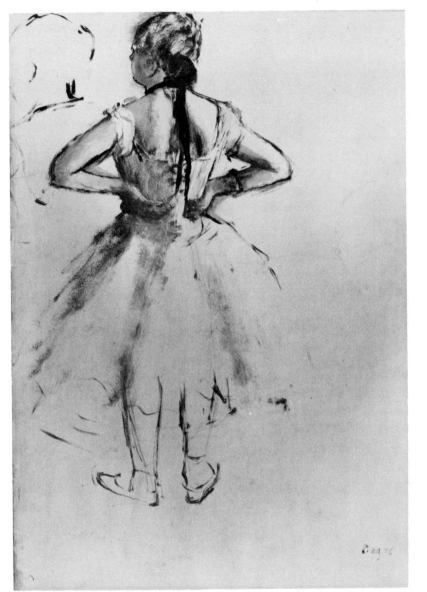

Figure 5.36
EDGAR DEGAS (1834–1917)
Back View of a Standing Ballerina
Oil on pink paper. 15⅛ × 10⅞ in.
The Louvre, Paris
Courtesy Musées Nationaux, France

objects and also keep them from an overbearing concentration on the figure in isolation.

Abstracting the Figure. Except for drawings executed in a strictly objective manner, all drawings are to some degree abstractions or extractions of what was observed in the subject. While we would not classify Degas or Schiele as abstractionists, their drawings show omissions, exaggerations, and other changes in the forms of the human figure (Figures 5.36 and 5.37). As the figure drawings of many twentieth-century artists show, there are countless ways of abstracting the human form. Some are only moderate adjustments on the figure's measurable

facts, as in the works of Degas and Schiele; others are highly subjective recreations that more insistently "process" human forms through a personally devised system of choice and change. Making various kinds of abstractions of the figure is instructive to students, even if they know their interests lie elsewhere. When you can do what you will with the forms of the figure, what you choose to omit and emphasize has important meaning; such changes from objective fact are likely to be in the direction of visual (and expressive) issues that hold special importance for you. Drawing in this way is an effective method of uncovering personal interests that deserve consideration. You may not wish to

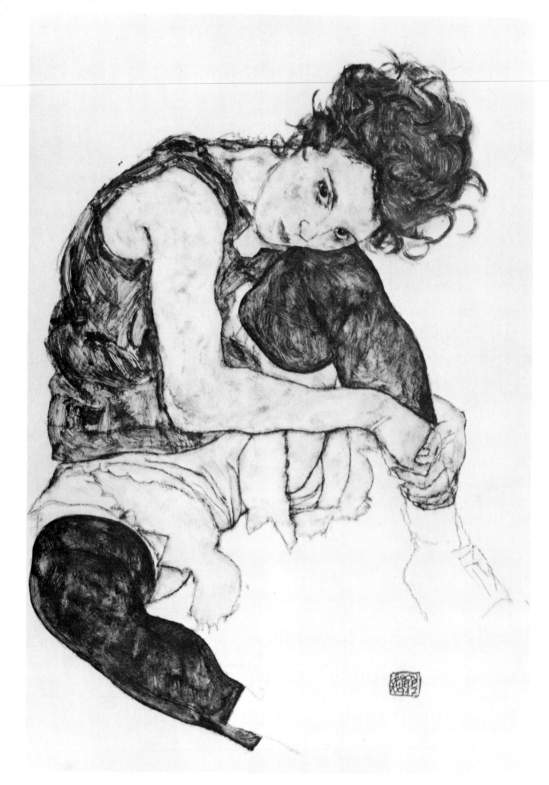

Figure 5.37
EGON SCHIELE (1890–1918)
Portrait of a Young Woman (1912)
Oil Sketch
National Gallery , Prague
Photo: Vladimir Fyman

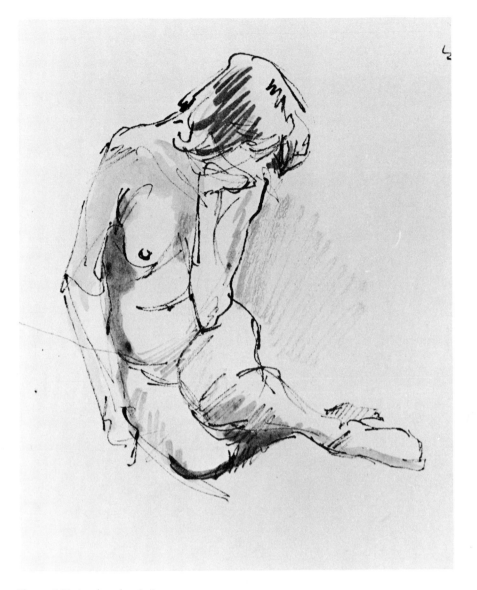

Figure 5.38 (*student drawing*)
Miguel Collazo, The Art Institute of Boston
Reed pen and brush, sepia ink. 10 × 8 in.

continue drawing in this or that abstract mode, but having "met" certain heretofore unknown interests in yourself, you may well wish to integrate them into whatever style of drawing most attracts you.

Try drawing the figure in ways that emphasize gestural, moving energies (Figure 5.38), structural considerations (Figure 5.39), or cubistic, expressionistic, and other modes developed by contemporary artists (Figures 5.40 and 5.41). Figure drawings in the surrealist mode provide opportunities for unusual juxtapositions and fusions of human and other forms,

and inventing such combinations, as in Figure 5.42, tests your ability to conceive and draw various masses and textures from your imagination. It is often the case among students at first reluctant to enter the realm of abstracted imagery that they experience a surge of inventive freedom that yields important gains in their ability to conceive more personally satisfying form and space events; to perceive more sensitively the nature of the marks that constitute their drawings, and the intensity of their expressive powers. Such insights, applied to any mode of drawing, will enhance results.

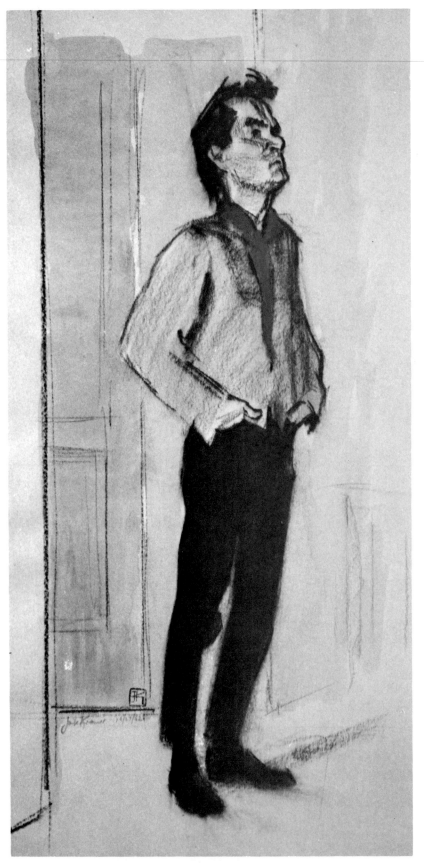

Figure 5.39
JACK KRAMER (1923–1983)
Standing Man with Orange Scarf (1962)
Black and red conte crayon with watercolor wash.
Estate of Jack Kramer

Figure 5.40
HENRI MATISSE (1869–1954)
Study for La Danse (1909)
Charcoal. 18¾ × 25⅜ in.
Courtesy of Musée de Grenoble

Figure 5.41
RAYMOND DUCHAMP-VILLON (1876–1918)
Seated Woman (1914)
Charcoal. 17¹¹⁄₁₆ × 10 in.
*Museum of Art, Rhode Island School of Design, Providence,
R.I., Mary B. Jackson Fund*

Figure 5.42
ODILON REDON (1840–1916)
The Grinning Spider
Charcoal on buff paper. 19¼ × 15¼ in.
The Louvre, Paris

Animal Drawing

The world of beasts and birds is a rich and delightful source of subject matter. The form and color of animals, their horns, manes, beaks, or wings, and the texture of their fur or feathers all provide the artist with new challenges in depicting living subjects of an elegant or unusual kind. Sometimes more graceful and expressively powerful than the human figure, such subjects reinforce our appreciation and wonder at living things, great and small.

The earliest depictions of animals date back to prehistoric times. The tradition of animal drawing in Western and Oriental art is an old one. Often, where the artist could study the animals, such drawings were highly sensitive and objective (Figure 5.43). Other early animal drawings, often of creatures the artist never saw, are charming in their naiveté. Today, even the most exotic animal or bird can be studied and drawn by visiting a nearby zoo or museum of natural history. If this is not convenient, a farm offers an interesting variety of animal subjects. Even the family cat or dog presents a challeng-

ing encounter with living forms of a graceful kind. Of course, drawing your pet or any other live animal usually requires you to establish a gesture drawing within a minute or so, since no animal is likely to hold a "pose" much longer than that. Once the essential character of the subject's forms are drawn, you can only refer to the animal for general form features, textures, and scale relationships among its parts. But this very restriction, and the bold, rhythmic nature of the forms of most animals, give such drawings a rather special spontaneity, animation, and charm (Figures 5.44 and 5.45). Because they are made without such urgency to get at the spirit of an animal's forms and action, drawings made from still animals on display, or from photographs of animals, may show more overall accuracy and detail, but may fail to match the vitality of drawings made from life. However, these subjects allow for extended studies that will familiarize you with important anatomical and textural features, and such studies should be part of any serious exploration of a particular animal's forms, as should a study of its surface anatomy (Figure 5.46).

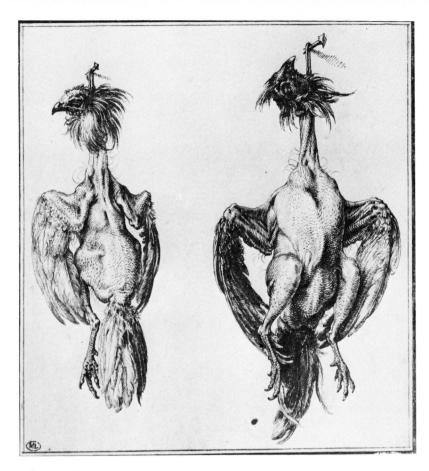

Figure 5.43
JACQUES DE GHEYN II (1565–1629)
Plucked Chickens Hanging from Nails
Pen and brown ink. 6½ × 5¼ in.
The Louvre, Paris

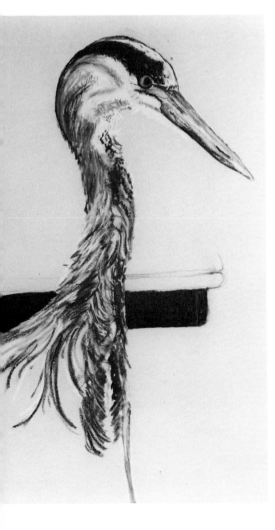

Figure 5.44 (*student drawing*)
Sara Bowen, University of Colorado
Pastel. 24 × 18 in.

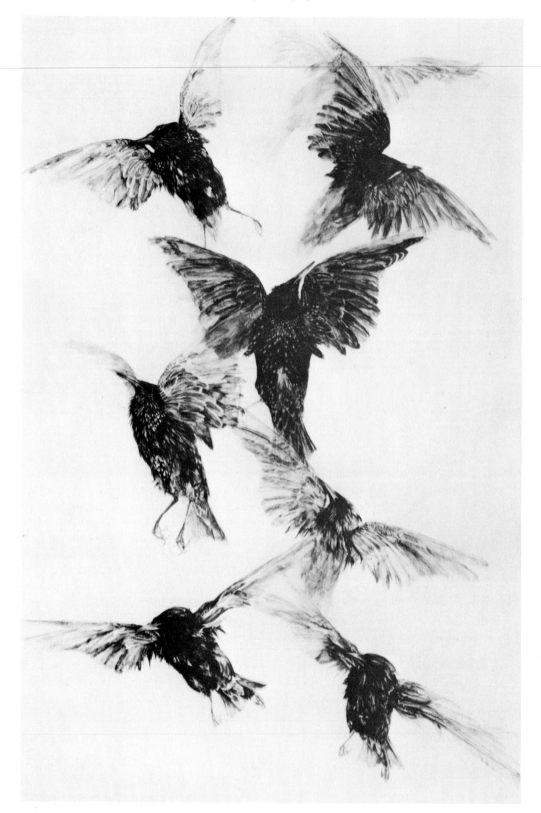

Figure 5.45
CAROL ARONSON
Starlings in Flight (1978)
Acrylic wash. 43 × 30 in.
Collection Gerry Grimaldi

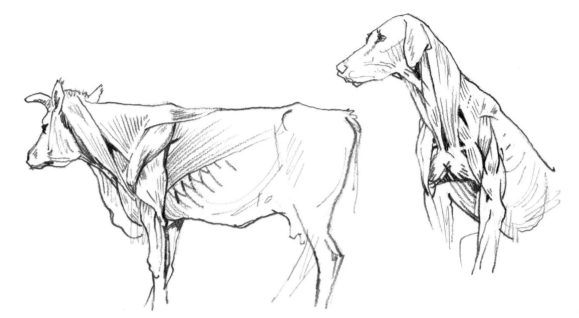

Figure 5.46

Landscape Drawing

The most diverse of subject categories, landscape drawings may include the human figure, still life, and animals. They may be of a panoramic rural or urban scene, or may focus on a very small corner of the outside world such as a tidal pool, a storefront, or a tree stump. Linear and aerial perspective often figure importantly in landscape drawings of an objective kind, as do the season, the weather, and the time of day.

Early artists often used landscapes as settings for humanity's various historical, religious, mythological, and social activities (Figures 5.47 and 5.48). Landscape drawing as a tradition in its own right is mainly a post-Renaissance development. With the spread of the Industrial Revolution and urbanization, the term "landscape" has expanded to include any kind of outdoor setting (Figures 5.49 and 5.50).

Although some beginners attempt landscape drawings from memory or imagination, such works invariably seem too generalized, picturesque, or tame. Drawings made on location, on the other hand, always show something of nature's compelling and limitless range of mass, space, light, and texture combinations. Indeed, it is the search for a specific outdoor setting whose visual and expressive characteristics are especially suited to an artist's creative purposes that makes a day spent drawing landscapes such an engaging activity.

Many artists prefer the broader, dry media such as charcoal, chalk, and pencil for landscape drawing, since these permit rapid notation and change. Other artists, however, are attracted to the chancier challenge of pen or brush and ink, finding the hatchings or tracery of line, or the painterly effects of washes, more compatible with their purposes. It is of course a practical matter to have your drawing materials stored in a lightweight and compact carrying case. An outdoor easel and a small folding stool are basic to landscape drawing unless you are using a sketchbook.

A unique feature of drawing panoramic landscapes is the critical nature of those lines and tones that define forms in the far distance. Because a single stroke may stand for a tree, a tower, or a hillside, its scale, shape, and direction on the page must be appropriate to its depictive task. A line or tone slightly too large or small, or somewhat wrongly shaped or placed, will badly distort such distant forms.

Landscape drawing tends to confront the artist with a variety of textures. Foliage, metal, water, glass, wood, and stone are only a few of the many materials whose textural characteristics are important to the drawing's clarity.

Figure 5.47
FRANCESCO GUARDI (1712–1793)
Doorway Leading to a Courtyard
Sepia (pen and wash). $5^{15}/_{16} \times 4^{3}/_{8}$ in.
Courtesy, Museum of Fine Arts, Boston, purchased from the
Francis Bartlett Fund through Mr. Walter Gay

Figure 5.48
GIOVANNI BENEDETTO CASTIGLIONE (1609–1665)
An Angel Appearing to a Journeying Patriarch (c. 1660)
Brush and red paint. 15⅛ × 21¹/₁₆ in.
The Philadelphia Museum of Art, the John S. Phillips Collection,
acquired with the Edgar Viguers Seeler Fund (by exchange)
and with funds contributed by Muriel and Philip Berman

Figure 5.49
PRESTON DICKINSON
Grain Elevators, Omaha (1924)
Pen and ink, charcoal, pencil, and pastel.
20⅛ × 14 in.
*Collection, The Museum of Modern Art, New York. The Joan
and Lester Avnet Collection*

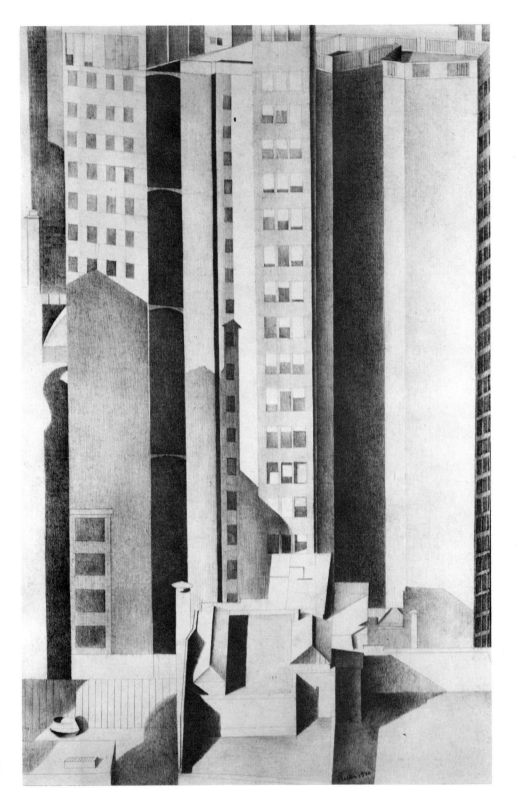

Figure 5.50
CHARLES SHEELER (1883–1965)
New York (Buildings) (1920)
Pencil. 19¾ × 12⅞ in.
*Courtesy of the Art Institute of Chicago, Friends of
American Art Collection*

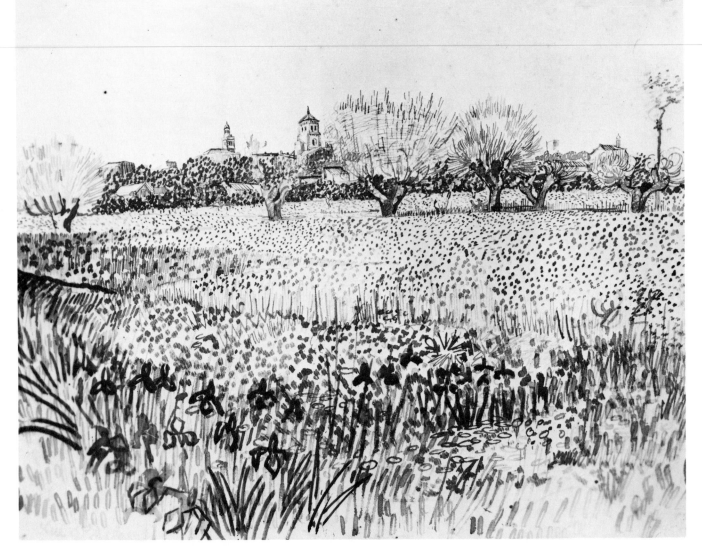

Figure 5.51
VINCENT VAN GOGH (1853–1890)
View of Arles (1888)
Quill pen and black ink.
Museum of Art, Rhode Island School of Design, gift of Mrs.
Murray S. Danforth

Texture often devours volume, the marks rising to the surface of the page, and care must be taken to keep those lines and tones defining texture from doing more harm than good. In general, it is a wise policy to include less rather than more textural detail, and to *suggest* broadly rather than *explain* explicitly the texture of the things you draw. That a richly textured drawing can have almost sculptural clarity among its volumes and interspaces can be seen in Figure 5.51.

Still-Life Drawing

Although still-life passages in mosaics and wall paintings appear in ancient art, the emergence of still life as a subject in its own right began in seventeenth-century Flanders and Holland with intricate floral or other subject arrangements, meticulously rendered. Nineteenth-century American artists such as William Harnett developed the "fool the eye" still life

to a point that remains unsurpassed for naturalism and overall artistic quality. In France, the tradition of the still life was a particular favorite. Among the many painters who had a powerful influence on how later generations of Western artists were to approach this subject category were Fantin-Latour, Renoir, Gauguin, Redon, and especially Cézanne. Cézanne's still-life paintings and drawings, in pointing to the abstract "scaffold" of dynamic actions that underlie the imagery, showed perhaps more than any other works how expressively vital the still life could be (Figure 5.52).

Still-life arrangements have included almost every kind of object imaginable. But the beginner would do well to avoid complex, highly textured, reflective, or patterned objects. Chandeliers, draped Oriental rugs, or highly polished metal objects would be poor choices for beginners because their "busy" surfaces tend to obscure their basic forms. But fruits and vegetables, pottery, objects of wood or leather, drapery of a single tone, books, plaster casts, certain instruments and tools, all offer limitless opportunities for composing and exploring interesting forms arranged to create dynamic

Figure 5.52
PAUL CÉZANNE (1839–1906)
The Three Skulls
Watercolor and pencil. 18⅞ × 24¾ in.
Courtesy of the Art Institute of Chicago, Mr. and Mrs. Lewis L. Coburn Memorial Collection

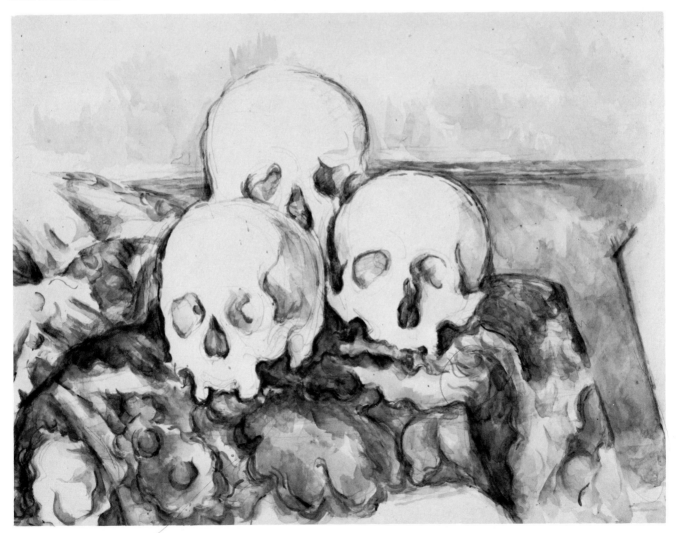

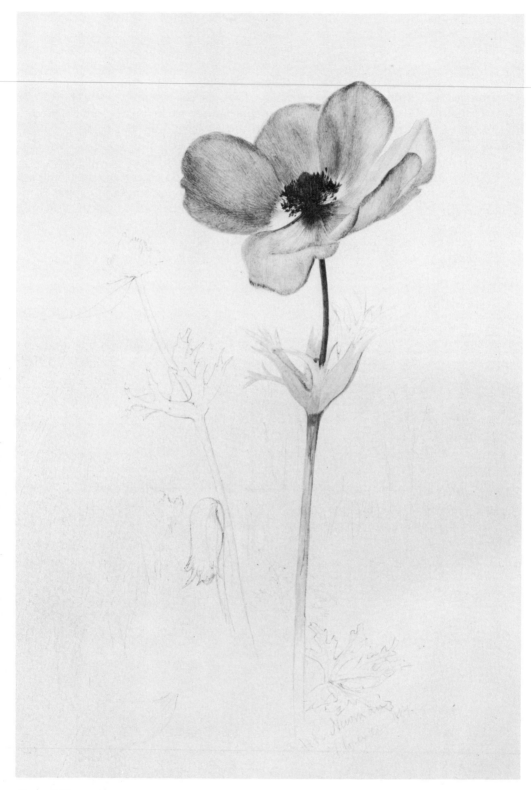

Figure 5.53
HENRY R. NEWMAN (1833–1918)
Anemone (1884)
Watercolor over graphite on cream paper.
15⅛ × 11¹⁄₁₆ in.
Courtesy, Fogg Art Museum, Harvard University,
Cambridge, MA, gift of Dr. Denman W. Ross

combinations of shape, value, texture, mass, and space.

For students, still-life drawing offers a number of important advantages. Objects selected for their interest can be arranged to suit one's particular sense of order, and the arrangements can be as simple or as challenging as desired. If a still life is placed in a location with a good light, where it will not be disturbed, a student can proceed at a deliberate pace and can return to it again and again until the work is thoroughly realized. The leisurely pace and privacy that are possible with still-life drawing are seldom available when drawing other kinds of subject matter.

In still-life drawing of an objective kind, linear perspective and the structural analysis of masses are often important considerations, as are compositional matters, especially those having to do with value and weight (Figures 5.53 and 5.54). Although some beginners find still-life drawing less than fascinating, the more sensitive students soon come to realize how inventive, engrossing, and informative this subject can be. Still-life drawing offers encounters with virtually every kind of visual challenge, and in the best drawings there are often provocative metaphoric qualities (Figures 5.55 and 5.56).

Figure 5.54 (*student drawing*)
Harriet Fishman, The Art Institute of Boston
Compressed charcoal. 18 × 24 in.

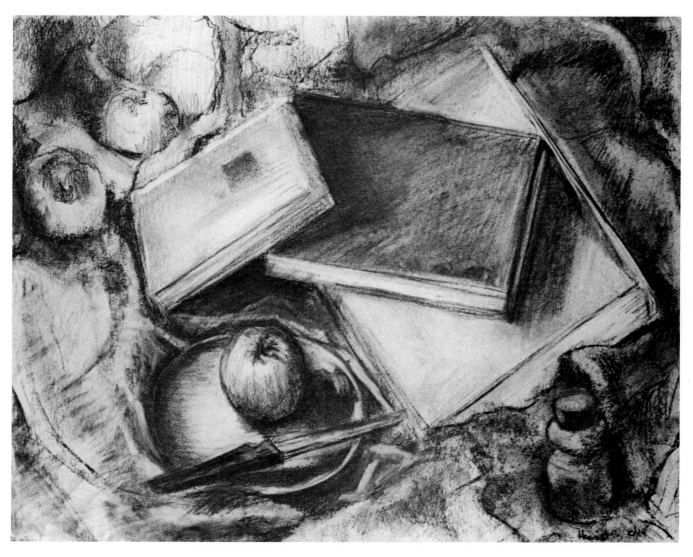

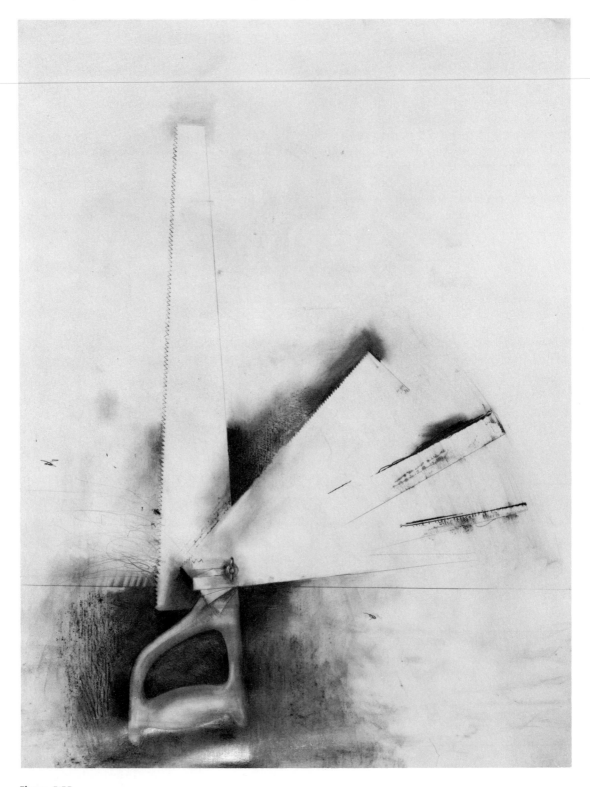

Figure 5.55
JIM DINE (1935–)
Untitled Tool Series (5-Bladed Saw) (1973)
Charcoal and graphite, 25⅝ × 19⅞ in.
Collection, the Museum of Modern Art, New York, gift of the
Robert Lehman Foundation, Inc.

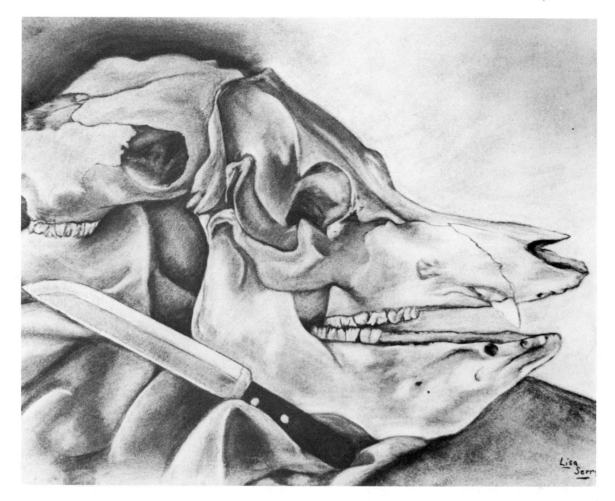

Figure 5.56 (*student drawing*)
Lisa Serry, Indiana University
Charcoal. 18 × 24 in.

Abstract and Nonobjective Drawing

Imagination and abstraction are essential factors in every creative act. In drawing, the ability to imagine—to invent visual concepts having to do with a personally intriguing imagery—and to abstract—to choose, alter, and simplify aspects of the things we draw in order to give form to our concepts—are the factors that determine *what* and *how* we draw; they are what stamp our drawings as ours.

Some early twentieth-century artists, giving their imagination free rein and submitting their subjects' forms to extremes of change, distortion, emphasis, and simplification, created images in which the things depicted were altered to a degree that made them difficult to recognize, but in doing so provided new visual experiences (Figures 5.57 and 5.58). Many later twentieth-century artists, recognizing the creative possibilities of such daring abstractions, invented numerous ways by which the familiar things around us could be "processed" through highly personal systems of interpretation. Abstract drawings, then, are works in which easy recognition of the familiar subsides in favor of personal styles of presentation, which provide dynamic visual experiences not otherwise possible. They may range in degree of abstraction from works in which the subject is still fairly recognizable (Figure 5.59) to those in which it is all but absorbed by the style of interpretation (Figure 5.60).

An early offshoot of abstract imagery, nonobjective drawing is, as the term implies, a mode of presentation in which the artist does not

(consciously) refer to any subject from the world around us. The configuration of a nonobjective drawing is entirely invented from the artist's imagination. For some artists, breaking free of what may be regarded as the constraints of rep-

resentation is a liberating step, enabling their imagination to roam freely, and to uncover combinations of visual elements and energies often charged with powerful dynamic force (Figures 5.61 and 5.62).

Figure 5.57
JUAN GRIS (1887–1927)
Breakfast (1914)
Pasted paper, crayon, and oil on canvas. 31⅞ × 23½ in.
Collection, the Museum of Modern Art, New York, acquired through the Lillie P. Bliss Bequest

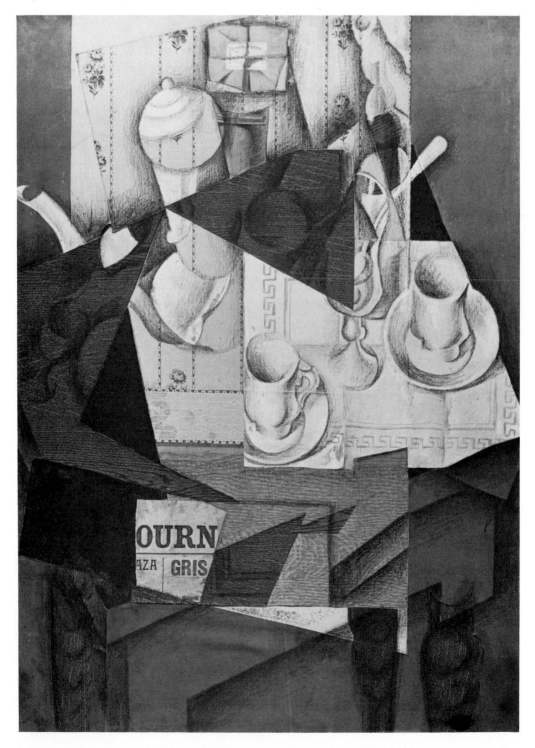

Figure 5.58
FERNAND LÉGER (1881–1955)
Verdun: The Trench Diggers (1916)
Watercolor. 14⅛ × 10⅜ in.
Collection, the Museum of Modern Art, New York,
Frank Crowninshield Fund

Figure 5.59
CONLEY HARRIS (1943–)
Northern Grove
Charcoal. 23 × 30 in.
Courtesy Boston Public Library, Print Collection
Photo: David H. Webber

Figure 5.60
FERNAND LÉGER (1881–1955)
Study for The Mechanical Elements (1918)
Pen and ink. 9¼ × 12 ⅛ in.
Kupferstichkabinett, Basel

Figure 5.61
JACKSON POLLOCK (1912–1956)
Untitled (1943)
Pen, ink, and pencil. $5\frac{5}{8} \times 17\frac{7}{8}$ in.
The Museum of Modern Art, New York; Anonymous extended
loan

Figure 5.62 (*student drawing*)
Jacque Craig, Rutgers University
Charcoal and pastels. 20 × 30 in.

Whatever our orientation to drawing may be, exploring the realms of abstract and nonobjective drawing generally yields important benefits. By requiring us to search for visual patterns and characteristics in a subject that offers a means for emphasis, omission, and change, abstract drawing strengthens our overall ability to see the world around us in a more relational, probing way. In making abstract drawings, in which dynamic elements are usually strongly evident, we come to understand better how the relational life of the elements may enhance our drawings when we are more engaged with representational imagery.

Because it avoids any reference to recognizable material, nonobjective drawing throws us back upon ourselves. Our nonobjective drawings are entirely the product of our imagination and cannot contain more than we know about the making of form and space, or about the **formal** life of the elements. That is, our nonobjective drawings must necessarily be limited by our experience and understanding of visual matters. Drawing nonobjectively can provide important insights on what impels us to use a particular medium in a certain way, or what drives us to use line, value, or shape to compose our works as we do. When you can conjure up any image you can imagine in any way you wish, then what you choose to draw, the medium you select, and the way you go about drawing are significant clues to psychological and creative interests that hold important meaning for you. You may not easily be able to explain or fully understand just why a certain style of shaping, use of a medium, or treatment of line is so insistently present in your work; but in discovering how strong a hold such characteristics have on your imagery (and, perhaps finding these idiosyncrasies present in your more figurative drawings as well), you come to meet aspects of yourself that are important to know about: your deeper personal and artistic needs and sensibilities.

When on occasion students ponder what they should draw, they generally review the subject categories we have just examined. Less often, they review the various themes and purposes that impel artists to draw. Here we will discuss a number of such "motives" for the making of drawings of whatever category.

THEMES

The Sketch

The term *sketch* suggests the kind of drawing we typically find in a sketchbook: a quick drawing, economically conceived, which captures a subject's essentials of action, energy, and form. A common practice in figure-drawing classes (but just as rewarding whatever the subject), the sketch, often gestural in nature, is ideal in training the student to sort out the important visual material from the unimportant details when assessing the subject's "raw data." Whether a time limit is imposed by the instructor (as is often the case in a studio classroom), self-imposed by the artist, or imposed by the situation itself (as when, for example, we are drawing bathers at the beach), one of the greatest benefits of sketching is in learning how to capture as much as possible of a subject's overall character and structure in a time period that is too brief for the task. It is in finding ways to simplify and summarize a subject's form, space, character, and action, in order to develop the image as far as we can within a five-, ten-, or fifteen-minute time period, that we first devise personal solutions for analyzing and drawing in a penetrating and authoritative way (Figures 5.63 ad 5.64).

Another important benefit derives from this: In learning how to see into a subject and sort out its essentials of form and spirit, we learn best how to begin a more ambitious drawing, whatever its thematic intent may be. In every extended drawing, whether of an hour's duration or far longer, there is a kind of "crisis" that occurs early in its development. It has to do with the quality of the artist's basic assessment of his or her subject—how well or how poorly the image is first conceived and begun. Unless we are able to see past a subject's particulars to its salient visual characteristics, the likelihood is poor that we will be able to launch a long drawing well. Even when we *are* skilled in this way, our first judgments need to be carefully evaluated early in the development of an extended study, for the rest of the drawing will be based on them. But without the insights, discipline, and experience that repeated quick sketching provides, the student beginning an

Figure 5.63
PAOLO VERONESE (1528–1588)
Studies for The Descent from the Cross
Pen.
Courtesy of the Art Institute of Chicago
Robert A. Waller Fund

Figure 5.64
NATHAN GOLDSTEIN (1927–)
Seated Female Figure (1974)
Reed pen, brush, and ink. 17 × 14 in.
Collection of the author

Figure 5.65
PAUL GAUGUIN (1848–1903)
Tahitian Woman (1892)
Pastel. 21¾ × 18⅞ in.
Courtesy of The Art Institute of Chicago, Gift of Tiffany and Margaret Blake

extended study is off to a shaky start. Those who cannot begin a drawing well cannot resolve it well.

Often the quick sketch is a preparatory work, intended more as an act of inquiry than of exposition. By extracting from a subject its main visual conditions, the artist is better able to conceive an approach to a major work in another medium (Figure 5.65). However, the sketch as an end in itself has enjoyed a long and popular tradition. For the artist, its appeal is in the challenge of saying a great deal with an economy of means; in the enjoyment of the calligraphic play of line and tone, as each mark takes on dynamic as well as descriptive duties; and in the spontaneity and wit of the resulting work.

For many connoisseurs, the sketch seems to be at the very heart of what drawing is all about. Unlike major visual works, or even more extended studies, which declare the artist's creative and personal philosophy, the quick sketch more nearly reveals the artist's soul.

Because of the brevity of the time involved, the chief pitfall of the quick sketch is in settling for the private store of drawing clichés we all possess. If we resist calling on these familiar solutions and concentrate instead on finding a concise and satisfying visual response to each observation, every sketch can be inventive and alive.

Although every drawing medium can be and has been used for sketching, beginners should avoid the fluid media until they have a sound grasp of the issues discussed in Chapter Two. In general, the broader and more erasable the medium, the better it will serve to establish a subject's measurable and dynamic essentials, and to avoid focus on surface niceties.

Because sketching well demands that the artist perceive essentials well, the importance of developing the sketchbook habit can hardly be overstated. Once you are determined to do some drawing on a daily basis (and significant progress in drawing is fastest if you do), the sketchbook makes it possible to expand your search for subjects to the world at large. Its portability and relative privacy allow you to draw in and out of doors, exploring every kind of subject and situation. And in confronting them with a wish to extract their fundamental visual and expressive nature in the direct and spontaneous manner that characterizes sketching, you can deepen your appreciation of the people, places, and things in the world around us as you advance your skills in drawing.

The Line Drawing

The quick sketch is often restricted to line drawing, and the element of line is central to drawing. Although pure tonal drawing is an important concept in drawing, it is the analytical, volume- and space-revealing, calligraphic play of line, used either exclusively or in conjunction with some value, that most artists turn to when drawing any subject for virtually any thematic purpose.

Because a single line may change in character and function along its course, it is sometimes difficult to identify a line as being of a particular type. However, lines usually can be sorted into several rough categories. While it is true that in practice most lines function in more than one way, most lines in a drawing suggest the dominant use the artist put them to.

A line drawing that attempts mainly to show the location, basic shape, and general proportions of a subject's parts and treats those parts in a schematic, general way usually consists of analytical or *diagrammatic* lines (Figure 5.66). The hatched lines that are used to establish a volume's planar structure and sometimes to suggest the light falling on a form are called *structural* lines. Not unlike the more sparsely used diagrammatic line, the structural line is always engaged in carving a subject's surface structure—the hills and valleys of a volume's terrain (Figure 5.67). Although in drawing every type of line is a calligraphic statement of some kind, we have come to think of the *calligraphic* line as an often curving, tactile, and spontaneous line, driven as much by dynamic as by structure-seeking motives. Such a line frequently shows a variation in its width as it turns and moves upon the page; often there is a rhythmic interplay with other lines. The calligraphic line is usually an energetic, fast-moving line (Figures 5.68 and 5.69). The delineating or *contour* line is defined more by its function than by its appearance. Such a line may be undulating or angular in character, or may fluctuate in attitude from the diagrammatic to the calligraphic. Instead of establishing a volume's edge,

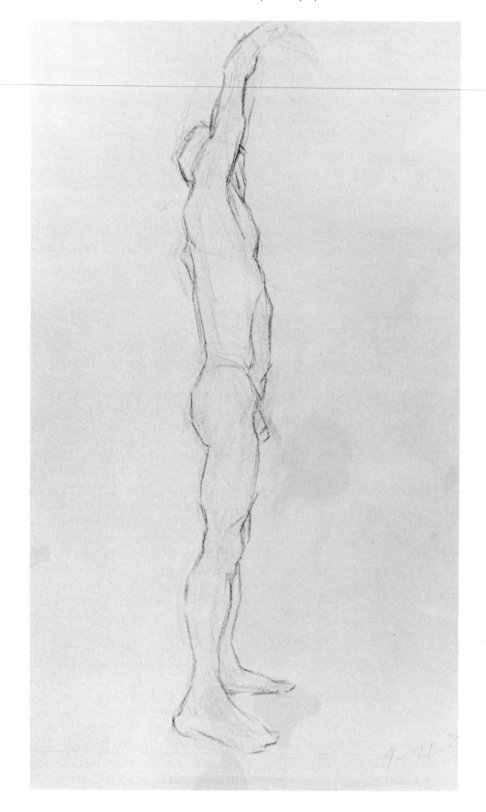

Figure 5.66 (*student drawing*)
Miguel Collazo, The Art Institute of Boston
Compressed charcoal and pencil. 24 × 18 in.

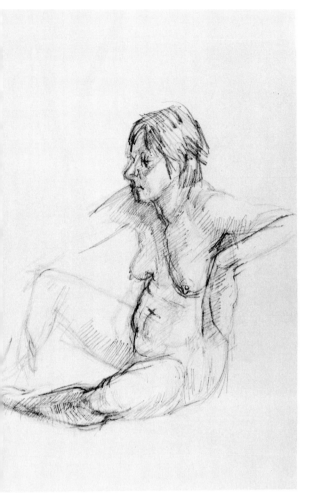

Figure 5.67
ISO PAPO (1925–)
Seated Nude Figure (1984)
Graphite pencil. 24 × 18 in.
Courtesy of the artist

Figure 5.68
FRANÇOIS LEMOINE (1688–1737)
Study of an Angel
Red chalk, 11$\frac{1}{16}$ × 7$\frac{15}{16}$ in.
The Louvre, Paris

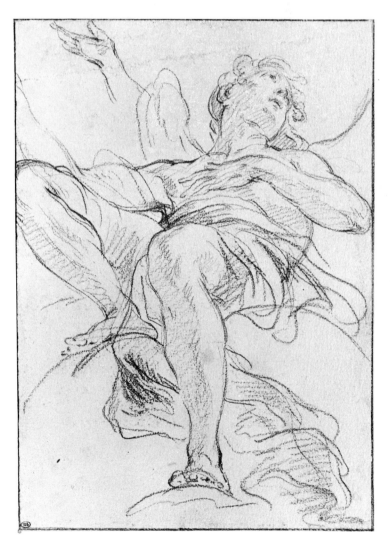

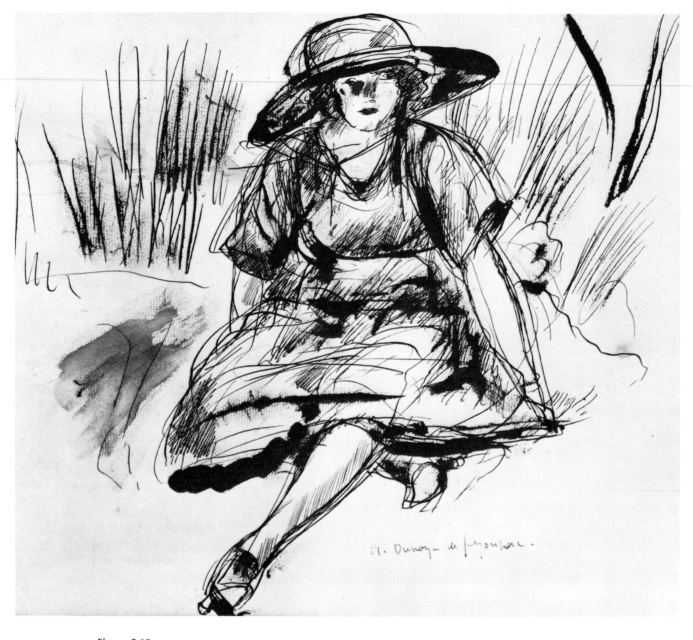

Figure 5.69
ANDRÉ DUNOYER DE SEGONZAC
Woman in a Large Hat
Pen and ink and gray wash. 12¹/₁₆ × 16³/₈ in.
Museum of Painting and Sculpture, Grenoble, France

cross-contour lines, move upon its terrain leaving a trail that reveals changes in the volume's surface (Figure 5.70A).

The variation in a contour line's width can suggest weight, the changing structural nature of a form's edge, and the pressure exerted by one form on another. Bearing down on the pen, brush, or other drawing implement to produce a heavier line on the underside of a part adds to the impression of the part's weight (Figure 5.70B). A heavier segment of a contour line suggests a flat, totally foreshortened plane; a lighter segment of a contour line suggests the turning of a curved plane (Figure 5.70C). A heavier weight of line at a point where inner forms press against a containing form or where forms press together underscores the tension among the forms (Figure 5.70D).

All lines express something. They reveal the authority, hesitancy, passion, or indifference of the artist as they are drawn. But the predominantly *expressive* line is one whose character and behavior in the drawing seem to suggest that the artist's need to experience and share feelings about the subject supersedes any other motive for its use. Such lines may express joy, anger, sensuality, power, tenderness, and so on. They support the emotive meanings of representational content and amplify the artist's expressive purpose

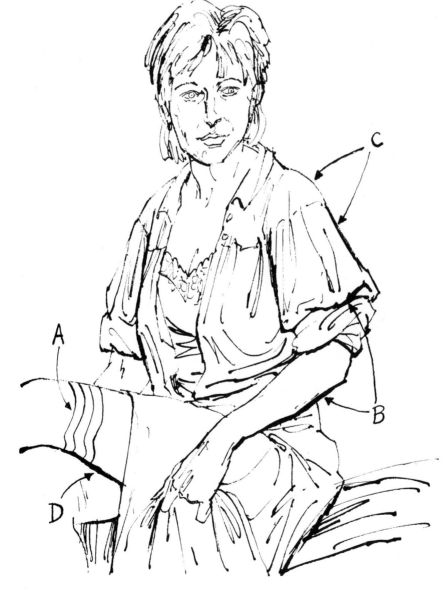

Figure 5.70

Figure 5.71
CLAES OLDENBURG (1929–)
Bicycle on Ground (1959)
Crayon on paper. 12 × 17⅝ in.
The Whitney Museum of American Art, New York, gift of the
Lauder Foundation, Drawing Fund
Photo: Geoffrey Clements

Figure 5.72
HONORÉ DAUMIER (1808–1879)
A Clown
Charcoal and watercolor. 14⅜ × 10 in.
The Metropolitan Museum of Art, New York, Rogers Fund,
1927

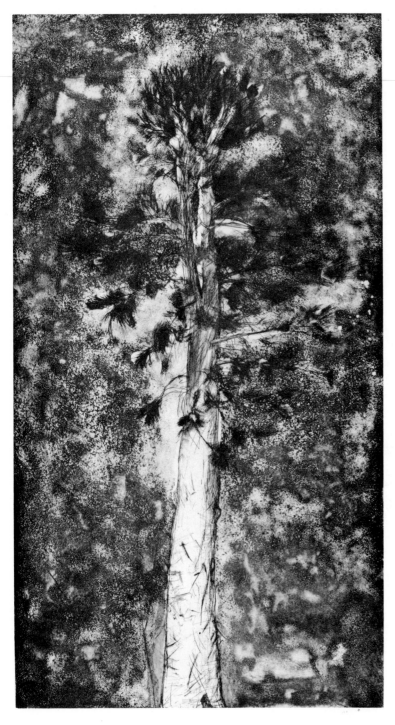

Figure 5.73
JIM DINE (1935–)
The Pine in a Storm of Aquatint
Drypoint and etching with aquatint. 57¾ × 22 in.
Courtesy Museum of Fine Arts, Boston, gift of Mrs. Frederick B. Dekmatel

These categories hardly begin to suggest the kinds of lines possible in drawing. Within *and between* each of these general categories are kinds and uses of line too subtle in their differences and too numerous to discuss. Then, too, every artist gives to his or her line drawings a certain personal nuance and inflection that modifies the types of lines being used. But knowing that there are such broad categories of line function and characteristics, each capable of achieving a particular result, helps us to know better how to proceed with our drawings in line.

In being the single most versatile element of drawing, line is adaptable to any subject and style. Capable of the most delicate exactitudes or the boldest slashes, it readily conforms to the artist's needs. But good line drawing requires the artist to make resolute choices. Like the trail of line deposited on paper by a lie-detector test, the lines we draw reveal our slightest waverings and hesitations as well as our commitment and empathy. The fullest knowledge of the capabilities of line comes from the use of pen and ink. Using a steel or reed pen on a sheet of good-quality drawing paper best enables you to experience the various kinds of line discussed above. This is not to say that the brush or the various dry media are not excellent choices for line drawing, but to suggest that in restricting your first line drawings to pen and ink you can recognize more fully both the versatility and the restrictions of this kind of drawing.

The Tonal Drawing

Too often overlooked as a means of drawing, the fully or predominantly tonal drawing is able to convey visual phenomena that pure line drawing cannot achieve (see Chapter Four, "Value"). Drawing tonally, the artist can show the inherent differences of value in the subject's parts: A cat is light in tone, grass is dark. Values explain the fall of light on surfaces, and through their changes of tone we read the surfaces as turning toward or away from the light source. Value is a powerful agent of expression; through its use different psychological moods can be suggested (Figures 5.73 and 5.74). Value is also a profound modifier of composition: By their scale, shape, contrast, and weight the tones in a drawing help organize and unify our images. Tonal drawings can show atmospheric effects,

Figure 5.74 *(student drawing)*
Dave Dornan, University of Utah
Charcoal. 18 × 24 in.

soft-edged shapes and masses, and textural characteristics not possible in line drawing.

Objective tonal drawing shifts the artist's attention from edges, boundaries, and the animated effects of line play to the structural, tonal, atmospheric, and textural conditions of the surfaces of masses in space as revealed by an illuminating source. Often closer to painting than to drawing, tonal drawings can be either highly detailed or direct and spontaneous (Figures 5.75 and 5.76). Even the media chosen for tonal drawing are sometimes those of painting. When an opaque paint is used, extensive reworking and overpainting is possible, giving the artist

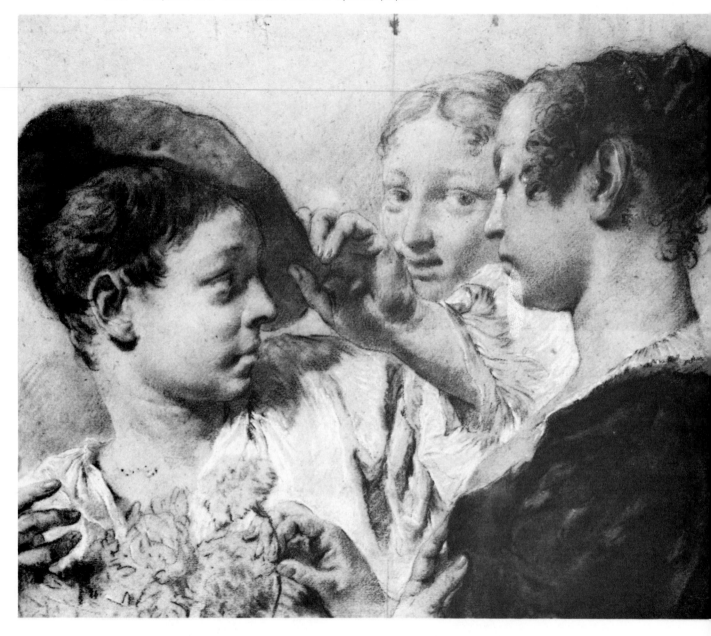

Figure 5.75
GIOVANNI BATTISTA PIAZZETTA (1682–1754)
Il Fiorellin d'amore
Black charcoal heightened with white chalk.
21⅝ × 15¹³⁄₁₆ in.
The Cleveland Museum of Art, purchase from the J.H. Wade Fund

an expanded range of control over the final result (Figure 5.77). Of course any medium can be and has been used for tonal drawing—including pen and ink, where extensive hatchings replace a more linear treatment.

Students beginning to draw tonally sometimes use too little value and tend to use tones in the lighter range. This often occurs because the student still relies on line as the drawing's

mainstay, using values as a later, separate step to clarify the work further. Such drawings sometimes have the look of a child's coloringbook: a line drawing that has been "filled in" as a separate operation. A better policy is to rely from the first on using value to sort out form and space, establish patterns of tone that define the drawing's basic compositional order, rough in the essential structural and dynamic condi-

Figure 5.76
CHUCK CLOSE (1940–)
Phil/Fingerprint II (1978)
Stamp-pad ink and pencil on paper. 29¾ × 22¼ in.
The Whitney Museum of American Art, New York,
anonymous gift
Photo: Geoffrey Clements

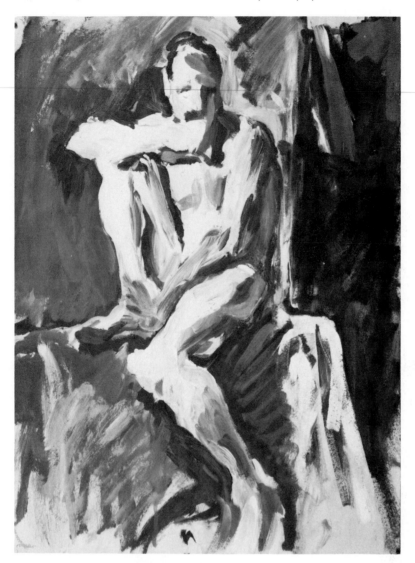

Figure 5.77 (student drawing)
John St. John, Kent State University
Acrylic. 24 × 18 in.

tions of the subject, and in general make sense of the subject by what tone, not line, reveals. This doesn't mean that some few diagrammatic lines can't be used at the outset to locate roughly and to shape a subject's parts, but that line should play a very minor role in the forming of the image.

The Line and Tone Drawing

The fullest range of drawing options requires the use of both line and tone. Such drawings sometimes contain passages in which line is dominant, and others in which tone predominates (Figure 5.78). Often, though, the artist will maintain a general sameness of emphasis on line or tone throughout the work, with one of these serving as the main "voice" and the other as a kind of visual "counterpoint." Or each may be employed to achieve the effects it alone can produce, as in Figure 5.79, where line is dominant, and in Figure 5.80, where value is. These works sometimes are of mixed media, which broaden the artist's visual options even further. Combining line and tone in some personal "recipe" of usage tends to promote livelier dynamic actions and a greater range of interpretive responses.

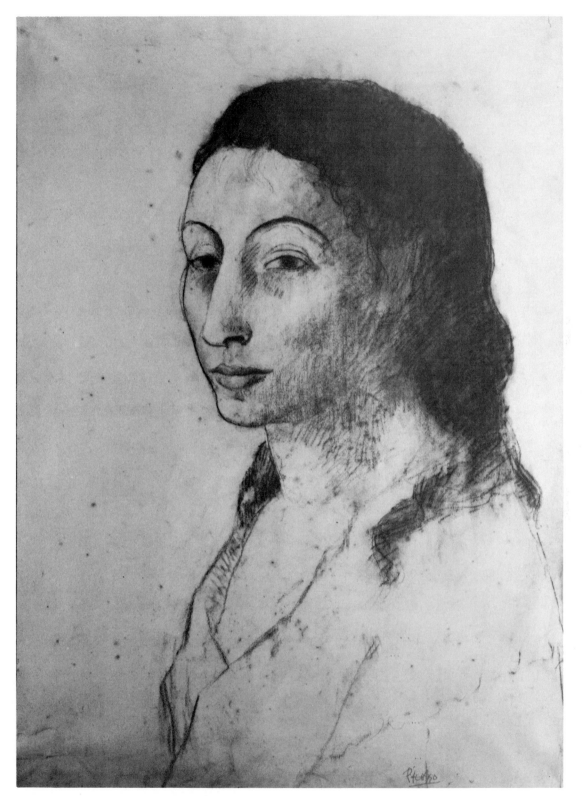

Figure 5.78
PABLO PICASSO (1881–1974)
Portrait of Fernande Olivier (1906)
Charcoal. 24⅛ × 18 in.
Courtesy of the Art Institute of Chicago,
Gift of Hermann Waldeck

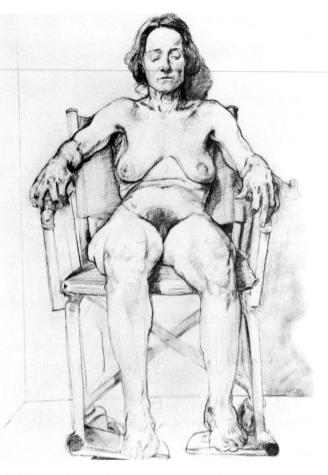

Figure 5.79
SIGMUND ABELES (1934–)
Seated Woman (1982)
Charcoal pencil. 24 × 18 in.
Courtesy of the artist

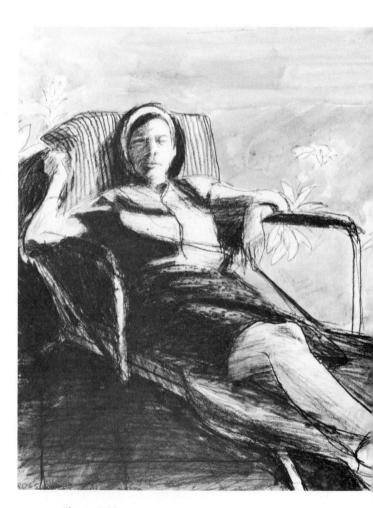

Figure 5.80
RICHARD DIEBENKORN (1922–)
Woman in Chaise (1965)
Crayon and gouache. 17 × 12½ in.
*Collection Richard Brown Baker on extended loan to
the Yale University Art Gallery*
Photo: Joseph Szaszfai

The Extended Study

Usually undertaken more for objective than subjective purposes, the extended study is any kind of investigative drawing developed over a period of several days or even weeks, which enables students to experience various perceptual and craft niceties that would otherwise be missed. Recent trends in art and in many schools of art indicate that the extended drawing is enjoying a revival. Once the mainstay of the European art academies, the extended study fell into disrepute because of the overbearing emphasis that came to be placed on minute surface detail and textural effects and on a "sweetened"

version of the forms and attitudes of Greek and Roman art. But when the artist's goals are shifted to a probing examination of a subject's structural and spatial nature and to the creation of a drawing alive with dynamic action, the benefits of the extended study are important indeed.

A sustained involvement with one subject, and continually refining judgments concerning subtleties of scale, shape, value, and so on, has the effect of increasing our sensitivity to the elements. In such "fine-tuning" operations we come to experience the important differences that little adjustments make to a drawing's overall clarity and order.

Figure 5.81
CHARLES SHEELER (1883–1965)
Interior, Bucks County Barn (1932)
Crayon. 15 × 18 ¾ in.
Collection of the Whitney Museum of American Art, New York, purchase
Photo: Geoffrey Clements

The many hours spent resolving a single drawing help us to know the subject's forms in a thorough and lasting way, which can be recalled in our mind's eye when drawing from imagination. The longer the time spent on an extended study, the clearer the subsequent memory of the subject's forms and details concerning various structural and spatial conditions.

Extended studies also enable us to make fine-tuned changes in a drawing's composition, finding subtle relational bonds and dynamic actions that more strongly weave a work together. And in becoming familiar with such subtle connections and activities, we expand our sensitivity to abstract matters to a more discriminating and refined level, which is then ready to serve us in even the briefest sketch.

Quite simply, in giving us large, unbroken blocks of time the extended study creates the conditions necessary to make discreet adjustments and subtle connections of every sort. But if subtleties of structure, value, texture, and composition are to have any real meaning in a work, they must be seen within the context of a work that was well conceived in its first moments (see Chapter Two). Examining the reasons for the failure of an extended study, we often find the problem to lie in its initial conception: We cannot resolve a drawing that we are unable to begin wisely. But when a sustained drawing "works," when it is a thoroughly realized expression of its initial thrust, it teaches us how to begin a drawing, how to resolve it, and points to the many dynamic and expressive phenomena, both fundamental and discreet, that this demanding form of drawing enables us to attempt (Figures 5.81 and 5.82).

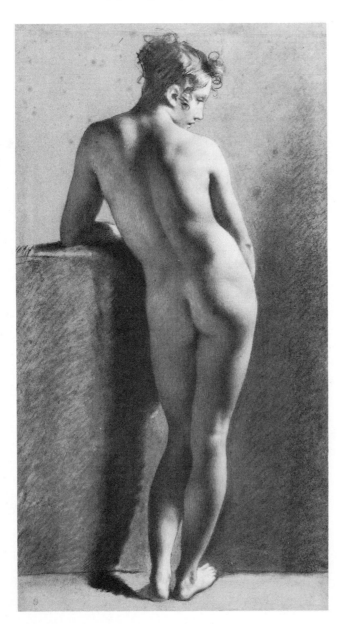

Figure 5.82
PIERRE PAUL PRUD'HON (1758–1823)
Standing Nude Figure
Charcoal heightened with white chalk on blue paper.
24 × 13¾ in.
Courtesy, Museum of Fine Arts, Boston, Forsyth Wickes Collection

The Predominantly Three-Dimensional Drawing

For some artists, a drawing's purpose may be to conjure up a certain level of realism, a certain balance between two- and three-dimensional phenomena, and a certain play of dynamic and depictive forces in the image. Whether the drawing is in line or tone, a brief sketch or a sustained study, it is always the possibility of achieving some personally satisfying form of expression that is the artist's true motive. Of course, virtually all artists contend with both two- and three-dimensional considerations in their work. The point here is to offer as one more drawing theme the idea of advancing either a two- or three-dimensional dominance in a drawing, whatever its subject.

When artists are attracted to predominantly three-dimensional imagery, they still look to the drawing's two-dimensional state to keep the resulting image from looking like a view through a window. Their emphasis on three-dimensions does not suggest a lesser interest in two-dimensional matters, but rather a harnessing of each dimension to the degree necessary for personally satisfying expression. Sometimes such artists bring a drawing's two-dimensional state almost as much to the fore as they do its three-dimensional one, as in Figure 5.83, where mass and space—figure and ground—are almost equally important and striking.

Figure 5.83
PAUL CÉZANNE (1839–1906)
Foliage (1885–1900)
Watercolor and pencil. 17⅝ × 22⅜ in.
Collection, The Museum of Modern Art, New York, Lillie P. Bliss Collection

The Predominantly
Two-Dimensional Drawing

For all the emphasis that most art teachers, artist-authors, and art students themselves place on an ability to analyze and fluently draw convincing volumes in convincing space, it must be noted that drawing isn't a form of "pretend"

sculpture, and the mode of drawing that accepts and even requires a predominance of two-dimensional matters is one that many twentieth-century artists have chosen (Figures 5.84 and 5.85). Rethinking a still life or a landscape as an image in a two-dimensional world makes us see it in fresh, original ways. Once free of the complexities and restrictions that are inherent in

Figure 5.84
JEAN DUBUFFET (1901–)
Nude from the series *Corps de Dames* (1950)
Reed pen and ink, wash. 12¾ × 9⅞ in.
Collection, The Museum of Modern Art, New York. The Joan and Lester Avnet Collection

Figure 5.85
HENRI MATISSE (1869–1954)
Composition with Standing Nude and Black Fern
(1948)
Brush and ink. 41³⁄₈ × 29³⁄₄ in.
Georges Pompidou National Center of Art and Culture, Paris
© A.D.A.G.P., Paris/V.A.G.A., New York, 1985

creating masses in a spatial field of depth, subjects can be assessed in ways that are closed to predominantly three-dimensional concepts. The play of shapes, textures, and values takes on new meanings, offers new possibilities for dynamic activity on the **picture plane**. Similarly, compositional and expressive options that are impossible for images that inhabit the realm of volume and space are readily available once we accept the picture plane as the main arena of visual play. Not surprisingly, such insights and innovations have some bearing on how we draw any subject when we return to a more three-dimensional mode.

The Message Drawing

Some drawing themes arise out of *nonvisual* issues, that is, issues having to do with any religious, social, political, or psychological interests or opinions, but not with primarily visual ones. The visual dynamics in such works are dependent on and mainly shaped by the needs of the drawing's nonvisual message.

Many artists at one time or another have been motivated by a wish to make some kind of social commentary. Many of Goya's etchings, Picasso's famous *Guernica*, and the commentary on society implied in some Pop art are examples of works about deeply felt human concerns, created by artists whose chief artistic interests are usually more visual than social or political (Figures 5.86 and 5.87). But other artists always seem to require such nonvisual stimuli to trigger the creative act, no matter what their subject may be (Figures 5.88 and 5.89). It is not necessarily true that such artists are more socially or politically aware than those artists whose works do not *directly* comment on this or that nonvisual matter (in fact, the general social and

Figure 5.86
PABLO PICASSO (1881–1974)
The Embrace of the Minotaur
China ink and wash.
Courtesy of the Art Institute of Chicago,
Collection Mrs. Tiffany Blake

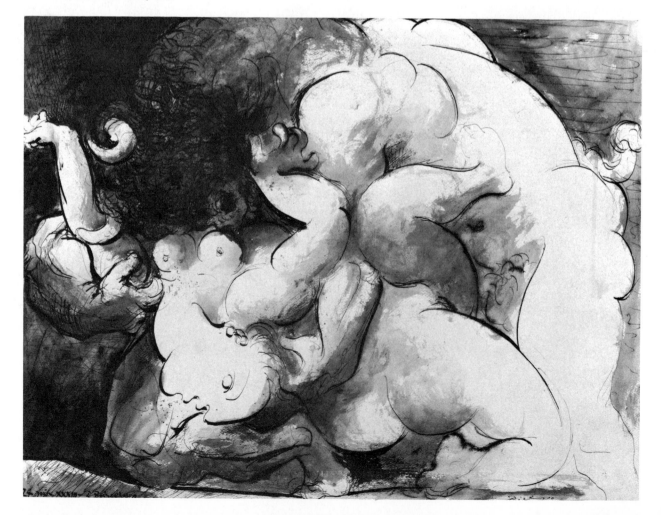

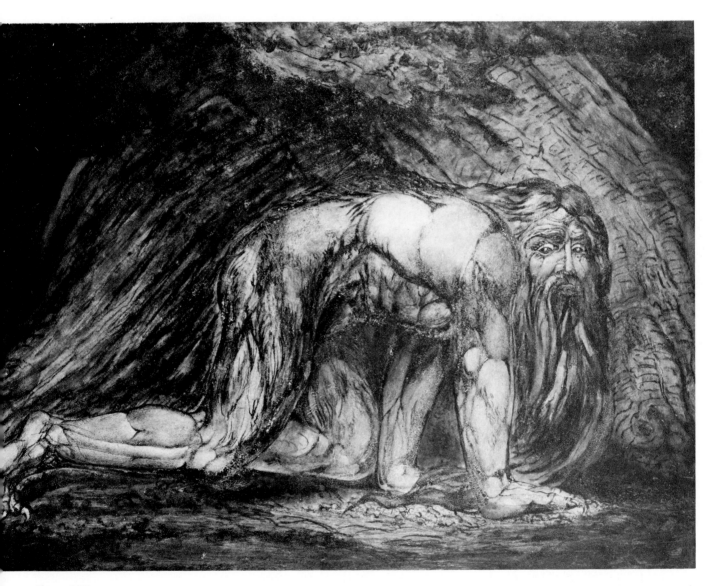

Figure 5.87
WILLIAM BLAKE (1757–1827)
Nebuchadnezzar
Color printed drawing. 16⅜ × 23⁹⁄₁₆ in.
Courtesy, Museum of Fine Arts, Boston, gift of
Mrs. Robert Homans

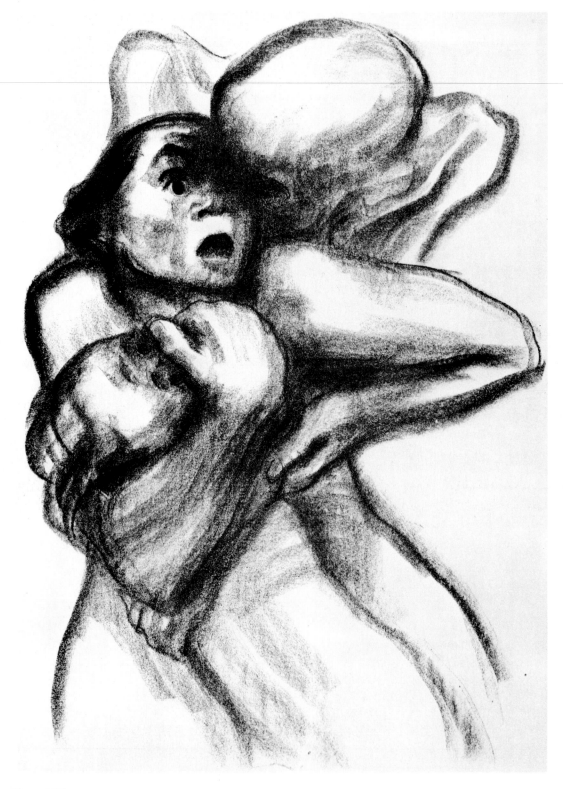

Figure 5.88
KÄTHE KOLLWITZ (1867–1945)
Death Reaches for a Child (1934–35)
Lithograph. 20 × 14 ⁷⁄₁₆ in.
*Courtesy of the Fogg Art Museum, Harvard University, Francis
Calley Gray Fund purchase*

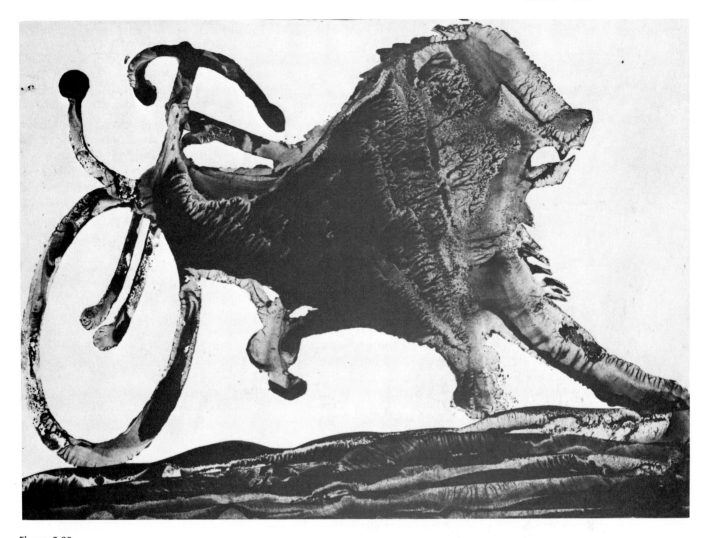

Figure 5.89
OSCAR DOMINGUEZ
Lion-Bicycle (1937)
Gouache and decalomania. 6 ⅛ × 8 ¾ in.
Georges Pompidou National Center of Art and Culture, Paris
© A.D.A.G.P., Paris/V.A.G.A., New York, 1985

psychological tone of most visually stimulated artists can be inferred from the overall character of their work, whatever its subject or theme). Rather, it seems that artists requiring a nonvisual motive as a precondition to creativity cannot find in the formal, dynamic possibilities of a subject a suitable basis for creativity. For them, the drawing's social function influences its form. And while it would be overstating the case to say that the first group finds nonvisual considerations to be a burden on creative freedom, and that the second group feels that visual issues undertaken for their own sake to be somehow too frivolous or indulgent, it is fair to say

that each group feels some sympathy with the charges made against the other.

Still other artists, and among them some of the best, fuse both visual and nonvisual considerations in their work, making it impossible to know whether the artist's impulse to draw a particular subject in a particular way began as a response to its visual or its nonvisual properties. Often the artists themselves cannot sort out the underlying motivations for a work. For our purposes, this approach provides us with the best mode of entry into the realm of drawing subjects and situations about which we have definite opinions and feelings. Instead of se-

lecting a subject we wish to support, such as a certain religious or political attitude or event; or a subject we want to condemn, such as poverty or war; we should select a more neutral subject: a tree stump, a reclining figure, an open toy box, or any subject that allows for several interpretations or is somewhat enigmatic in character.

Next examine the subject for the following: its environment, its basic dynamic nature, its effect in shaping your reactions to its forms and structure, and the overall mood it seems to project. From this mixture of objective and subjective responses, try to settle on a few general decisions: (1) the drawing's size and whether it will be vertical or horizontal; (2) the medium and the type of support to be used; (3) the drawing's basic mode of expression (line, tone, etc.); (4) how to express your general reaction to the character and mood of the subject; and (5) whether the drawing is to be a spontaneous, quick drawing or a more extensive study. With these decisions and reactions established, begin to search for a compositional arrangement that

will best support the drawing's shape, subject, and mood. In doing this, you will be "setting the stage" further for the drawing's expressive message. Allow your choice of shapes, tones, and textures to be influenced by the psychological tone you wish to convey. Be firm about deciding whether a particular line, volume, tonal change, or handling is amplifying your expressive point or diminishing it, and remove or change anything in the drawing that weakens your meaning. Your message may be carried directly by the subject matter itself; as, for example, a tree stump conveying the ravaging of our forests, or a toy box alluding to the appealing play of children. Or the message may be more metaphorical: the tree stump suggesting stubborn endurance, and the toy box our vulnerability in an uncaring world. In searching out a subject's meanings, avoid imposing arbitrary ones having little to do with the subject. Instead, try to respond to both its form and mood, letting the message issue partly from the subject's overall nature.

But because your subject can suggest more

Figure 5.90
RENEE ROTHBEIN
Study for the Holocaust Series (1984)
Brush and black ink. 14 × 17 in.
Courtesy of the artist

Figure 5.91
HYMAN BLOOM (1913–)
Landscape # 12
Charcoal. 45 × 59 in.
Courtesy Museum of Fine Arts, Boston, gift of Emanuel L. Josephs
in memory of Esra M. Josephs

than one interpretation, try selecting another medium, another shape and size for the drawing, and searching for another emotive "reading." Doing a second or even a third drawing from the same subject, each with its own nonvisual allusions, will show you how large a part you can play in processing the raw materials of the world around us.

When a drawing's formal, dynamic life is in part determined by a nonvisual theme (however dear to us), a danger exists that the resulting work will have been weakened as a visual "treat for the eyes" because of the demands of the drawing's message. When this does occur, the drawing may be more of a propaganda statement or a case of special pleading than a visually provocative and satisfying image. But if you take care that the drawing's nonvisual meanings never supersede its dynamic, formal ones, the results may show each theme to support the other. In this way the drawing's visual dynamics can enhance the drawing's expressive purpose, and its expressive purpose can urge on a dynamic play among the marks that is most suited to the drawing's message. At its best, such an objective/subjective approach to drawing can lead to images of the most compelling and transcendental kind (Figures 5.90 through 5.95).

189

Figure 5.92
CLAES OLDENBURG (1929–)
Preliminary study for Image of the Buddha Preaching
(1967)
Pencil. 30⅛ × 22⅛ in.
*Collection, The Museum of Modern Art, New York, gift of
Mr. and Mrs. Richard E. Oldenburg*

Figure 5.93
GEORGIA O'KEEFFE (1887–)
New York Rooftops (c. 1925–30)
Charcoal. 24¼ × 18⅝ in.
*The Fine Arts Museums of San Francisco, AFGA, gift of
Mrs. Charlotte S. Mack*

Glossary

abstract The essential arrangement and dynamic nature of the elements and of the forms they produce. All visual works possess an abstract basis. Also used to define any image presenting a marked rearrangment of a subject's characteristics, often to a degree showing little resemblance to its actual appearance.

analyze (analytical) In drawing, to find in a subject basic facts pertaining to structure, organization, and dynamic phenomena.

axis (axial) The real or imaginary center line of a volume. The center line assumed to run in a volume's longest dimension is called the long axis; the center line running at a right angle to the long axis is called the short axis. Such axes reveal a volume's orientation in space.

binder The ingredient in any drawing or painting medium that holds the pigment

particles in suspension (in wet media) or together (in dry media).

calligraphy (calligraphic) In drawing, an animated, often cursive line that may show varying widths and values among its turnings. Such lines, personal in nature, possess the free-flowing character and idiosyncracies of individual handwriting styles.

chamois A soft, cloth-like leather material used for blending tones in works made with most dry drawing media.

collage A technique of image-making in which assorted materials such as paper, wood, veneers, cloth, buttons, string, etc. are glued onto a rigid support. Often painted or drawn passages are added to achieve the desired result.

complementary colors Colors that are opposite one another on the color wheel; for

example, green is the complement of red and blue the complement of orange. Complementary colors always consist of one primary and one secondary color.

configuration As used here, a drawing's overall pattern and shape upon the page. Although matters of volume and space affect our response to a drawing's configuration, the term refers primarily to a drawing's two-dimensional nature.

contour A line defining the outer edges of a mass. Unlike outlines, which more schematically set off one mass or space from another, contour lines are volume-revealing in purpose.

dynamics The sense of movement, change, pulsation, or confrontation within or among a drawing's elements. Dynamic energies are also present in a work's representational content, often manifested by physical weight, by a sense of movement, and by the location of parts.

empathy As used here, the capacity to experience the behavior and expressive nature of a subject and of the elements and parts in a visual work of art.

figural (figurative) Denoting any kind of representational imagery.

form In the fine arts the term usually refers to the overall visual character of a work or the character of each of its parts. Often, as in this book, the term is synonymous with the terms volume and mass.

formal The organizational structure of a work as conveyed by the location and visual nature of the elements and of the forms they produce.

grain The surface texture or tooth of paper or other supports used for drawing.

hatching (crosshatching) A technique of modeling form and space in which ranks of parallel lines produce light or dark tones, depending on the number and closeness of such lines in a given area. In crosshatching, such groups of parallel lines are drawn crossing over each other at differing angles.

measure To establish in a drawing the length, breadth, and depth of observed volumes and their interspaces, as well as to establish their location and scale.

model (modeling) In drawing, the process of forming an impression of volume and space on a flat surface.

monochromatic Pertaining to variations in value of a single color. The term defines any work executed in one hue but showing a range of values of that hue from light to dark.

optical As used here, pertaining to what the eye perceives objectively.

picture plane The actual flat surface upon which a visual work is executed. Despite the illusion of volume and spatial depth in representational imagery, artists and connoisseurs take into account the fact that the marks creating the illusion actually exist on the surface of the support.

plane (planar) In a drawing, a shape which, by abutting other shapes, gives the illusion of volume. In nature, the facets that many surfaces show, as for example in the folds of a drape, the ledges of a rock formation, or the five curved sides of a banana.

relation (relational) In drawing, the phenomena of visual associations and contrasts based on similarities and differences among the elements and parts of a work.

space (spatial) In the visual arts, pertaining to intervals between pre-established points or boundaries on the picture plane (two-dimensional) and to areas possessing depth as well as length and breadth (three-dimensional).

stippling A drawing technique in which tones and textures are created by drawing

dots in patterns of varying density.

tactile As used here, referring to the sense of touch.

tone (tonal) Pertaining to the various values from white to black by which the artist expresses a subject's volumes and spaces, as well as the inherent lightness or dark-ness of its parts and the play of light upon them.

tooth The surface texture or grain of paper or other supports used for drawing.

unity The evident, overall belonging and relatedness of the elements and parts of a work of art.

BIBLIOGRAPHY

GENERAL TEXTS

Arnheim, Rudolf. *Art and Visual Perception*. Berkeley and Los Angeles: University of California Press, 1974.

Arnheim, Rudolf. *Toward a Psychology of Art*. Berkeley and Los Angeles: University of California Press, 1972.

Bertram, Anthony. *1000 Years of Drawing*. London: Studio Vista Ltd., 1966.

Blake, Vernon. *The Art and Craft of Drawing*. London: Oxford University Press, Inc., 1927. Reprinted by Hacker Art Books, New York: 1971.

Bro, Lu. *A Studio Guide*. New York: W. W. Norton & Co. 1978.

Chaet, Bernard. *The Art of Drawing*. New York: Holt, Rinehart and Winston, Inc., 1970.

Collier, Graham. *Form, Space and Vision*. 3rd ed. Englewood Cliffs, N.J.: Prentice-Hall, Inc., 1972.

Edwards, Betty. *Drawing on the Right Side of the Brain*. Los Angeles: J.P. Tarcher, Inc., 1979.

Eisler, Colin. *The Seeing Hand*. New York: Harper & Row, Publishers, Inc., 1975.

Goldstein, Nathan. *100 American and European Drawings*. Englewood Cliffs, N.J.: Prentice-Hall, Inc., 1982.

Goldstein, Nathan. *The Art of Responsive Drawing*, 3rd ed. Englewood Cliffs, N.J.: Prentice-Hall, Inc., 1984.

Hale, Robert Beverly. *Drawing Lessons from the Great Masters*. New York: Watson-Guptill Publications, 1964.

Hayes, Colin. *Grammar of Drawing for Artists and Designers*. London: Studio Vista Ltd., 1969.

Hill, Edward. *The Language of Drawing*. Englewood Cliffs, N.J.: Prentice-Hall, Inc., 1966.

Lambert, Susan. *Reading Drawings*. New York: The Drawing Center, 1984.

Martinez, Benjamin, and Block, Jacqueline. *Perception, Design, and Practice*. Englewood Cliffs, N.J.: Prentice-Hall, Inc., 1985.

Mendelowitz, Daniel M. *Drawing*. New York: Holt, Rinehart and Winston, Inc., 1967.

Moskowitz, Ira. (ed). *Great Drawings of All Time* (4 vols.). New York: Shorewood Publishers, Inc., 1962.

Rawson, Philip. *Drawing*. London, New York, Toronto: Oxford University Press, 1969.

Ruskin, John. *The Elements of Drawing*. New York: Dover Publications, 1971.

Sachs, Paul J. *Modern Prints and Drawings*. New York: Alfred A. Knopf, Inc., 1954.

Winter, Roger. *Introduction to Drawing*. Englewood Cliffs, N.J.: Prentice-Hall, Inc. 1983.

ON PERSPECTIVE

Ballinger, Louise. *Perspective, Space and Design*. New York: Van Nostrand Reinhold Company, 1969.

James, Jane H. *Perspective Drawing: A Directed Study*. Englewood Cliffs, N.J.: Prentice-Hall, Inc., 1981.

ON ANATOMY AND FIGURE DRAWING

Goldstein, Nathan. *Figure Drawing*. Englewood Cliffs, N.J.: Prentice-Hall, Inc., 1981.

Kramer, Jack. *Human Anatomy and Figure Drawing*. New York: Van Nostrand and Reinhold Company, 1972.

Peck, Roger. *Atlas of Human Anatomy for the Artist.* New York: Oxford University Press. 1951.

Perard, Victor. *Anatomy and Drawing.* 4th ed. New York: Pitman Publishing Corporation, 1955.

Richer, Paul. *Artistic Anatomy.* trans. Robert Beverly Hale. New York: Watson-Guptill Publications, 1971.

Thomson, Arthur. *A Handbook of Anatomy for Art Students.* New York: Dover Publications, Inc., 1964.

Vanderpoel, John H. *The Human Figure.* New York: Dover Publications, Inc., 1958.

ON MEDIA AND MATERIALS

Chaet, Bernard. *An Artist's Notebook.* New York: Holt, Rinehart and Winston, Inc., 1979.

Dolloff, Francis W., and Roy L. Perkinson. *How to Care for Works of Art on Paper.* Boston: Museum of Fine Arts, Boston, 1971.

Watrous, James. *The Craft of Old Master Drawings.* Madison, Wisc.: University of Wisconsin Press, 1957.

INDEX